SURFACE ENCOUNTERS

Cary Wolfe SERIES EDITOR

SURFACE ENCOUNTERS

Thinking with Animals and Art

RON BROGLIO

posthumanities **17**

UNIVERSITY OF MINNESOTA PRESS

MINNEAPOLIS • LONDON

The University of Minnesota Press gratefully acknowledges financial assistance provided by the Department of English, Arizona State University, for the publication of this book.

Chapter 1 was previously published as "Meat Matters from Hegel to Hirst," *Antennae: Journal of Nature in Visual Culture* 14 (Winter 2010): 58–71. Chapter 3 was previously published as "Making Space for Animal Dwelling," in *(a)fly (Between Nature and Culture)*, ed. Bryndis Snæbjörnsdóttir and Mark Wilson (Reykjavik: National Museum of Iceland, 2006), 21–27. Chapter 4 was previously published as "'Living Flesh': Human Animal Surfaces and Art," *Journal of Visual Culture* 7, no. 1 (April 2008): 103–21, and as "'Living Flesh': Human Animal Surfaces and Art," in *Animals and the Human Imagination,* ed. Aaron Gross and Anne Vallely (New York: Columbia University Press, 2011); copyright 2011 Columbia University Press; reprinted with permission of the publisher.

Translation of "The Eighth Elegy" in *Duino Elegies* (1922) by Rainer Maria Rilke reproduced courtesy of A. S. Kline.

Printed transcript from "Up to and Including Her Limits" by Carolee Schneemann reproduced courtesy of the artist.

Published by the University of Minnesota Press
111 Third Avenue South, Suite 290
Minneapolis, MN 55401-2520
http://www.upress.umn.edu

Broglio, Ron.
Surface encounters : thinking with animals and art/Ron Broglio.
 p. cm. — (Posthumanities ; 17)
Includes bibliographical references and index.
ISBN 978-0-8166-7296-7 (hc : alk. paper) — ISBN 978-0-8166-7297-4 (pb : alk. paper)
1. Animals (Philosophy). 2. Other (Philosophy). 3. Surfaces (Philosophy).
4. Animals in art. 5. Art, Modern—20th century. 6. Art, Modern—21st century. I. Title.
B105.A55B76 2011
113'.8—dc23

2011018304

Printed in the United States of America on acid-free paper

The University of Minnesota is an equal-opportunity educator and employer.

17 16 15 14 13 12 11 10 9 8 7 6 5 4 3 2 1

To my wife, THERESA

Life is said in many ways.

—ARISTOTLE, *De anima*

CONTENTS

ACKNOWLEDGMENTS

Properly, I should begin by thanking the animals. They, of course, will not recognize this thanks, nor particularly care about this book; nevertheless, without them and their alien agency, this book would not be possible. *Surface Encounters* has been a labor of love, passion, and joy. There are few moments in one's life and writing that can provide such glad days. Writing this book has been that for me.

I sincerely hope this work has been brought energy and interest to all involved in making it possible. I would like to thank the artists discussed in this book. I appreciate their time spent in conversation with me and their willingness to risk inclusion in the strange hybrid that is this work. The concepts for this book grew from an initial invitation by Bryndis Snæbjörnsdóttir and Mark Wilson to write for the catalog of their *(a)fly* exhibition. I am thankful for their invitation that became the impetus for further writing. I'm grateful to Steve Baker, who from the beginning has been a wise friend with advice on writing and interviewing. I am grateful to the UK Animal Studies Group and in particular Erica Fudge, Jonathan Burt, and Gary Marvin for their labors to establish the field of animal studies and unflagging energy toward this end. Thanks to Rosemarie McGoldrick for organizing the 2008 and 2011 Animal Gaze Symposiums at London Met and to Ross Birell for conversations at the Glasgow School of Art and in *Art and Research*. Thanks go to

Giovanni Aloi and his tireless labors to create a home for animal studies scholarship at *Antennae: Journal of Nature in Visual Culture* and Rikki Hansen for her radio program. Many thanks also to the North American animal studies scholars whose work and friendship lend much to this book, including Susan McHugh, with whom I've had over a decade of conversations about animals; Randy Malamud, my Atlanta animal comrade (along with Pam Longobardi and Lori Marino); Nigel Rothfels; Susan Squire, a generous and beloved colleague; and Ruth Ozeki, Joan Landes, David Frazer, and Alice Kuzniar. For years Kari Weil and Tom Tyler have been companions in thought on a number of projects, and it has been a pleasure to exchange ideas and concepts with them. Thanks to Richard Nash, Hugh Crawford, Narin Hassan, Carol Coletrella, Pamela Gilbert, and the tenacious Eugene Thacker for their careful readings and kind encouragement. Other companions who have sustained my thinking include Paula Young Lee, a companion in thinking meat; Donna Haraway, who stays with the trouble and frictions of human–animal encounters; Andy McMurry, a steadfast thinker of nature; Jane Prophet, my go-to art resource; and Chris Pair, my cohort in an *Animality* chapbook and failed documentary film. Thanks also to the Culture and Animals Foundation for helping support the film and book efforts.

Thanks to a large number of scholars in my other field of study—British Romanticism—including but not limited to Steve Jones, Neil Freistat, Alan Liu, Marilyn Gaull, Richard Sha, Charles Rzepka, Adam Potkay, Jeff Cox, Thora Brylowe, Talissa Ford, Michael Gamer, David Baulch, and Rob Mitchell. Thanks also to my generous colleagues at Georgia Gwinnett College, where I found a home for a year. They provided encouragement and support for this project.

Over the years of labor a few comrades have particularly sustained my work, and they deserve special mention. A special thanks to David Clark, whose intellectual generosity and insight are unbounded. Thanks to Marcel O'Gorman and his Critical Media Lab, where I could explore the bounds of my work. Thanks to the animal revolutionaries Fredrick Young, Charlie

Blake, Claire Molloy, Steve Shakespeare, and Frida Beckman. Thanks to Paul Youngquist, who is an animal revolutionary to the bones and has seen me through many a scrap. Because of you all, I have begun thinking the revolution (my next work), and *Surface Encounters* is for me its prelude. Thanks to Mark Lussier, my colleague at Arizona State University, whose generosity has helped my scholarship thrive, and to Arizona State and the department of English, which continues to support my work.

Many thanks to Cary Wolfe as a critical voice and sustained supporter of this work through its various iterations from early conference papers many years ago to a published book. Thanks to Doug Armato and all those at the University of Minnesota Press who have made the process of seeing these ideas in print a pleasure.

Finally and most particularly, many thanks to my wife, Theresa, who has been a sure and steady companion throughout my academic career and who has made my work possible.

Introduction

Staying on the Surface

This book focuses on a singular problem: What is an animal phenomenology? What is it to be an animal, not as observed from an objective perspective of natural history, but from the fur of the beasts themselves? This does not mean asking what it is like to run like a cheetah. The concern in this problem is not likeness. It is not an issue of similarity; rather, what is running for the cheetah? What is swimming for the seal and slithering for the anaconda and bedding down for the cat—to name but a few animals that appear in this book. Traditionally, phenomenology is interested in how humans are embedded in their world—a world of material things, cultural meanings, and physiological engagement. As such, phenomenology is decidedly anthropocentric; it is interested in how we humans move in the world as we perceive it. There are good reasons for such bias. After all, the human world is what we know best, and inquiry into the animal world proves rather tricky.

Some readers will recognize in this problem of animal phenomenology an echo of Thomas Nagel's essay, "What Is It Like to Be a Bat?" There is an extended discussion of Nagel later in this book, but for now, let me simply say that the problem of embodying another perspective haunts philosophy and art. How is one to get outside of one's world to think and to feel from another point of view? This is a particular challenge when thinking may not involve rational cognition, and when feeling is done through sense organs differently

attuned than our own.[1] What does it mean to think with a different body and different mind in a differently constituted world? In these questions of the animals' worlds, we are confronted with how to understand others' perspectives without reducing them to our own and without throwing out parts of these others' worlds that we cannot understand. When these others are not human, their radical disjunction from anything we understand as our world creates grave problems. In its foreignness, the animal other becomes radically Other.

Traditionally, animals have been viewed as having limited faculties. Their poverty of faculties is supposedly evident in their "lesser" ability to reason, in their language, and in their use of tools. Their skills are lessened by measuring them against every standard in which we consider ourselves superior, and by this superiority, we differentiate ourselves from them. In each case, the animals are measured by our yardstick and come out wanting. I characterize the supposed inferiority of their abilities by a shorthand called "living on the surface." According to a long cultural and philosophical tradition, animals do not engage in the self-reflexive thought that provides humans with individual and cultural depth of being; instead, animals are said to live on the surface of things.[2] Surfaces are seen as fleeting appearances, mere shadows lacking the substantiality found in the "depth" of human interiority. Animals supposedly do not have the depth of memory and the ability to process events and memories as humans do; instead, their lives are a series of instances, one after the other as fleeting events in time, rather than a thoughtful narrative. Their lack of critical reflection reveals their lives to be "like water in water," as Georges Bataille says, meaning that the animals do not differentiate among themselves, their actions, and their environment: "There was no landscape in a world where the eyes that opened did not apprehend what they looked at, where indeed, in our terms the eyes did not see."[3] They do not think in the abstract about the things around them, and so do not see objects as objects.

So it is that we have cornered the animals by limiting their sense of depth. We have corralled them under the concept *animal*. What depth they do have is dismissed as lesser than that of humans, or so foreign as to be untranslatable

and not worth pursuing in our human endeavors. This flattening of animals' worlds into a thin layer of animal world as a life on the surface of things has legitimated any number of cruel acts against animals.[4] What I would like to pursue here is how the notion of "animal surface" can be turned against its negative uses. The surface can be a site of productive engagement with the world of animals.

Contemporary art has a particular investment with surfaces that is useful in unhinging philosophical concepts and moving them in new directions. Artists are keenly aware of the optical and physical surfaces that function as the material for making art. The surfaces presented in the world are doubled by surfaces created by the artists, be they on paper, canvas, photographic paper, film screen, surfaces of installation objects, or body surfaces of performance art. Artists negotiate the optical and material surfaces presented to them in the world and the surfaces of their materials of expression. The allusive and illusive surfaces form a language—both material and cultural—for artistic expression. It is not a formal language and syntax but a comportment and way of proceeding. This expressive language formed from the double fold of these surfaces creates conditions for thinking the problem of contact between the "surface" animal world and our own. Working between these surfaces, folded within them, artists create works that prompt thought in new directions.

While art functions within the cultural world, the very human world, much of the art under discussion in this book comes to terms with nonhuman realms. The works point outside of culture to alien spaces. I am interested in how art calls to us to consider and negotiate the space of this animal other. The artists and their works do not present a unified mode of proceeding but rather heterogeneous approaches and attitudes for understanding the nonhuman.

At stake is the ability to think about the Other, those agents and beings radically different from ourselves. How are we to understand that which differs from our capacity to comprehend? The conjecture of this book is that such thinking is possible within particular parameters. Foremost, it is a thinking

that arises from the event, action, and encounters with the animal others. This is a corporeal thinking that risks itself, mind and body, in the acts of encounters that differ with each animal. (The event is not simply singular but a swarm or pack that multiplies with each engagement.) Additionally, thinking the Other in this case is possible only if we consider thinking as an activity in the wake of philosophy as a series of experiments and paths toward producing tentative, sometimes fragile, and hybrid meaning. In particular, and as I'll take up in later chapters, pidgin language—as a makeshift and cobbled-together language of words and gestures between two different groups—has been particularly helpful for me as a figure for thinking alongside animals.

To engage the animal other certainly constitutes a question of ethics—or as I note in chapters 1 and 2, a question of violence and consumption of another and its world. How can we meet the other on terms other than our own without co-opting this other for our own ends? I have tried to establish a figural language for talking about and actually engaging with animals. I am interested not simply in if it is possible to meet the Other but how—by what methods this encounter in the no-man's-land between humans and animals could take place. Certainly this would be no totalizing understanding but rather an understanding that always has its potential for collapse before it.

As may be evident throughout the book but most particularly in its closing chapters on Becoming, engagement with animals is not only a question of ethics but also of ontology. Primarily, I am interested in questions of ontology—our being and comportment in our world and on this earth. Realizing and taking seriously that there are other beings with other worlds and ways of being on this earth means reassessing humanism and what it means to be human. Early on I establish the figure of hybridity—what it means to be both human and animal. Hybridity haunts the chapters that follow by serving as a fundamental operator in our engagement with nonhumans.

If what is at stake is how we think about (and alongside) the Other, hybridity and becoming put up other stakes: rethinking humanims. As most deep approaches to animals studies claim, by measuring ourselves in relation

to the nonhuman, humanism deconstructs by way of its necessary supplement, the animal. Indeed, the animal that therefore I am and inaccessible animality (of humans and nonhumans) fashion the human. The outside—surfaces not "within" the "depths" of human interiority—opens up humanism causing inflections in its boundaries. Some of these inflections and risks in restructuring (non)human community are outlined in this book. A more developed look at this restructuring, indeed an animal revolution in the constitution of community, would be another work, one yet to come.

While humans and animals live on the same earth, they occupy different worlds. If we cannot access what it is to live from the standpoint of the beast, then our understanding of the animals and their worlds comes from contact with the surfaces of such worlds—the sites where the human and animal worlds bump against each other, jarring and jamming our anticipated cultural codes for animals and offering us something different. This book seeks to take the negative claim of animals living on the surface without cultural or individual depth of being and turn the premise into a positive set of possibilities for human–animal engagement. I am not claiming that animals live *only* on the surface; indeed, biologists and ethicists continue to find a depth of thinking in the lives of animals. What will become evident in the middle chapters of this book is that such depth, if radically other than our own, remains necessarily closed off to us and that the surface of interaction between humans and animals becomes a zone for thinking such inaccessible locales that may prove to be but other surfaces yet unexposed.

The supposed poverty of the (animal) surface provides an opportunity for thinking differently. If philosophy is to think the unthought of thought, it will be at such limits, horizons, and surfaces where we meet the Other. The concept of the surface has a long-standing affiliation with illusions, appearances, and art.[5] Jean Baudrillard's association of surfaces with simulacra turns this "bad copy" of the real into a hyperreal.[6] In his version of reading surfaces, the real as a model and standard is abandoned altogether. Without any model from which to judge the truth of appearances, every surface sets its own standards. The result is a proliferation or heterogeneity of truth-claims with

no singular ground by which to make a judgment.[7] The world is a series of appearances flashing before us in an ongoing becoming; yet in order to capture this becoming, we give it a sense of being. Nevertheless, the being of that which appears to be is itself mere appearance and illusion. The true is no longer what *is*, but rather unfettered *becoming*. Twentieth-century theorists have turned the value and valences of surfaces into a strength rather than weakness. They see in the surface the flash of becoming hidden by our attempt to solidify appearances into being and depth of meaning. If, as has been the supposition of Western thought, animals live on the "mere" surface of things, then they have something to tell us about the world of becoming. Staying on the surface with animals affords us an invaluable modality for thought, and for pursuing the unthought of thought.

Contemporary artists have particular sets of tools that are not available to philosophy. While philosophy delimits itself through language and reason (including the limits of reason), artists can create striking nonlinguistic and asignifying works. They can appeal to a tradition of such works in modern art, while extending the site of such works to engage with the world of animals. The artists considered in this book are not concerned with mimesis or representing animals according to a natural history tradition or a kitsch assimilation of animals into our world as tamed or cute or defeated; rather, these artists have unmoored themselves, even ever so slightly, from the cultural grounding of meaning and the solidification of being over becoming. They have become unmoored in order to take seriously the world of the animal on its own terms. In other words, these artists take seriously the problem of an animal phenomenology.

To ask what is an animal phenomenology is to engage in an unanswerable question. Lest readers become disheartened at the outset, it is worth noting that the very impossibility of understanding the animal as Other serves as the productive friction by which authentically new thinking and art are produced. The problem itself becomes a means of creating outside of what is acceptably known and intelligible. Unlike conventional engagement with animals, the problem of ascertaining an animal phenomenology inscribes within itself and

announces in advance its own impossibility; that is to say, it recognizes that the rules, grounds, and engagements that such a problem creates are always shaky and tentative rather than authoritarian demands that assimilate the animal, and in doing so annihilate its difference or unintelligibility. The interrogative prolongs thought and forestalls an answer that would too neatly close our relationship to the opacity of the animal Other. Stephen Laycock describes the dynamic of an open question and positions it against our common mode of question and answer:

> But answers that obdurate their questions without remainder comprise no more than "information." Such "digital" [on/off, yes/no, 1/0] questions are minimal openings, like the negative internal space of a puzzle piece that awaits a specific extroverted form, or like a specifically designed lock that can offer itself only to a key of particular specifications, thus "giving only dead and circular replies to a dead and circular interrogation."[8]

In the question that suspends and defers clear answers, we learn the intrigue of thought. We learn to comport ourselves in a way that, rather than imposing on the Other, is able to question the foundations of what it means to be human.

Perhaps, as David Clark has proposed, the very question "What is an animal phenomenology?" serves as its own answer. The event structure of the question, its open-ended act, occasions an interrogation without an expectation of return. The role of the question is to open inquiry into other modes of thought, to an animality and the multitude of animals and their ways of being.[9] The invitation extended to the reader is to take up this question, to ask it in the company of the artists and philosophers and animals under discussion here. There is a certain absurdity to asking this question. It is an absurdity addressed in the closing chapters of this book. Engaging in the event that is this question itself is an invitation to a becoming, to a crossing over that restructures what it means to think and what it means to be human, in particular to be human alongside other animals.

By recognizing the impossibility of knowing from the fur of the Other, animal phenomenology asks us to think of our own fragility. The problem announces in advance that our worldview has limits that prevent our pursuits (and our claims arising from them) from being all-encompassing. Instead, in what could be a profound ecological gesture, this question that inscribes within itself its own failure or impossibility allows us to think of human fragility. As Cary Wolfe and Cora Diamond note, fragility and exposure are modes of relating to animals.[10] As Michel Serres explains, it is a fragility we share with the earth itself.[11] While much of the history of philosophy has been about mastery of thought over and against the stuff of the world, fragility allows us to think otherwise, to think differently. It is such difference that plays out over the course of this book.

While the question of an animal phenomenology challenges humanism and its scaffolding of mastery, the question itself, if pressed, fragments. There is no single animal phenomenology. Indeed, each sort of animal carries itself differently on earth and fashions a different sort of world. For example, Donna Haraway and Tom Tyler have actively pursued an understanding of the dog's life. Such a life fragments further upon consideration of different breeds and different individual animals. To ask what is an animal phenomenology is a question that serves as a lure. It draws us into an endless progression of other questions about specific animals and their lives. Indeed, throughout this book, readers will note how artists have taken into account the various worlds and worlding of specific animals—Wilson/Snæbjörnsdóttir's polar bear habitats, Olly and Suzi's tentative coyote, Coate's amphibious seal, to name a few examples.

Perhaps to ask what is an animal phenomenology concedes too much to humanism. It grants too much to the argument that there is a divide between humans and all other animals. Yet in making this concession, the question as lure proves useful by drawing us into an abyss where "all other animals" become a wide array of different ways of being. Such a variety—being manifest in so many ways—wears thin the walls of a human/animal divide. Eventually one might ask what are animals' phenomenologies, and the misnomer

of a singular animal phenomenology could be put aside. I have maintained the singular question of an animal phenomenology as an opening gambit in what culture calls "the animal"; it is a play of stakes that eventually open onto more complex questions involving the plurality of animals lurking within the pages of this book.

Animal worlds set a limit to human knowledge and serve as the starting point for contemporary animal artists who slough off social values of humanism in order to produce opaque objects that bear witness to the other side of the animal–human divide. They are not interested in mastery of nature or mastery of expression. Theirs is not an illustrated natural history. My fundamental speculation is that the wonder of such art is found in the play of surfaces; it is here in the contact zones, between the outer edge of a human world and the animal world, where exchanges take place. Art brings something back from this limit and horizon of the unknowable; it bears witness to encounters without falling into a language that assimilates or trivializes the world of the animal. This art instead provides an infectious wonder at the animal world on the other side of human knowing.

It bears emphasizing that animal phenomenology is a lure within this book. Animal phenomenology is an impossible horizon because humans fundamentally return to a human phenomenology, or at least its limits and what can happen to human phenomenology as it bears witness to that which remains closed to us. In this book I do not examine specifics of how animals think and feel. The approaches by neurobiology and animal behavioral science have done much to speculate in these areas. Rather, I am using the limit of knowing as a site of productive inquiry. It is difficult enough to arrive at any certainty about what I think and feel, and it is perhaps impossible to know what another human feels. Extending this problem to animals only rebounds to show the complexity of thinking without foundation of certainty. Without transparency of knowing the Other, I've found recourse in discussing the frictions and follies of animal encounters.

In the contact zone between humans and animals, something does take place. This something cannot be translated into human knowing or human

relations without loss and distortion of the event. Indeed, the human–animal contact zone becomes a contact without contact, a relation of nonrelation and communication whose language would be under erasure. As will be evident in these chapters, our comportment in the world and our means of communication become stretched, bent, and malleable in the wake of encounter. Artists in this book struggle to bear witness to the presence of the nonhuman—the alien presence among us. In the shadows and in the wake of encountering the animal, how is one to articulate the event? Where is there a language without translation, loss, blindness, or appropriation? Aware of these pitfalls, these artists inscribe within their works a sense of fragility and mutability. My writing about works in the wake of animal encounters creates another encounter and another wake. For me the problem has been to create a way of talking about the art that does not appropriate nor assume too much—or subsume too much. It means doubling the inscribed fragility of "knowing" or ~~knowing~~ when placing the work (and the event) within an economy of discourse and thought.

This book is not about what lies under the fur of the beast as some presence that ever recedes before us. Rather, it is what happens on the surface when we encounter animals as unassailably animals. The event of encounter, the problem of animality, remains the animals "before us," as Derrida says. They are before us and we come after them, in their wake and in a wake mourning the incommunicability of encountering them. The encounter as event is an untimely now—a "now" outside of human time—a moment that puts aside before (us) and after (them). It is not a question of what animals are up to in their worlds but that they are up to anything at all, and that we in our worlds bump up against them. What happens amid the friction and gliding between human and animal worlding?

Turning from the general approach of this book to its particulars, each chapter introduces and develops a series of concepts for entering the world of animals. In most cases, the concepts are intimately entwined with the work of a particular artist examined in the chapter. The art invokes concepts, and the concepts further our understanding of the art. Through direct and

oblique approaches, the art and concepts turn and return to the problem of animal phenomenology—what is "felt in the blood, and felt along the heart" of the animal.[12] The book has three movements. The first two chapters explore artist approaches to animality, the second two take up the immanence of animal worldings, and the final chapter along with the coda leap the supposed fence of the human–animal divide and explore a Becoming-animal.

How is one to approach animality? Archimedes once said: "Give me a place to stand and with a lever and I shall move the world." The problem is, where can one stand outside the world by which to lever it? Chapter 1 examines how the art of Damien Hirst finds a lever in the abstract conceptual apparatus that enframe animals under the rubric *animal.* Through conceptual works, Hirst hoists us up out of the animals' worlds into a world of ideas where human self-reflexive consciousness finds its purposiveness and its home and, unfortunately, leaves the animals (or their carcasses) behind. In contrast, the second chapter looks at approaching the animal from immanence rather than transcendence: Carolee Schneemann's Dionysian revelries are paired with Nietzsche's satyr in order to illustrate the chiaroscuro human–animal nature of what it means to be human.

Choosing immanence as a method of inquiry into animals, the next chapters pursue the issue of engaging animals without the safe distance of enframing or enclosing (and closing off) the animal worlds. Through the work of Bryndis Snæbjörnsdóttir and Mark Wilson, chapter 3 develops the concept of animal *Umwelt,* or world. In chapter 4, Olly and Suzi work in the far reaches of the globe where they are out of place, but where the animals they encounter are very much at home. Their work bears witness to the contact zone between animals and humans.

In "Minor Art," Marcus Coates seeks to collapse the differences between humans and animals to embrace surfaces as becomings. Rather than a friction between worlds delineated in the previous sections, Coates imagines a plane or site in which attributes of the human and nonhuman are exchanged among species, and the solidity of the substantive terms *human* and *animal* becomes porous boundaries. The brief coda tests the concepts of the book

by using Matthew Barney's *Drawing Restraint 9,* where human and animal encounters lead to metamorphosis.

Given the wide array of contemporary animal artists, my selection of six artists may appear idiosyncratic. I have tried to choose artists whose work corresponds to particular issues in philosophy and is unique it its engagement with animals. Certainly there are many other artists with related conceptual interests; I leave it to other writers to explore the animality within those works. The present study is admittedly limited in scope so as to provide some room for developing ideas in a narrow rather than ranging study of artists. For readers interested in more breadth of art, I recommend Steve Baker's well-known book, *The Postmodern Animal,* along with his subsequent essays and his forthcoming work *Art before Ethics: Animal Life in Artists' Hands,* and I point readers to the animal-art journal *Antennae,* edited by Giovanni Aloi. Additionally, the phenomenological approach to animals suggested in *Animal Others: On Ethics, Ontology, and Animal Life,* edited by Peter Steeves, has informed the philosophical tact of this present work.

I am interested in the way art reveals the world of the animal as a necessary lacuna in human knowledge.[13] Art reveals the inability to articulate the world of the animal; art sets a limit, a blindness to our insight, while at the same time providing us with the palpable biotopic zone of interaction where the boundaries of worlds jostle each other.[14] By working from the animal to human art, rather than the other way around, the impossibility of an animal phenomenology becomes the productive limit from which artists find inspirational and transformational material for their work.

In these chapters, there is little direct criticism or critique of the artists discussed (with, perhaps, the exception of the chapter on Damien Hirst). Rather, the book diplomatically enlists the artists as allies in thinking animality. The goal is to produce a line of thinking that builds on the labor and construction of these artists. Their engaging cooperation, hospitality, and vulnerability through conversations, correspondences, and studio tours have been an important part of the process of writing this book. I have not tried to find a space where as an objective critic I can stand outside the works of these artist and

discuss them. Rather, I am interested in extending the artists' experimentations into the studio of cultural and philosophical thought. What might be produced not by reflecting back on the artwork but by taking off with the art and making it do work in other realms? Part of enlisting the artists has meant not co-opting their work for philosophy but rather translating and then extending the work beyond the discipline of art into other modes of thinking and expression. This move has been facilitated by the transdisciplinary modes of inquiry the artists themselves have established.

The artists are not philosophers. While working across disciplines, they are critically aware of and a part of the language and traditions of contemporary art and speak to this community. Moving the work to engage specifically with the lure of animal phenomenology reveals not only the potential but also their limits in articulating the event of contact and encounter. I discuss these limits briefly within each chapter. For example, for Schneemann, are animals more than props for human discourse about sexuality and gender? By omitting any interaction with live animals in their work, have Snæbjörnsdóttir and Wilson put aside the most difficult of questions—the event of encounter itself—and left in its place a series of anthropological investigations of human representations of animals? For Olly and Suzi, is canvas really a contact zone, or are they simply baiting animals to come into contact with the drawings in a naive view of transspecies communication? For Coates, is his becoming-animal simply a sly wink and nod game in which he leverages cultural desires for communication to advance his own artistic ends? And finally, are animals for Barney more than figures for human cultures and psychic states? Such questions should be understood not primarily as criticisms of the art and artists but more fundamentally as a recognition that the question of animal phenomenology provides a foil for unpacking the possibilities and the lacunae within these works.

Chapter 1, "Meat Matters," examines how human values of depth and interior reflection are used to minimize the animal and its world. Many of Damien Hirst's best-known works grapple with the seemingly alchemical, violent transformation of life to death and opaque to knowable as animals

become meat. To understand the significance of such alchemy, the chapter traces meat as the metaphysical moment when the animal is killed for raw material, and human meaning; nature is laid bare, made lifeless and exposed, in order to be subsumed within cultural intelligibility. At the same time, the notion that nature can be made fully present to us is worth reconsidering: how do the metaphors of nature hiding and nature revealed ground our understanding of animals, and how might we begin to think outside of this predominant approach to nature?

The relationship between meat and knowing can be found in Francis Bacon's justification for dissection and vivisection. For this seventeenth-century natural scientist, knowledge attained in cutting open animals helps restore humans to an Edenic world. Such empirical and positivist claims about the ability of science to restore human well-being are furthered by G. W. F. Hegel's philosophy. For Hegel, through dialectic tension, the material world is subsumed by consciousness into full knowledge and intelligibility. In his *Encyclopedia*, eating becomes the transformation of dead matter into life, and intellectual consumption transforms matter into self-presence. These valences of dissection and consumption provide a means of grappling with Hirst's work. At the same time, as shall be seen throughout this chapter, meat is never simply the animal opened up and made intelligible–consumable; meat has its own frictions that prevent human intellectual and physical consumption of the animal.

The second chapter, "Body of Thought," responds to the Baconian idea of cutting open and consuming the animal body by using a different model as method: the figure of Dionysus. Carolee Schneemann's work, and in particular *Meat Joy*, exemplifies Dionysian art in which the animal cut open becomes the site of a frenzied feast of destruction. The feast doubles the fragmented nature of our human–animal being and comments on the act of artistic creation. Here, consumption becomes a performance of human animality and a plane of immanence by which the human meets the animal, even as the human seeks to consume the animal Other. Friedrich Nietzsche's satyr as both animal and man grapples with the tensions in this double way of being,

which is intimately woven into Nietzsche's ontology. Artists and scholars working with animals are tasked with recognizing the ground from which they work, be it the intimate animality indicative of the satyr or the distance or obfuscation of one's animal nature as figured by the shepherd who is always a staff's distance from the animal flock. To be a bit more forceful in this claim, I have ventured from the ontology implicit in the satyr and the shepherd to the means by which they stage their eating, and I have equated eating, consumption, and incorporation with epistemology. The problem of the satyr is how he incorporates, makes singular and whole, his divided body *(corpus)*. The satyr's Dionysian feast is a frenzy of destruction that doubles the fragmented nature of his own being; his eating and his epistemological ability to know or make sense of his self and his world remains as fragmented as his human–animal nature. In contrast, Martin Heidegger's "shepherd of Being" knows and manages his flock, but his eating (what Derrida calls his *bien manger*) is never explicitly discussed; the shepherd is stuck between his managing and eating, or between *manage* and *manger*. We know that the shepherd will take his sheep to the butcher, but how the cutting up and eating (or, epistemologically, how the divisions leading toward knowledge) take place gets averted.

Having established immanence as a mode of inquiry, the next section, which focuses on animal worlds, provides the central conversation about a theory of animal surfaces. Chapter 3 examines how artists Bryndis Snæbjörnsdóttir and Mark Wilson work in the margin between the animal and human worlds. They do not provide a perspective from the animal's point of view, nor one solely from the human's. In as much as the animal world is unknown to us, it remains as what Rainer Maria Rilke calls a "nowhere." Yet as explored and recovered in the artists' works *nanoq: flat out and bluesome* and *(a)fly*, their artworks reveal a "nowhere without the no." We cannot know this "no" through direct investigation and interrogation of the animal or its dwellings; indeed, only by upending the groundedness of home and recalling the stray (animal) in our own dwelling can we obliquely glimpse another's abode. Rilke claims that "[w]e know what is outside us from the

animal's face alone." Following Snæbjörnsdóttir and Wilson as they track the animal world, we can begin to understand an "outside us" that is in our very midst.

The "outside" or animal's perspective has been strikingly described by the early twentieth-century scientist Jakob von Uexküll, a founding figure in ethnology and biosemiotics. In *A Foray into the Worlds of Animals and Humans,* Uexküll moves beyond mechanistic biology to develop a line of inquiry into the animal's sense of its surroundings—something close to an animal phenomenology. Uexküll presents an infinite variety of perceptual worlds that are as different as the animals themselves. Each animal species holds its own point of view and its own distortions of the actual earth. These perspectives reflect how the body of the animal has evolved over ages to adapt to the earth and to meet the animal's needs. We are left with the understanding that there is no single unitary world and no unified space or time; instead, time moves differently for each species, and each animal senses and shapes space quite differently. The work of Snæbjörnsdóttir and Wilson illustrates the heterogeneity of animal worlds put forth by Uexküll.

Because the world of the animal remains foreign to humans (or, as Thomas Nagel says, we will never know "what it is like to be a bat" from the bat's perspective), we can only know the animal through surfaces. We know it through contact with the surface of the animal and the surface of the animal's world, or "bubble," as Uexküll explains. Chapter 4 explores how Olly and Suzi work with the animal surface, its living flesh, as well as the surface of the animal world as it meets our own in contact zones. The work of Olly and Suzi provides a test case for breaching the divide between human worlding and the "poor in world," or mere surface lives of the animal as explicated by Heidegger. The artists' paper spreads out as surface between the animal, and the artists create a contact zone at the edge of the human and animal worlds. The paper marks a productive site for pidgin language that counters human interiority as the space for thinking. The pieces of paper circulate in a human–animal economy and bear witness to an animal world. This witnessing is not a knowing and consuming that subsume the animal and its world

and subsequently deprive animals of a space outside human understanding. These works leave the mystery of the animal and its world intact while calling attention to its existence.

Following from concepts developed in the middle section of the book (including worlding alongside animals and a pidgin language that emerges from encounters), the final section, which is about Becoming, considers infectious transformation between human and animal states that are activated by an encounter. Chapter 5, "A Minor Art," considers the work of Marcus Coates as a becoming-animal. When Coates performs his shamanistic rituals as artistic social intervention, when he descends to the "lower world" and squawks with the birds and grunts with the deer, he is enacting a minor art. One of the features of minor art espoused by Deleuze and Guattari is the move from metaphor to metamorphosis (what they will later characterize as "becoming"). The good metaphor and obedient literary image work because of a social agreement based on selection, which signals the proper relationship between vehicle and tenor. The well-regulated metaphor manages elements to be included and those to be discarded in the relationship between vehicle and tenor. Coates's work botches or misplaces these proper relations, which results in the death of metaphor and the rise of metamorphosis. Sounds and words, gestures and bodies lead us away from established social configurations—away from the metaphors that we have forgotten are metaphors, now inscribed as social truths. We are led instead to meanings and marks of signification whose selection is based on the hybridity of two worlds being negotiated tentatively and temporally; meaning becomes immanent to a particular place and time within a particular set of quasi-social exchanges.

Animals challenge language and representation that too often purport to be disembodied thought. To make thought move and do real work at the horizon of the unthought, representation should create a friction, reciprocity, and exchange between the human symbolic system of representing and the physical world shared with other creatures—the marks and remarks of various *Umwelts*. To think alongside animals means to distribute the body of thinking, creating a distribution of states or plural centers for valuing, selecting,

and marking/making a world. Coates's masks and dances are not a disguise or mimicry. They are a flattening of human interiority toward a minor aesthetic.

The brief coda or tail on Matthew Barney considers how lifting restraints of language and gesture and ritual set in motion a transformation of human–animal boundaries. This brief examination of his video work *Drawing Restraint 9* puts into play and suggestively plays with prior figures and concepts formed throughout the book.

The concepts developed in this book are not intended as an end to the maddening and haunting opacity of the animal world, and indeed, the coda keeps worlding an open-ended event. In the end is our beginning. I hope the concepts and art discussed here bring us to a state of wonder rather than knowing. In moments of wonder come the possibilities of developing problems and questions that allow us to think the outside, the Other, and the animal. In the vertiginous exploration of animal phenomenology, we unmoor ourselves from comfortable, habitual dwelling and set out on a stroll in the worlds of animals and humans.

Meat Matters

Distance in Damien Hirst

Meat is the moment when what remained hidden to us is opened up. The animal's insides become outsides. Its depth of form becomes a surface, and its depth of being becomes the thin lifelessness of an object exposed. Meat makes the animal insides visible, and through sight the animal body becomes knowable. And while meat serves as a means for us to take in the animal visually and intellectually, it also marks the moment when the animal becomes physically consumable.

In meat there is a transformation from living to dead, from hidden to revealed, and from indigestible to edible. As the marker of this change, meat has a visceral materiality. The material form of dead animal flesh is haunted by the trace of a life transformed into an object through the violence of death. The willful life of an animal becomes an object that shows little ability to resist human understanding, manipulation, and consumption.

Many of Damien Hirst's best-known works grapple with the seemingly alchemical, violent transformation of life to death and opaque to knowable as animals become meat. To understand the significance of such alchemy, this chapter traces meat as the metaphysical moment when the animal is killed for full presence, material, and meaning. Nature is laid bare, made lifeless and exposed, in order to be subsumed within cultural intelligibility. At the same time, the notion that nature can be made fully present to us is worth

reconsidering. How do the metaphors of "nature hiding" and "nature revealed" ground our understanding of animals, and how might we begin to think outside of this predominant approach to nature?

Hirst has created a number of works that involve whole animals or cut-up animal parts. These works range from animal parts in jars or tanks of formaldehyde, as in *The Lovers' Cabinets* (1991) and *Some Comfort Gained from the Acceptance of the Inherent Lies in Everything* (1996), to whole animals in formaldehyde, as with *Isolated Elements Swimming in the Same Direction for the Purpose of Understanding* (1991) and *Away from the Flock* (1994). In some of these pieces, the animals or their parts are placed on shelves as if in a natural history exhibit or in a biology laboratory; in others, the use of livestock animals—cattle, pigs, and sheep—recalls cutting animals for consumption.

Hirst has a long-standing interest in medical specimens, and intertwined with this is a curiosity about death and dead bodies, evident from early work as a student at Goldsmiths onward. His medical fascination is evident in an early show he curated called *Modern Medicine* (1989), and in his more developed works that explicitly use laboratory instruments and specimens. Hirst's citation of dissection and vivisection provides a means of reading his use of animals as material for art. By leveraging this history of cutting open animals, the artist is plying animal death as an avenue for human knowledge of nature and of ourselves, or, as Hirst says, "that whole idea of killing things to look at them."[1] As we shall see with Francis Bacon, one does not simply "look at them," but the insides are exposed as a visually accessible outside to be interrogated for the benefit of human knowledge.

The relationship between meat and knowing can be found in Bacon's justification for dissection and vivisection. For this seventeenth-century natural scientist, knowledge attained in cutting open animals helps restore humans to an Edenic world. Such claims about the ability of science to restore human well-being are furthered by G. W. F. Hegel's philosophy. For Hegel, through dialectic tension, the material world is subsumed by consciousness into full knowledge and intelligibility. In his *Encyclopedia,* eating becomes the transformation of dead matter into life, and intellectual consumption transforms

matter into self-presence. These valences of dissection and consumption provide a means of grappling with Hirst's work. At the same time, as we shall see throughout this chapter, meat is never simply the animal made intelligible; meat has its own frictions that prevent human intellectual and physical consumption of the animal.

CUTTING OPEN

Mother and Child, Divided (1993, Figure 1) is Hirst's first work to display the full bodies of large animals cut open. The work led to his winning the Turner Prize in 1995. In this particular piece, the artist has bisected the bodies of a cow and a calf by cutting each from head to tail. The halves are then encased in glass tanks of formaldehyde. The four tanks with the animal halves are separated by a narrow space of a few feet, and the calf and cow are placed one in front of the other. The animals appear to be pristine specimens in some sort of natural history display. Viewers are often repulsed or shocked at the visceral materiality of the sculpture, yet at the same time they are captured by wonder at the insides of these domesticated animals. It is a double reaction often provoked by Hirst's work: a repulsion at the materiality of the piece, and an intellectual curiosity about the animal and the making of the work. Hirst succinctly describes this: "Animals become meat. That's abstract."[2] This move from material to abstraction is essential for understanding Hirst, as well as the historical and philosophical tradition of dissection that informs his work.

Many pursuits of knowledge about nature are conducted under the simple claim made by the Greek philosopher Heraclitus: "Nature loves to hide." Like much of Heraclitus' work, this aphorism is incredibly suggestive, while leaving basic assumptions and details unspoken. His phrase has generally been taken to mean that nature veils itself, or that the essential nature of things is hidden.[3] It is not simply that nature remains unknown, but rather that it is in the nature of nature to hide. It "loves" to hide; its proclivity is to remain unknown and out of human grasp. If nature hides, it is not infinitely unknowable; rather, hiding implies its opposite: finding. Inquiry from the Greeks on has taken Heraclitus' phrase as impetus to lift the veil on nature

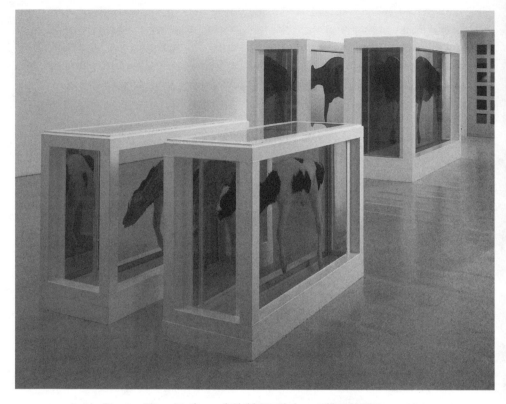

FIGURE 1 Damien Hirst, *Mother and Child, Divided,* 1993. Steel, GRP composites, glass, silicone sealant, cow, calf, and formaldehyde solution. 74.8 × 126.97 × 42.91 in (1900 × 3225 × 1090 mm) × 2 tanks. Photographed by Prudence Cuming Associates. © 2011 Hirst Holdings Limited and Damien Hirst. All rights reserved, ARS, New York / DACS, London.

and reveal what has been kept hidden from us. As we shall see, cutting animals open serves as one way of lifting the veil, exposing the interiors as visually accessible exteriors.

Heraclitus' aphorism sets up an antagonistic relationship with nature. Revealing nature would be to go against its pleasures; what nature loves is to

hide. We go against nature's nature for the sake of human knowledge. Nature hidden by a veil heightens the metaphors of penetration, violence, and denuding, which become the operative images of revealing and knowing nature: for the sake of our pleasure in knowing, we rend the veil of nature's pleasure.

In the spirit of Heraclitus, the early modern essayist Bacon pursues his experimental inquiry into various properties of nature. While Bacon's experimental method is not the detailed procedures of modern science, his trials were novel in their attempt to ground knowledge on repeatable experiences rather than on speculative reasoning alone. He modeled his inquiries into nature on early modern trial inquisitions[4]; nature was on trial and must be tested in order to find its secrets. Because nature hides, artificial means are necessary to pry open its truths: "The secrets of nature are better revealed under the torture of experiments than when they follow their natural course."[5] Bacon's *Novum Organum,* or "new instrument," provides both a logic and an empirical instrumentation for experimenting on nature, or torturing "her" into confessing what remained hidden. Its methods are intended to supplant the speculative theory and logic of Aristotle's *Organum,* which at the time held sway in science and natural history.

Bacon shows a similar spirit of inquiry in his earlier work, *The Advancement of Learning*: "Neither ought a man to make scruple of entering and penetrating into these holes and corners, when the inquisition of truth is his whole object."[6] Caroline Merchant parallels Bacon's inquiry into nature with "the interrogations of the witch trials and the mechanical devices used to torture witches," including "the supposed sexual crimes and practices of witches."[7] Added to the metaphor of nature as veiled and hiding secrets is that of witchery with its magical practices that defy human understanding. Bacon's method was to bring nature from its hiding places into the light, from distance into full presence, and from witchery into reason and intelligibility. He shifts nature from interiors unseen and unknowable to interiors cut open as exteriors exposed for human accessibility.

Bacon's job was that of inversion: turning the "holes and corners" inside out, and so bringing the corners nearer and making the dark holes into visible

surfaces. Implicit in the *Novum Organum* is what contemporary philosopher Jacques Derrida calls the logic of presence. Simon Lumsden summarizes Derrida's position thus: "This metaphysics of presence aspires to master objective being, it claims that being can be understood in Heidegger's terms ontically, and that being is definable and knowable. Being is presented *exclusively* as something perceived, intuited and known, and is thereby reduced to an expression of the perceiving and knowing subject."[8] As Derrida notes, *being,* as a fundamental category for an object, is here dependent on human perception. We make things in nature present by our attention to them; they become present to us. In the human demand for intelligible presence, the vacuous nature of holes and corners becomes objects of scrutiny to be filled or penetrated—or, better yet, turned inside out and so made into easily reachable surfaces and nonvacuous objects. It is worth asking: Why can nature not retain holes and corners? Why must it become objective being that can be disclosed to the human knower? It is a set of questions that will be pursued throughout this chapter, and remains a haunting witchery throughout subsequent chapters as well.

The metaphysics of presence is most lucidly illustrated in Bacon's rhetoric concerning dissection and vivisection where the prelapserian state of Adam's knowing and naming animals is restored by scientific inquiry. In Genesis, God gave to Adam "dominion over the fish of the sea, and over the birds of the air, and over every living thing that moveth upon the earth."[9] God brings each creature before Adam, who then names them.[10] This original act of naming is equated with knowing. The eighteenth-century physician Benjamin West calls natural history "the first study of the father of mankind, in the garden of Eden."[11] After the Fall and the babble that follows in its wake, naming as knowing is lost. The difference between Adam and the rest of us is succinctly summarized by Bacon's contemporary, Thomas Adam, in his *Meditations Upon Some Part of the Creed*:

Thus God gaue the nature to his creatures, *Adam* must giue the name: to shew they were made for him, they shall be what hee will vnto him. If *Adam* had

onely called them by the names which God imposed, this had been the praise
of his memory: but now to denominate them himselfe, was the approval of his
Iudgement. At the first sight hee perceiued their dispositions, and so named
them as God had made them. Hee at first saw all their insides, we his posterity
ever since, with all our experience, can see but their skinnes.[12]

As Erica Fudge notes in *Perceiving Animals,* Adam's ability to name beasts
is equated with his ability to see deeply. Such sight was a gift given to him
by God. Through naming animals, the whole of the animal is made present
to Adam and is knowable. Adam knows animals through and through. For
Bacon and his contemporaries, banishment from Eden resulted in our inabil-
ity to perceive animals and thus through perception, understand them. After
the Fall, language is fractured and no longer coincides with the fullness of
being of the things named. So for Bacon, where language and perception lack
utility, science must make up the difference.

God gave Adam the ability to see the essence, the nature or ontic being
of each animal. His seeing and naming are a knowing by which the intelligi-
ble aspect of each animal becomes the truth of this animal. Here signifier and
signified, sign and object, representation and reality are in alignment. To
know the name is to know the creature. In *The New Atlantis,* as elsewhere,
Francis Bacon, who sees in science the possibility of restoring humanity to a
prelapsarian state of knowing, equates dissection with just such a look below
the skin. Nature is tortured into truth. As Fudge explains:

In the new science the object and the word coincide, there is no distinction
between the signifier and the signified, the inside and the outside.... What exists
beyond, as a third term—the referent—is the experimenter. There will always be
someone performing the experiment, seeing the insides and the outsides, and it
is the experimenter who is Bacon's human "for whensoever he shall be able to call
the creatures by their true names he shall again command them." Adam the orig-
inal namer, is the great vivisector: he sees beneath the skins. [Advocating vivisec-
tion as knowledge and control,] Bacon's Eden is never Edenic for the animal.[13]

Nature is turned inside out. The animal interiors become exteriors to be named and known. In cutting and opening the animal body, its witchery and mystery are turned aside by the knife. Holes and corners become open surfaces that are viewable, namable, and knowable. Unlike vacuous dark holes and corners, surfaces become pliable objects under human dominion. In cutting, the experimenter changes the animal and its otherness into flesh as an object consumed by reason. As Bacon explains in *The New Atlantis,* science is set for "enlarging of the bounds of human empire."[14]

Through empirical investigation, Bacon wants to transform the world into intelligible objects. Underlying his method is an unspoken metaphysics of presence in which all of nature is opened to and made present by and for human inquiry. The foreignness of nature is overcome. In terms of animals, their strange and mysterious worlds and lives are transformed through death into objects of knowledge. Bacon justifies such violence as an act of dominion by which man reinstates his preeminence and grasps at his prelapsarian state. Once placed on the dissecting table or preserved in formaldehyde, animals are no longer so foreign and unknowable.

Returning for a moment to Hirst's work, the opening of the animal and availability of animal insides for human inspection are perhaps nowhere more evident than in *Some Comfort Gained from the Acceptance of the Inherent Lies in Everything* (1996, Figure 2). In the work, two cows have each been sliced into six even parts. The parts are placed in transparent tanks of formaldehyde and positioned in a line. The cows' segments are shuffled one after the other, with the animals facing in opposite directions. The animal body is opened for interrogation. The outside hide and the inside flesh and viscera stand visible behind the glass. The viewer cannot touch nor be contaminated by the flesh, yet he or she has access to it as sight becomes a means of knowing and possessing.

With Bacon, access to animal insides facilitates a restoration to a purer spiritual state: the reinstatement of humans in the garden of Eden. For Hirst, the spiritual quality resides in the abstract movement that comes after the initial shock of seeing the carved animal. Recall Hirst's statement that "animals become meat. That's abstract."[15] In *Some Comfort Gained,* the abstraction

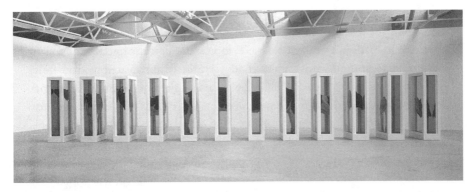

FIGURE 2 Damien Hirst, *Some Comfort Gained from the Acceptance of the Inherent Lies in Everything,* 1996. Glass, stainless steel, cow parts, and 5% formaldehyde solution. 85.43 × 40.16 × 20.87 in (2170 × 1020 × 530 mm) × 12 tanks. © 2011 Hirst Holdings Limited and Damien Hirst. All rights reserved, ARS, New York / DACS, London.

appears in the title and in the arrangement of tanks such that, as the exhibition catalog explains, "Hirst presents a physical and spiritual union between partners, a desperate isolation in their merger."[16] The animals do not feel this union, nor are they torn by its impossibility. As presented in the title, the "Lies" of such a "spiritual union" are human fables, and the "Comfort Gained" from debunking these fables is a human comfort. At no point is the animal or its world the subject of this art piece.[17] Instead, the full presence of its body as flesh is made available for the gesture of "that's abstract." The movement to abstraction extends Bacon's "human empire" into the animal and its innards. No longer is the animal's body its own, nor is its world of opaque holes or corners inaccessible to us. If the animal has a world outside of human knowledge, the logic of presence dictates that such a world is of no import. Only that which is present and presentable to "the perceiving and knowing subject" has status as being.[18] Hirst's dissection and naming of his work takes up Bacon's use of dissection to restore Adam's naming and power over animals. The lie overturned in Hirst's title is a human lie, and the

comfort gained is also human. If, as Fudge claims, "Bacon's Eden is never Edenic for the animal," then Hirst's art is never beautiful for the animal.[19]

While animals appear to be central to Hirst's dissection sculptures, they are not the focus of his work; instead, they are the material used to prod viewers into reflection. The interior of the animal is made exterior flesh so that we might visually take it in and reflect on it. These works are not about the animal's death, though it may provide the initial shock; instead, if there is any lasting meaning in the work, it is gained in reflecting on our own interiors and the interiority of human thinking. The titles of Hirst's work move us from the material object to abstract reflection on human states of affairs. *The Lovers' Cabinets* is one such example. In the work, the entrails of eight cattle are placed in four jars in four cabinets; each jar and cabinet is given a name: "The Committed Lovers," "The Spontaneous Lovers," "Compromising Lovers," and "Detached Lovers." Cattle flesh becomes a figure for an abstract meditation on human desire.

For Hirst, the slicing and division of flesh operates as a figure for abstract diachronic tensions. Bodies are joined yet separated in *The Lovers' Cabinets*, *Some Comfort Gained from the Acceptance of the Inherent Lies in Everything*, and *Mother and Child, Divided*. Bodies and parts once together are now separate, and those once separate are now intertwined. This dynamic structure is analyzed by Mario Codognato in his reading of *Some Comfort Gained*:

> They [the cattle] combine to construct a vision that is at once fragmentary and coherent, where our every expectation is mystified in a simultaneous perception of the habitual external appearance and the internal structure of the body, the mechanism of life and the condition of death, the stratagem of art and scientific investigation. The cross-over constructs a mental territory, where sensorial perceptions and reason temporarily enter into a diachronic and destabilizing relationship.[20]

As in much of the writing on Hirst, Codognato notes that the energy of the work resides in "a mental territory" for the viewer who tries to reconcile abstract concepts presented in the title with the sculpted material forms.

The epigraph to Codognato's essay on Hirst is particularly telling. He quotes Hamlet: "O that this too too sullied flesh would melt, thaw and resolve itself into dew."[21] While for Hamlet the "sullied flesh" was his own, in Hirst, the flesh is that of animals. The animal and its flesh never "resolve[s] *itself* into dew"; however, the flesh is resolved by the viewer into a purer form—a translucent and shining dew of thought. It is the audience that transforms the material form into unsullied concepts—mental images of love, death, and desire. Dissection in Bacon is more than opening up the material of nature; in opening the animal (exposing interior as exterior flesh) and in naming the animal and its parts, Bacon seeks a spiritual end for man and a restoration to the Garden of Eden. In Hirst's work, animal flesh is put to human spiritual ends as well.[22]

EATING THE OTHER

In summary, we have seen in Hirst's work the use of matter as the base from which to build a mental conflict that resolves itself in the mind. It is in human thought that the full presence of the animal form and the conceptual tensions that it suggests find resolution. Hegel establishes a similar pattern of material violence and the demand for full presence of nature—every nook and cranny—as a means to a higher end. Perhaps nowhere is the voracious appetite of human thinking more explicit than in his search for absolute knowledge. While Hegel's idealism contrasts with Bacon's empiricism, the two meet in their transformation of the natural world through a metaphysics of presence. Hegel's clear articulation of this metaphysics as well as contemporary critiques of its violence make his work a useful means of explicating the cuts and corpses of Hirst's animal art.

As Lumsden explains, "philosophy has been concerned with establishing 'transcendental schema' by which we discern the truth of objects and the world and then organize it according to a rational and logical structure."[23] Like Bacon, Hegel created a schema meant to supplant Aristotle's logic. For Aristotle, objects have a self-contained singularity, and his logic proceeds by deductive reasoning as to the contents of these singularities. The essence of any thing is determined by its properties and what characteristics are

excluded. Man, for example, is defined as a rational animal, which assumes that man shares properties with other animals, but that reason is exclusive to humans. Aristotle's logic and his natural philosophy proceed by drawing lines of inclusion and exclusion; how these lines are drawn and who does the drawing are the fundamental concerns of his transcendental schema. Hegel considers Aristotle's logic as overly static in its lines of inclusion and exclusion; therefore Hegel sets out to create a system in which objects dynamically relate to one another. In his dialectical thinking, negations or contradictions are resolved by transformation into a synthesis or higher unity. His system moves toward a totality in which the totality overcomes yet preserves the lesser wholes that preceded it and from which it is constituted. In what is called the *aufhebung,* or sublation, nothing is lost or destroyed; instead, each whole is raised up to a higher level of meaning and being as it gets subsumed into a more expansive wholeness. My gambit here is that Hegel's organic logic of sublation is a means of describing the dynamics and tensions in Hirst's work, where matter is divided or opened up to create contradictions in need of resolution.

Hegel maintains that the transformation undergone in sublation is not an interpretation or representation of an object by a thinking subject, but instead is the most proper realization of the object:

> By the act of reflection something is altered in the way in which the fact was originally presented in sensation, perception, or conception. Thus, as it appears, an alteration must be interposed before the true nature of the object can be discovered. . . . Now, at first sight, this seems an inversion of the natural order, calculated to thwart the very purpose on which knowledge is bent. But the method is not so irrational as it seems. It has been the conviction of every age that the only way of reaching the permanent substratum was to transmute the given phenomenon by means of reflection.[24]

This "alteration" or "transmut[ation]" is the site of metaphysical violence.[25] The witchery or mystery of nature (to use Merchant's terms) cannot be left

alone. Animals are not allowed a nook or hole or corner; instead, the mystery of nature is exchanged for the alchemy of transmutation, alteration, and sublation. In Hegel and in Hirst, all of nature is made present to thought, and gains fuller presence by thought.

For Hegel, thought liberates the universal from the singular and sensate instances of objects. Universalization—the move toward a totality and wholeness—is the fundamental project of philosophy. In his foreword to Hegel's *Logic,* John Niemeyer Findlay explains that

> it is that activity conceived as a subject, itself universalised and given to itself, and not merely active in specific materials. The liberating activity of the Universal or the Ego is further said to be one that liberates the essential, intrinsic, or true nature of the object: it may profoundly change the manner in which things stand before us in sensation, intuition, or representation, but this change of manner is no subjective distortion as maintained in the Critical Philosophy: it is a bringing out of what the thing in itself truly is.[26]

In such a transcendental schema, there is no outside and no remainder. Nothing is lost nor destroyed; instead, it is transformed into "what the thing in itself truly is." With sublation, everything becomes available for examination by thought, every experience is present to the conscious subject, and every object is internalized by the thinking subject.[27] Objects become meaningful only as they are made present to the knowing subject. Transmutation changes the object of knowledge from something external to the thinking subject to that which is present to the subject and then to that which is internalized. In short, we eat the other.

Eating is more than a metaphor for knowing. For Hegel, it is a moment in the upward spiral of sublation toward a greater totality and unity of being. As Romanticist scholar David Clark puts it: "For Hegel consumption and digestion are not merely illustrations of consciousness improperly borrowed from the naturalistic realm, but part of the underlying incorporative logic."[28] Eating is "the power of overcoming the outer organism" and so building up

the interior subject.[29] Hegel's philosophy is a dialectic–hermeneutic circle; his *Encyclopedia* leverages the Greek root *circle,* by which all objects are encircled within the philosophy. As Howard Kainz explains, "this highly self-reflective system is described by Hegel as a 'circle of circles.'"[30] Each circle within the dialectic turns upon itself, but also like a spire, it "gives rise to a wider circle" to become a "massive self-producing, self-justifying, and self-correcting system which demystifies, and works out the concrete details of Aristotle's primal presentation of the Idea as 'self-thinking thought.'"[31] There is nothing outside the self-reflexive subject other than that which is to be eaten—either physically, or at the more refined plane of abstraction and mental appropriation.

We have seen this move in Bacon's treatment of animals, and Hegel joins Bacon in opening up the animal body. Eating exposes the animal interiors as exteriors of flesh—meat—for the human subject. At issue is how Bacon and Hegel make sense of that which is foreign or other than themselves. Hegel's dialectic logic pivots around its ability to ingest what is alien to the self, and so make it part of the self and sensible to oneself; stated differently, "digestion names the means by which the organism relates itself as an object, as other to itself."[32] The outside—the animal—becomes a means by which human interiority can think itself. Damien Hirst's work functions as an Hegelian exercise inflected by natural history's demand for the full presence of nature in and through the death of animals. The animal serves as the other or outside by which we reflect on our own interiority.

Resistant Flesh

It would be disingenuous to say that Hirst's art functions simply under Hegel's dialectic because there are important exceptions. Not all of the animals in Hirst's natural history works get split open to expose their insides. His well-known *The Physical Impossibility of Death in the Mind of Someone Living* (1991, Figure 3) proves a useful instance of an artist wrestling with animal flesh and interiors. The work consists of a fourteen-foot tiger shark suspended in a tank of 5 percent solution formaldehyde. The shark's jaws are opened as

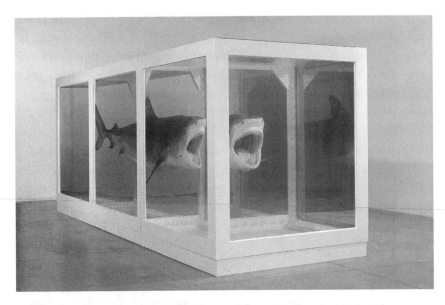

FIGURE 3 Damien Hirst, *The Physical Impossibility of Death in the Mind of Someone Living,* 1991. Glass, steel, silicon, formaldehyde solution, and shark. 2170 × 5420 × 1800 mm. Photographed by Prudence Cuming Associates. © 2011 Hirst Holdings Limited and Damien Hirst. All rights reserved, ARS, New York / DACS, London.

if to emulate the sublimity and fear invoked by the fictional shark in the pop-icon film *Jaws* (1975).[33] The shark piece was shown by Charles Saatchi in 1992, along with Hirst's *A Thousand Years,* as part of the Young British Artists show. The work was an immediate sensation. The popular press was aghast at the fish in a tank costing £50,000 to produce—£6,000 to acquire the shark (by commission from fishermen in Australia) with the remaining expenses for preservation, construction of a tank, and transportation. Yet despite—or perhaps because of—the controversy that swirled around the animal sculpture as a conceptual artwork, Hirst was nominated for the Turner Prize.

Hirst went on to garner fame and amass a fortune with his art and celebrity status—itself a sort of performance art. However, the shark did not hold up so well. *The Physical Impossibility of Death* began to decompose; the

formaldehyde was intended to arrest death, sealing the animal death into a singular moment prior to dissolution of the body. In this death without decay, the artist wanted the viewer to experience the sublimity of nature with teeth, yet the animal and not the human is the one dead. The decay of the shark began to cloud the pristine clarity of the problem of death to be contemplated by the viewer: the animal in decay obscured the sublimity of the artwork.

The shark decomposed because it was not adequately preserved. Getting the formaldehyde solution to penetrate through the skin of the animal and into its insides proved a difficult task that was never fully accomplished. Consequently, the animal began to decay from the inside out; its skin wrinkled, and the tank became murky. Hirst attributes at least part of the decay to the Saatchi Gallery adding bleach to the shark tank. After its initial display in 1992, the tank became increasingly clouded with decayed flesh, and the shark seemed to sag a bit. So in 1993, the gallery had the shark opened up and its flesh cut out. In place of the inner flesh, the gallery put a fiberglass form and molded the shark skin around it. Hirst was not satisfied with the results: "It didn't look as frightening. You could tell it wasn't real. It had no weight."[34] Interesting here is Hirst's investment in the animal interior as that which was never meant to be seen. His investment in an unseen interior is contrary to his other natural history works in which the insides are intended to be viewed. Visitors to the Saatchi Gallery were not told about the change, and most thought they were looking at an entire shark. Because the audience saw what they believed was a shark, and not a hollowed-out shark, Hirst's comments are curious. Others apparently did not see a massive animal corpse with no weight, so why was it an issue for him? And why would the lack of innards prevent the animal from appearing just as frightening?

Contrary to his work with dissected animals, opening up the shark to insert an artificial form violates the integrity of *The Physical Impossibility of Death*. In this particular piece, Hirst seems interested in preserving a place for the animal interior as something separate from the human world, something not to be opened. In this instance, because nature loves to hide, it is allowed to hide. Perhaps it does not hide fully—the shark's death was commissioned,

after all. However, the work can be seen to pivot around the idea that the dead shark "knows" something that is "physically impossible" for the "mind" of the human viewer. The reflexive interiority of the human subject does not gain access to the animal interior. Its body is not cut open as meat, and the Hegelian *aufhebung* is thwarted by the thickness of the animal's skin and flesh. The shark's innards bore witness to the inaccessible interior of the animal—an interior that the artist could not penetrate with formaldehyde and that he intended to protect from the view of spectators. Yet it is this preservation of the interior of the animal that could not be preserved by Hirst: the animal rotted from the inside out. The clouded tank with its bits of decayed flesh exposed the interior of the animal that was meant to be sealed off from sight.

When Saatchi sold the piece to Steven Cohen in 2006, Hirst proposed replacing the shark with a new tiger shark. Cohen funded the endeavor, which cost in excess of $100,000. Buoyed by these finances and years of practice in working with formaldehyde, Hirst took to preserving another shark and placing it in the same tank in which the former animal had failed to hold up to the artist's wishes. Some of the details of the undertaking are worth noting in order to appreciate the degree of labor involved in maintaining the artist's concept of a whole predatory animal suspended in a tank. Carol Vogel describes the preservation project in her site visit and interview with Hirst for the *New York Times.*[35] In a pool-size tank at an abandoned hangar of the Royal Air Force station in Gloucestershire, Hirst and five assistants stand in 224 gallons of formaldehyde working over a thirteen-foot tiger shark. The shark's body is penetrated with hundreds of needles to inject it with the formaldehyde (Figure 4). The needles vary in length to reach various surfaces and depths—nooks and crannies—of the animal body. These needles minimally open up the animal interior and so leave the body intact and removed from visual inspection.

While the extremity of cost and effort in this work appears to be part of the "sensation," or sensational quality, for which Hirst is known, one wonders why he went to such financial and physical expenditure for what will never be

FIGURE 4 Damien Hirst and assistants preserving a tiger shark, 2006. Photograph by
Steve Forrest / *The New York Times* / Redux.

seen—the inside of the shark's body. It is precisely this invisibility that makes
the work intriguing. *The Physical Impossibility of Death* is powerful because of
the interplay between the interior of the animal and the viewer's own interi-
ority. The animal insides are not only the interior of the animal, but they also
mark a unique space, a space that we will never know—the space that death
has inhabited in this animal. Despite the prevalent demand for full presence
of the animal—a demand met in dissection—in this work, absolute knowl-
edge and full presence is denied to the viewer. We sense that there is some-
thing beneath the surface of the animal, and we know that Hirst and his team
have taken great pains to preserve this interior, which seems more significant
than "mere" flesh, as if the animal had an interior self. Such this imagined
shark self would be the animal's means of knowing and engaging the world
outside of our ability to comprehend or colonize the animal.

Revising an Architecture of Presence

Hirst hints at something beneath the surface of animals in his cleverly titled *Something Solid Beneath the Surface of All Creatures Great and Small* (2001, Figure 5). Yet the "something solid" is most readily identified as the bare bones of the animal bodies put on display in glass cases as if in a natural history museum exhibit. If there is an animal interiority as "something solid," we cannot see it on display here. The work responds to *The Physical Impossibility of Death* by showing that there is no empirical space of animal interiority; there are only layers of interiors to be exposed. This inability to find a material

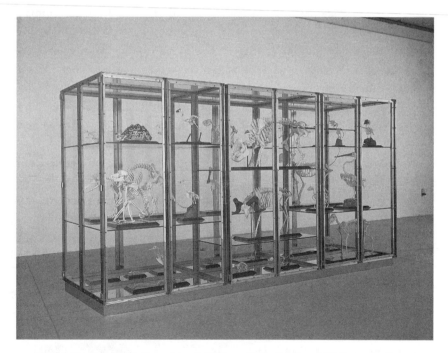

FIGURE 5 Damien Hirst, *Something Solid Beneath the Surface of All Creatures Great and Small,* 2001. Nickel plated stainless steel and glass cabinet with animal skeletons. 81 × 148 × 48 in (2057.4 × 3759.2 × 1219.2 mm). © 2011 Hirst Holdings Limited and Damien Hirst. All rights reserved, ARS, New York / DACS, London.

interiority has been a historical rationale for licensing dissection. The interiority, if it exists, is immaterial—meaning that to humans, the animal place of its own is inconsequential; however, animal interiority may be immaterial simply in the same way that human interiority is also not visible bones nor flesh.

While Hirst's other natural history works open the animal for inspection, the restored *The Physical Impossibility of Death* and even *Something Solid Beneath the Surface* maintain the veil over nature. They allow for trace or specter of interiority of the animal as a space not visible, namable, and knowable to us. As outlined previously, the predominant strand in Western philosophy and science has been to demand a full presence from the animal; however, there is a less well-known tradition that seeks to preserve the space of the animal as something inaccessible and unknowable. In his final dialogues on epistemology, Cicero considers the value of cutting open animal bodies: "This is why doctors . . . have carried out dissections, in order to see this emplacement of organs. As the Empiricist physicians say, however, the organs are no better known, for it may be that if they are uncovered and deprived of their envelopes, they are modified."[36] Cicero did not believe in an agonistic struggle against nature; teasing nature from its hiding place is itself unnatural and results in a perversion of knowledge.

More striking is the claim by the German Romantic philosopher and natural scientist Johann Wolfgang von Goethe. For Goethe, nature is visible, but we do not have a mind that can see her. As Valentine warns the wayward Faust:

> We snatch in vain at Nature's veil,
> She is mysterious in broad daylight,
> No screws or levers can compel her to reveal
> The secrets she has hidden from our sight.[37]

Hadot notes that "her real veil consists in having no veil; in other words, she hides because we do not know how to see her, although she is right before

our eyes."[38] Visibility and knowability are turned upside down. While dissection opens the invisible to make it visible and intelligible, Goethe claims that nature is already in the light of day though it remains obscure to us: it is visible—already opened up—but never knowable. Following Goethe's claim, opening up an animal does not equate to knowing the animal. Light does not equal knowledge in this case, and presence is still a sort of absence or mystery. If dissection is meant to open a space for full presence and knowledge—by which we know/consume the animal flesh—then Goethe has created a different sort of architecture of knowing. Here nature is in the open, but remains invisible, unintelligible.

Twentieth-century phenomenologist Maurice Merleau-Ponty extends the significance of the invisible. While preparing his unfinished text *The Visible and the Invisible,* Merleau-Ponty noticed a fundamental problem within his earlier work: phenomenology made its break with Cartesian philosophy and the mind–body problem by pursing perceptual knowing rather than abstract or disembodied knowledge. However—and herein lies the issue—both abstract knowledge and perceptual knowledge maintain a divide between subject and object. The persistence of such a divide troubled Merleau-Ponty. As Renaud Barbaras summarizes the issue, after *Phenomenology of Perception,* "the relevant opposition for him is not the opposition between a philosophy of reflexive consciousness and a philosophy of embodied consciousness, but between an ontology of the object—to which both of these philosophies refer—and a new kind of ontology, which he must delineate."[39] Reflective consciousness from Descartes to Hegel to Merleau-Ponty maintains the privileged interiority of the human subject through which all objects gain meaning in the act of human knowing, be it perceptual knowing or abstract reflection.

Merleau-Ponty observes that phenomenology "succeeds in overcoming the natural attitude by changing the beings into their meaning but is mistaken in defining the meaning itself as *essence,* namely, as something fully positive and clearly determined, a plenitude attainable by an intellectual intuition."[40] We grasp the essence of the object through its appearance—a natural attitude critically reflected on in phenomenology; however, phenomenology is

mistaken in describing the meaning gleaned from appearance as the essence of the thing. The problem here is that essence maintains a sense of plentitude, of something full and fully present as grasped by an intellect. Such perception implies a perceiving subject with consciousness and a self-consciousness. This subject discerns presence from absence of contemplation, or nonpresence. As mentioned earlier, Hirst grapples with the problem of the subject–object divide, first with his natural history displays, which establish subject–object relationships, and then in a more complex fashion with *The Physical Impossibility of Death in the Mind of Someone Living.* Here perception by the human with reflexive consciousness is of no help—it is "physically impossible"— in understanding shark as anything other than object. Its life and its death and deadness cannot be grasped by "the mind of someone living." What Hirst provides is not (as Merleau-Ponty critiques) "something fully positive and clearly determined, a plenitude attainable by an intellectual intuition." Rather we are haunted by the veil that remains before us but is impossible to lift.

Merleau-Ponty wants to avoid the perception of presence as equated with knowledge. In *Visible and Invisible,* he gestures toward a new kind of being "against the philosophy of the thing and the philosophy of the idea. Philosophy of 'something'—something not nothing."[41] Such a philosophy would allow for "something" without the need for full presence, and a conscious subject to discern the seemingly vague "something" as a "thing" or object rather than a nothing. Barbaras explains that Merleau-Ponty moves from a "philosophy of the positive [full and fully present] thing to a philosophy of *something.*"[42] As the title *Visible and Invisible* implies, visibility and knowability are but the one side of something: vision and knowing do not take place as immanent or transparent presence of the thing known before the perceiving subject; rather, vision and knowledge imply distance and violence. They also imply an invisibility—what cannot be seen or opened to our understanding. Such invisibility is "not nothing," as if the object can only either exist or not exist; instead, the tension between the visible and invisible describes the opacity of the world of stuff itself within a world of perceptions, rather than a

feature of human consciousness.[43] Opacity is not a consequence of our failed sense organs, but rather the nature of things in a world of perception. Withdrawal or invisibility is an essential part of the being of beings: animals withdraw beyond the horizon of our world and our understanding.

Returning to Hirst's *Something Solid Beneath the Surface of All Creatures Great and Small,* there is indeed "something" beneath the surface of creatures. It is not a thing, an object, but a "something" in Merleau-Ponty's sense of this term. This something is not available to us. We cannot open up the animal in order to find it. The natural history display of skeletal forms exhibited by Hirst gives us only the bare bones, but not the solidity of the animal's "something"—a space apart from human perception. At the limit of our perception we encounter the friction and opacity of other ways of being that remain inaccessible to us. Following Goethe, this something of the animal is an open secret. Hirst's works are a series of structures around the limits of access to this secret approached through the tradition of lifting nature's veil.

⊰[2]⊱

Body of Thought

Immanence and Carolee Schneemann

Carolee Schneemann's performance piece *Meat Joy* (1964) functions as closely as possible to a modern artistic vision of a Dionysian ritual:

> *Meat Joy* has the character of an erotic rite: excessive, indulgent, a celebration of flesh as material: raw fish, chickens, sausages, wet paint, transparent plastic, rope, brushes, paper scrap. Its propulsion is toward the ecstatic—shifting and turning between tenderness, wildness, precision, abandon: qualities which could at any moment be sensual, comic, joyous, repellent. Physical equivalences are enacted as a psychic and imagistic stream in which the layered elements mesh and gain intensity by the energy complement of the audience.[1]

Recall that chapter 1 examined the attempt to abstract the animal surface by lifting it to a level of semiotic meaning within human culture. Schneemann's work inverts such abstraction. As we saw in Hirst's *The Physical Impossibility of Death in the Mind of Someone Living,* there is a space that remains unavailable to human representation; yet, as a limit, it proves to be a valuable site for artistic production. With Schneemann, the Hegelian consumption of the animal other takes an erotic turn; in it, the *aufhebung,* or sublation, fails. It reverses itself until humanness becomes flattened onto the same plane as meat and animal bodies in "an erotic rite." In contrast to abstraction, leveling

the human makes humanness another surface working alongside meat as flesh cut open.

The previous chapter took up the issue of art as a cutting open and consumption of the animal body. More precisely, the animal is scarified for knowing and artistic consuming. In a double move, the animal is consumed, but only by being preserved (in formaldehyde). Through this double move, the animal becomes object subsumed within culture. The current chapter considers a means of artistic engagement modeled after the figure of Dionysus. Here, consumption becomes a performance of human animality on a plane of immanence. The philosophical companion to such performance is Friedrich Nietzsche's satyr, the friend of Dionysus in the philosopher's early statement on art, *The Birth of Tragedy*. As both animal and man, the satyr grapples with the tensions in his double way of being.

Common to both Schneemann's and Nietzsche's Dionysus is a ritual disorientation of the human, a loss of selfhood, and a rending of flesh in the production of an art that reveals the nonhuman animal that is intimately woven within the human, and what it means to be human. Rather than the animal being subsumed within culture, humanness is leveled onto a plane of immanence alongside that of the animal. The twentieth-century philosopher Martin Heidegger attempts to counter the specter of the animal in Nietzsche's satyr by introducing a related though separate figure, the human as the "shepherd of Being." As we shall see, Heidegger's shepherd keeps the animals, including his own animal nature, at a distance as something to be herded or managed. This shepherding and distancing is echoed by critics of Schneemann's performance works.

When engaging with animals, the issue for art and philosophy remains recognizing the ground from which one works, be it the intimate animality indicative of the Dionysian satyr or the distance or obfuscation of one's animal nature as figured by the shepherd. To be a bit more forceful in this claim, I have ventured from the ontology implicit in the satyr and the shepherd to the means by which they stage their eating, and (as in chapter 1) I have equated eating, consumption, and incorporation with epistemology.

The problem of the satyr is how he incorporates, makes singular and whole, his divided body *(corpus)*. The satyr's Dionysian feast is a frenzy of destruction that doubles the fragmented nature of his own being. His eating and his epistemological ability to know or make sense of his self and his world remain as fragmented as his human–animal nature. In contrast, Heidegger introduces humans as the "shepherd of Being": the human shepherd knows and manages his flock, but his eating (what Derrida calls his *bien manger*) is never explicitly discussed. The shepherd is stuck between his managing and eating, or between *manage* and *manger*. We know that the shepherd will take his sheep to the butcher, but how the cutting up and eating (or, epistemologically, how the divisions leading toward knowledge) take place gets averted. Carolee Schneemann's work, and in particular *Meat Joy*, exemplifies Dionysian art in which the animal cut open becomes the site of a frenzied feast of destruction that doubles the fragmented nature of our being and comments on the act of artistic creation.

Satyr

Schneemann began her career as a painter but quickly moved into performance as a way of asserting the female body over and against its use by male artists.[2] Ever since cinema theorist Laura Muvey's "Visual Pleasure and Narrative Cinema," art theory has made much of the male gaze that objectifies women and their bodies. As Muvey explains: "In their traditional exhibitionist role women are simultaneously looked at and displayed, with their appearance coded for strong visual and erotic impact so that they can be said to connote *to-be-looked-at-ness*."[3] Schneemann is keenly aware of this gaze, and as we shall see, she subverts it in two ways: by using the haptic or tactile quality of her visual work to collapse the distance of sight into visceral touch, and by creating works that are fundamentally, physically (not just visually) tactile and call forth the risk and messiness of touch, the infection of touching, over and against the safe distance of looking. Drawing on her background as a painter, Schneemann's painterly performances work as large temporal canvases textured with straining bodies, paints, objects, and surfaces for painting.

Meat Joy is a fairly early work. The piece was first performed as part of the First Festival of Free Expression at the American Center in Paris, then later in London and New York. Such work was "[a]mong the first visual images that constitute the lexicon of an explicitly feminist avant-garde vocabulary" and is historically situated within the era of Happenings and assemblage.[4] The piece became a touchstone for understanding Schneemann's project of exploring desire through body performances and tactile surfaces.

Meat Joy begins with the performers in casual clothes, applying the last bits of makeup, sewing on feathers, smoking, and drinking as if backstage. After a blackout, the men and women approach and retreat from one another in loosely choreographed fashion while removing their apparel until only scant, tattered clothes remain. The men heap paper onto the women. They bind the women in paper and rope as "body packages"; then bonds loosen as couples roll together and the women are lifted into the air—all in roughly sketched gestures and movements to create particular vectors, lines, and trajectories repeated throughout the work. Pyres of paper and bodies intertwine; men and women paint one another. Then a serving maid drops animal flesh onto the bodies, which respond with spasms, twists, groans, and laughter; bodies and meat mingle (Figures 6 and 7). Then more dancing and painting ensues until the central woman cries, "Enough, enough!" and the stage goes black.[5]

Senses are opened, and bodies are opened also as hierarchical valuation collapses. In *Meat Joy,* bodies become the site and surface of sexual desire, painting, and meat, seemingly without distinction among these valances. Several months after the performance, the avant-garde filmmaker Jonas Mekas noted how the work "brings us back to the touch, smell, to the surfaces of things and bodies; it accepts, with love, everything that our insistence on ideas (certain ideas) kept us away from; even what was 'repellant,' like 'raw' meat, or chicken guts, what we usually dread & fear to touch."[6] That which is repellant and abject is discarded as "not mine" yet still "of me, from me, like me." The discarded and abject matter floats with a life of its own and couples in new and unexpected ways—body parts up against body parts—that

rebound on the viewer, only to disorient the possessive nature of subjectivity. The "mine" and "not mine," the parts like me, and those that (however like me) I reject are mixed together to disturb the sense of who I am and what is "proper" to my being.

In an iconographic moment, a man uses a mackerel to stroke the body of a woman. The fish stands in for both paintbrush and phallus yet remains a fish—a flesh pressed against flesh, a consumable form against desires for consumption. The work becomes a celebration of surfaces with their frictions, stacking, unraveling, pushing, and pulling. The prelude to *Meat Joy* captures this dynamic by announcing: "Action with materials: gesture from activity

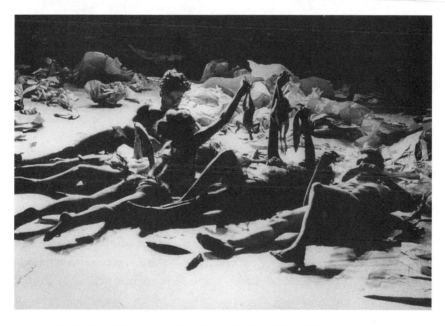

FIGURE 6 Carolee Schneemann, *Meat Joy*, 1964. Raw fish, chickens, sausages, wet paint, plastic, rope, and shredded scrap paper. Performers (left to right): James Tenney, Dorothea Rockburne (legs), Carolee Schneemann, Sandra Chew, and Stanley Gochenouer. Judson Church, New York City. Photograph by Tony Ray-Jones. Copyright Carolee Schneemann.

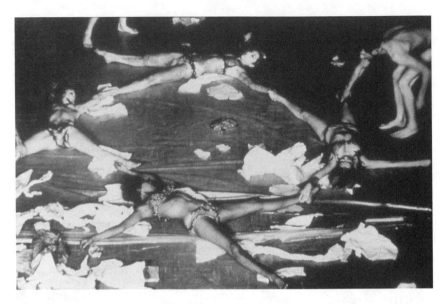

FIGURE 7 Carolee Schneemann, *Meat Joy*, 1964. Raw fish, chickens, sausages, wet paint, plastic, rope, and shredded scrap paper. Performers (clockwise, starting from top): Carolee Schneemann, Annina Nosei, Stanley Gochenouer (man standing), Sandra Chew, and Dorothea Rockburne. Judson Church, New York City. Photograph by Al Giese. Copyright Carolee Schneemann.

of tearing / pushing gluing rumbling ripping rubbing scratching spilling."[7] Humans are not simply that which consumes the world in a Hegelian *aufhebung;* rather, we too are surfaces opened up as meat–canvas–sensual flesh and are jostled alongside other paper and flesh and human and animal surfaces. As Rebecca Schneider describes this collapse of hierarchical valuation: "Schneemann experimented with 'flesh as material' and imagined a nervous system of bodies in interaction with interchangeable bodily parts, all in the service of sexual freedom and sexual pleasure."[8]

Early on, critics noted the collapse of human bodies with other objects as sets of surfaces played out in the work. Mekas continues his comments by saying that

we realize that we can't look disdainfully at the meat world without some-how somewhere deeper in ourselves condemning our own meat, our own body, our own soul. So that *Meat Joy* becomes an act of liberation and an act of contact with the essence; a philosophical (or religious?) essay on Essence, Matter & Being.[9]

He realizes that we "find our depths *via* the object, *via* the surface world."[10] The ritual frenzy of *Meat Joy* is an investigation of humanness and being through surfaces. In chapter 1, knowing was figured as nature hiding and humans seeking by opening up and unveiling what wants to remain hidden. In *Meat Joy* knowing gets constructed by veils alone, and the veils themselves that constitute "our depths," our being.

One of the distinct turns in modern philosophy is reading the human as not apart from but immersed in a world of surfaces, a shift most notably developed by Nietzsche. Where *Meat Joy* develops liberation through con-tact with surfaces, in his early work *The Birth of Tragedy*, Nietzsche uses Dionysus to much the same ends. Schneemann's flesh as material for art and Nietzsche's reading of the Dionysus myth both trouble a sense of humans as unique and apart from the world of things.

Nietzsche opens *The Birth of Tragedy* by examining the origin of tragic drama for the Greeks. He situates tragic drama's birth in the chorus, which he aligns with the figure of the satyr, friend of Dionysus. Contemporary scholars of Greek drama believe Nietzsche was essentially correct in this point: the tragic chorus derived from the nonindividuated mass of revelers, the satyr-chorus of Dionysian worshippers who exhibited passion and sexual energy in ritual celebrations.[11] Dionysian revelers undergo abulic transports to become like the half-man, half-animal satyr.[12] Such transformation annihilates the individuals and opens them to an abyss between ecstatic truth experienced in the rituals and their mundane realities. For Nietzsche, the satyr, as a divided creature between human and beast and standing between nature and culture, is an important figure for expounding on the relation between art and truth in *The Birth of Tragedy*. As Lawrence Hatab summarizes:

The phenomenon of "drama" (literally, an action) and dramatic imperson-
ation are born in the mimetic enchantment of Dionysian enthusiasts who iden-
tify with the satyr celebrants of the god who have identified with Dionysus
through ecstatic transformation. So for Nietzsche, tragedy begins with the
satyr, representing a Dionysian experience of exuberant life force beneath the
Apollonian illusions of civilization.[13]

As the tragic chorus borrows from the ritual dithyramb, it takes with it the
sense of vision, revelry, energy, and transformation. Consequently, Dionysus
and the satyr serve as the figure for how art functions through illusion, force,
and transports. It is exactly such illusion, force, and transport effected in
Schneemann's work of ritual frenzy where contact among surfaces becomes
the mode of transforming the mundane into events and encounters that
extend or distend what it means to be human.

Nietzsche asserts the vitality of the satyr at the expense of what he consid-
ers the modern representative of art, the shepherd as tricked-up dandy:

> The satyr and the idyllic shepherd of later times have both been products of a
> desire for naturalness and simplicity. But how firmly the Greek shaped his
> wood sprite, and how self-consciously and mawkishly the modern dallies with
> his tender, fluting shepherd! . . . [T]he satyr was man's true prototype, an
> expression of his highest and strongest aspirations. He was an enthusiastic
> reveler, filled with transport by the approach of the god. . . . The satyr was sub-
> lime and divine—so he must have looked to the traumatically wounded vision
> of Dionysiac man. Our tricked-out, contrived shepherd would have offended
> him, but his eyes rested with sublime satisfaction on the open, undistorted
> limnings of nature. Here the archetypal man was cleansed of the illusion of
> culture. . . . Even as tragedy, with its metaphysical solace, points to the eternity
> of true being surviving every phenomenal change, so does the symbolism of
> the satyr chorus express analogically the primordial relation between the thing
> in itself and appearance. The idyllic shepherd of modern man is but a replica
> of the sum of cultural illusions which he mistakes for nature. The Dionysiac

Greek, desiring truth and nature at their highest power, sees himself metamor-
phosed into the satyr.[14]

Unlike the shepherd, the satyr instantiates the relationship between "the
thing in itself and appearance," because of his own divided nature that is
not drawn over by a false sense of unity. In like manner, the satyr chorus
functions not as individuals, but as an ecstatic multitude that learns, from
the divided nature of the satyr, to express its own relationship between the
appearance of individuation in the quotidian world and the thing-in-itself.
For Nietzsche, questions of management, feasting, and knowledge center
around this abyss or caesura within the satyr and within the human.

It is not a particularly difficult stretch to see Nietzschean sensibilities in
Meat Joy. After an onstage blackout, the performers leave the quotidian world
behind as they spiral into an ecstatic multitude whose gestures open up
the human–animal being. They enter into this exploration by proximities
and frictions of the bodies in orgasmic gestures, wound in ropes and paper,
and flopping among fish and chickens and sausages. The performers act out
the tension between an appearance of individuation in everyday life and the
unfathomable and intoxicating depths of the thing-in-itself. The issues of
"Essence, Matter & Being" are manifest in the "traumatically wounded vision
of Dionysiac [hu]man."

SHEPHERD

The dark yet libratory gestures found in the Dionysian rituals have their coun-
terpoint in critics who find our divided human–animal nature an unnatural
model for defining humanness and the privileged interiority of the human
subject. Schneemann imagines and addresses the critics of her approach in *Up
to and Including Her Limits* (1973–76); in an attempt to counter Nietzsche,
Heidegger takes to task the satyr by employing his own figure, the "shepherd
of Being." In both cases, at issue is the distance of the critic from the material
under examination, and the critic's desire to unify the multitude and herd or
manage its disorienting force.

In *Up to and Including Her Limits,* Schneemann is suspended naked on a harness and rope. She extends her body and uses a crayon to draw on the walls surrounding her until she creates a web of marks and remarks (Figure 8). Schneemann describes the performance: "My entire body becomes the agency of visual traces, vestige of the body's energy in motion."[15] Because of the relationship between rope, harness, body, and crayon, slight movements or shifts in the body's tension change Schneemann's position and her reach. The vertiginous hanging creates a strange effect: "Being taken over—possessed—not a process of will . . . force of the concentration is overwhelming . . . I move to 'meet' it, to be submerged."[16] This feeling of possession echoes the Dionysian loss of the mundane self by immersion into the frenzy of the satyr chorus.[17]

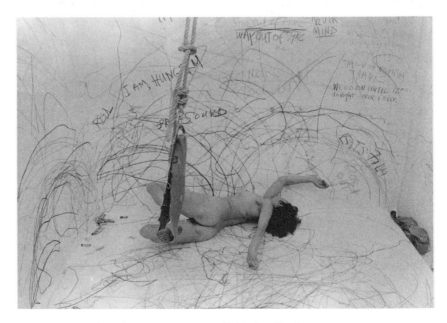

FIGURE 8 Carolee Schneemann, *Up to and Including Her Limits,* 1973–76. Performance. Live video relay; crayon on paper, rope and harness suspended from ceiling. Studiogalerie, Berlin. Photograph by Henrik Gaard. Copyright Henrik Gaard.

FIGURE 9 Carolee Schneemann, *Kitch's Last Meal,* 1973–76. Super 8mm film, color, double projection-vertical. Sound on cassette. Copyright Carolee Schneemann.

The voice of the critic emerges in the tape and film element of *Up to and Including Her Limits*. Adjacent to the performance area, Schneemann places a double-screen projection of her Super 8 film *Kitch's Last Meal* (1973–76), accompanied by the sound tapes for the film. The film is a sequence of images of Schneemann's cat, Kitch, eating. Schneemann shot footage of the cat eating one of its meals each week for as long as the cat lived, from the animal's seventeenth year until her death at twenty. She included in the film the everyday life surrounding the animal (Figure 9).

In *Up to and Including Her Limits,* the voices of the tape (as audio component to the film) strike against Schneemann's naked-body drawing. The voices layer the work with another sense of being possessed, but this time with her "inner voices" projected from the outside. Tape 2 includes the following imagined conversation as narrated by Schneemann:

I met a happy man
a structuralist filmmaker
—but don't call me that
it's something else I do—
he said we are fond of you
you are charming
but don't ask us
to look at your films
we cannot
there are certain films
we cannot look at:
the personal clutter
the persistence of feelings
the hand-touch sensibility
the diaristic indulgence
the painterly mess
the dense gestalt
the primitive techniques

(I don't take the advice of men
they only talk to themselves)

[...]

he said you can do as I do
take one clear process
follow its strict test implications
intellectually establish a system of permutations
establish their visual set

I said my film is concerned with
DIET AND DIGESTION[18]

Schneemann insists that the "structuralist filmmaker" is not a particular per-
son; instead, this figure functions as a voice in her head and a force within
culture. In an interview with Daryl Chin, she explained that "[t]he sound-
track tape: does NOT DEFINE MY aesthetic! it is the interpretation of my imag-
inary enemy—I have put the words into 'his' mouth to stand for resistant/
blocked apperceptions."[19] The critic is a general enemy against which she is
working. He rails against the "clutter" and "hand-touch sensibility" and wishes
the artist would "intellectually establish a system of permutations." Here,
intellect is shorthand for disembodied reason. It is clear that what the critic
opposes is the messiness of immanent engagement between the artist and
her work, including the artist as part of the work. The critic is happy to create
films that maintain a distance between the artist and the artwork. This would
maintain the structural(ist) integrity of the artist as one who manipulates
materials, but stands apart from such materials. He objects to a blurring of
boundaries and the vertiginous loss of identity between subject and object,
artist and work. Yet as the "I" in the dialogue points out, every artwork is a
matter of consumption, a work projected out by the artist and consumed or
taken in by the audience. The filmmaker refuses the body that consumes—a

body Schneemann asserts in capital letters: "I said my film is concerned with / DIET AND DIGESTION."

While Schneemann imagines her critic, Nietzsche's counterpoint can be found in Heidegger, who took up challenges in Nietzsche's philosophy but selectively omitted questions of the body and concerns for immanence. In 1936, Heidegger began what would become a decade-long series of seminars and lectures on Nietzsche. David Ferrell Krell goes so far as to say that "Nietzsche's impact on Heidegger's thought is second to none."[20] In the preface to his four edited volumes of seminars titled *Nietzsche*, Heidegger explains that the lectures in these volumes "provide a view of the path of thought I followed from 1930 to the 'Letter on Humanism' (1947)."[21] The influence of the Nietzsche lectures reaches even further because the "Letter on Humanism" initiates a series of questions on technology, dwelling, and the call to thinking in the wake of metaphysics. While the lectures reveal Heidegger's path, they also give the contemporary reader a reflection on roads not chosen. Heidegger's selection from Nietzsche, as well as his method of reading, tells us more about Heidegger than Nietzsche. For example, while Nietzsche is often concerned with the human body—its physiological functions and its animal nature—Heidegger curiously omits Nietzsche's thought concerning the issue of man's kinship with other animals.[22] The lacuna suggests Heidegger's own intentions, as well as crucial moments in which he remains uncomfortable with Nietzsche's philosophy as it vitally engages with issues of the human animal. At the intersection between the human's animal body and thinking, Heidegger and Nietzsche decidedly differ.

For both Nietzsche and Heidegger, the relationship between animals and thought starts with the issue of "DIET AND DIGESTION": eating as knowing, and eating as incorporation. The connections between eating and knowing are extensive, and both philosophers make use of them in different ways. Eating means taking the other from outside and possessing it, and taking it in until there is no difference or distinction between self and other as the food is digested. Epistemologically, eating becomes a way of thinking about the outside or unknown in thought: How can the unknown ever be known except

by making it like the self, the known? In other words, to know is to digest and incorporate the other. Yet as is quite obvious in this extended metaphor, knowledge and eating entail violence to the other. This is why Scheenmann is so assertive in claiming "I said my film is concerned with / DIET AND DIGESTION" and why too she incorporates this narration in a performance work in which her body strains in a harness as she marks on canvas. Violence is encoded in the knowing and the making of her art in which the body—her body—figures as a site of production amid corporeal containment, restraint, and an open access to observation.

Derrida addresses these same issues of knowing the other and the violence of knowing when posed with the question: Who comes after the subject? He works through the problem of the "who" by considering its relations to the outside and the fundamental question of eating and the feast:

> The question is no longer one of knowing if it is "good" to eat the other or if the other is "good" to eat, nor of knowing which other. One eats him regardless and lets oneself be eaten by him. . . . The moral question is thus not, nor has it ever been: should one eat or not, eat this and not that . . . but since *one must* eat in any case and since it is and tastes good to eat, and since there's no other definition of the good *(du bien), how* for goodness sake should one *eat well (bien manger)*?[23]

The questions become then: how are we to manage eating well *(bien manger)*, and who is this "I" who manages or regulates eating? For Heidegger, the shepherd manages that which he eats *(mangez)*, while for Nietzsche, the satyr's self-management coincides with his eating *(manger)*. With this cross-linguistic pun, I am drawing from a tradition of such conceptually appropriate and linguistically questionable wordplays such as found in Derrida's *Glas.* Here and elsewhere, Derrida (and many Derridians) have used pseudo-etymologies and puns as a way of striking at Heidegger's quasi-etymologies employed to construct arguments throughout his oeuvre. My slippage across languages and the linguistic questionability is intended to fold into the concept

of "pidgin language" developed in chapters 4 and 5 and to denote instability in meaning and shifts between the physicality of speech (words sounding alike) and their meanings.

In anticipation of the contrast between Heidegger and Nietzsche, several options become evident. One may keep food—intellectual or material—at a distance, deferred and with elaborate preparation. It may be something we point at and name, such as "the animal," something (in Heideggerian fashion) that remains "poor in world [*weltarm*]," whose animal world is cut out and overcooked to be eaten. Or it may be that food functions as that which draws us near to things—as Heidegger longs for in the opening of his 1949 essay, "The Thing," in which "despite all conquest of distance [through technology] the nearness of things remains absent."[24] Such a drawing near would perhaps look less Heideggerian (with his meditation on *techne*) and more like something out of Nietzsche's *The Birth of Tragedy* turned cookbook. That is, as already intimated in Schneemann's work, we may learn to draw near via Dionysus and his grapes rather than via the shepherd and his crook. The very identity of Dionysus centers around consumption: he is the god of wine, and in areas of Greece where he is said to have been the first to tame bulls, he is a god of agriculture. According to Greek rites centering around Dionysus (which Nietzsche uses to his own ends), his revelers crush and imbibe grapes in an intoxicating feast. They rend the flesh of animals—usually a goat or bull, but in some rare instances humans as well—and eat their flesh and drink their blood, believing it to be the body and blood of Dionysus himself, who at times takes on animal form. By drinking the wine and blood and eating the flesh, the revelers exceed the mundane world and learn from their god, who emulates the intoxicating fruits in his own immolation.[25]

At the very beginning of his lectures on Nietzsche, Heidegger offers his students a provocative fragment from Nietzsche:

> For many, abstract thinking is a toil; for me, on good days it is feast and frenzy . . . the feast implies: pride, exuberance, frivolity; mockery of all earnestness and respectability; a divine affirmation of oneself, out of animal plenitude

and perfection—all obvious states to which the Christian may not honestly say Yes.[26]

One can imagine the thrill of a student attending such lectures and the possibilities opened by such a rich and dense passage. But in typical fashion, Heidegger withdraws the pleasure of the feast and the thrills and expectations for the students by proceeding to explain,

> Feasts require long and painstaking preparation. This semester we want to prepare ourselves for the feast, even if we do not make it as far as the celebration, even if we only catch a glimpse of the preliminary festivities at the feast of thinking—experiencing what meditative thought is and what it means to be at home in genuine questioning.[27]

Heidegger withdraws the feast, its food, and the "animal plenitude and perfection" that is part of the joy of eating. He substitutes "painstaking preparation" toward catching a glimpse of "the feast of thinking—experiencing what meditative thought is." The feast with its animal plenitude becomes the feast of thinking that is meditative rather than frenzied and removed and abstracted from, rather than replete with, corporality. Heidegger offers a future feast though one that never arrives; his feast is always promised, but upon approach, the eating is deferred indefinitely across a decade of seminars and their published form in the four volumes titled *Nietzsche*. He never gets to the body of thought and thought on the body. Nietzsche is unable to provide a retort to this later philosopher; nevertheless, we shall trace such a reply in both Nietzsche's and Schneemann's work.

As quoted by Heidegger, Nietzsche's passage on thinking as feast and frenzy brings together bodily incorporation and knowledge. The quotation displays eating and knowing as an ecstasy and violence reminiscent of the Dionysian festivals in Nietzsche's early work, *The Birth of Tragedy*. What is at issue in knowledge and incorporation—and knowledge *as* incorporation— is the problem of how the outside finds its way into the privileged interiority

of the human subject. Furthermore, and as Nietzsche will ask: How is this knowledge not only a mental acquisition, but also a bodily functioning dependent on physiology? For Schneemann, it is exactly this issue of thinking with one's body and making the body immanent to the work of art that is at issue in her corpus. *Up to and Including Her Limits* uses limit as a double valence: the artist is at her limits in an ecstatic effort to extend her physical and symbolic reach in her work while the viewer is confronted with the limit of being able to take in and understand the intensity and physicality from Schneemann's point of view. Within her artwork or from outside it, artist and critic alike are at their limits. For Nietzsche and Schneemann, knowing and corporeal comportment are intertwined.

Turning to Heidegger provides an instructive difference similar to the one we have seen between Schneemann and the critical voice of the structuralist filmmaker in tape 2 of *Kitch's Last Meal*. Like the structuralist who erects barriers to the artist's corporeal work, Heidegger erects his own limits by which to push against the reach of Nietzsche's Dionysus. Heidegger and the structuralist critic prefer a distance and objectification by which to take on their objects of study. It is curious that just after his lectures on Nietzsche, in the "Letter on Humanism," Heidegger situates man as the idyllic "shepherd of Being":

> Man does not decide whether and how beings appear, whether and how God and the gods or history and nature come forward into the clearing of Being, come to presence and depart. . . . But for man it is ever a question of finding what is fitting in his essence that corresponds to such destiny; for in accord with this destiny man as ek-sisting has to guard the truth of Being. Man is the shepherd of Being.[28]

If the Nietzsche lectures "provide a glimpse of the path of thought which I followed between 1930 and the 'Letter on Humanism,'" then it is worth examining why Heidegger chose the figure of the shepherd in the shadow of Nietzsche's Dionysus and, by extension, the god's friend: the satyr.

The contrast between Heidegger and Nietzsche is evident in how the shepherd and satyr manage their flocks: both rend the flesh of animals, but for the shepherd, shearing and slaughter happen offstage and out of sight. Such omission serves as a tellingly discarded part of Heidegger's metaphor and path of thinking. The offstage killing contrasts with Dionysus and the satyr, both of whom embody a reflexive act of self-division even as they divide up the other, the grape, the animal, the eatable (*Ask the Goddess* [1993–97], Figure 10). In Heidegger's shepherd, there is a distance between the human and the animal and the human's own animality. For Heidegger, man cuts himself off from his animal nature, but he does so only to tend to the open and let beings be as such. This is the primary function of the "shepherd of Being" as one who cares: he cares, but does so by removing himself from the immanence of Being amid the multitude of the flock.

In this passage from the "Letter on Humanism," Heidegger refers his readers to Dasein and care in *Being and Time* to support his notion of shepherding. In section 44 of *Being and Time,* Heidegger explains that Dasein is "always already ahead of itself," because it is able to think its own future and being toward death.[29] Dasein, then, in its very structure is concerned about the potentiality-for-being of its own being. Such concern for what is not, but could be, is the care that allows Dasein to shepherd beings. The shepherd gathers and discloses beings: "as long as there is an understanding of being [the shepherd's role] and thus an understanding of objective presence, we can say that *then* beings will still continue to be."[30] This role of shepherding becomes formative for Heidegger's later writing—in "Building, Dwelling, Thinking," for example—in which mortals bring together the fourfold: namely, they shepherd the earth, sky, divinity, and mortals.

Perhaps Heidegger is much more adept than the voice of Schneemann's critic. He is aware that his shepherd and his stance on shepherding beings reinstate a humanist hierarchy. Concerned about the anthropocentrism in his thinking, Heidegger thus attempts to alleviate the centrality of the human through the call that comes from outside: "For man becomes truly free only insofar as he belongs to the realm of destining and so becomes one who

FIGURE 10 Carolee Schneemann, *Ask the Goddess*, 1993–97. Performance. Odense
Festival, Denmark. Copyright Carolee Schneemann.

listens, though not one who simply obeys."[31] In the "Letter on Humanism," this call is characterized as: "Man does not decide whether and how beings appear." Yet within the same passage, man is situated as the shepherd. It seems that man is destined to be the "shepherd of Being," and as such, he is elevated above animals and his own animality. Just before the shepherd passage, Heidegger goes out of his way to make the division between the shepherd and other animals quite clear—and so to separate himself from a figure such as the satyr, which is immersed in animality as a being among other beings:

> Of all the beings that are, presumably the most difficult to think about are living creatures, because on the one hand they are in a certain way most closely akin to us, and on the other are at the same time separated from our ek-sistent essence by an abyss. However, it might also seem as though the essence of divinity is closer to us than what is so alien in other living creatures, closer, namely, in an essential distance which, however distant, is nonetheless more familiar to our ek-sistent essence than is our scarcely conceivable, abysmal bodily kinship with the beast.[32]

That which is outside—the animal—is produced by the exclusion of the inside of man, our animal nature and "abysmal bodily kinship with the beast." Heidegger grudgingly acknowledges our connection to animals, but only to place an abyss between us and them and to further this divide by claiming without foundation that, indeed, we are closer in nature to divinities than we are to other animals. The nature of animals remains "what is so alien in other living creatures." What is alien "in" animals is the very thing which is "in" us; however, Heidegger removes this "in" and places it on the other side of the abyss—as far from human as possible. It is in this caesura, in this abysmal divide, that the satyr is most at "home." And it is this that creates a fundamental difference between Nietzsche and Heidegger.

Certainly Heidegger has contemplated and figured many an abyss: the divide between beings and being, the rift between being concealing itself and human sheltering of beings, the difference between the sudden and radiant

appearance of being and its unfolding.[33] In all these cases he marks a cleft and attempts a leap; yet in the divide at hand (between bodily kinship and our ek-sistence as beings aware of foundational being) Heidegger fails to attempt a crossing.[34] Where the abyss is for Heidegger a no-man's land, for Nietzsche this abysmal nature of the human is figured as a central concern and the home of the satyr. For Nietzsche the unfathomable is the very site of pro-ductive force, where the hybrid figure of the human–animal satyr fashions Dionysian rites as the prototype and foundation of art. Nietzsche is not ask-ing that the site of the abyss become intelligible; he does not wish to save the abyss from being just that. Rather, its very obscurity is its mode of managing or *manger* being.

Schneemann leverages an abyss in her works. She is continually casting ropes across the abyss between the bodily animal nature of humans and the cultural distancing from our animality. To recall the words of Jonas Mekas:

> [*Meat Joy*] brings us back to the touch, smell, to the surfaces of things and bod-ies; it accepts, with love, everything that our insistence on ideas (certain ideas) kept us away from; even what was "repellant," like "raw" meat, or chicken guts, what we usually dread & fear to touch—glittery, vomity substances (under the excuse of our own "delicateness," the delicateness of our natures . . .).[35]

The "mess" derided by Schneemann's critic is this problem of organizing the organs—ours and the animals'—so as to hold together the human organism rather than allowing bodies and body parts to mix across individuals and species. The work functions as a "nervous system of bodies in interaction with interchangeable bodily parts."[36] While thought has always been about managing distance between subject and objects, Schneemann collapses dis-tances and finds productive thought in the surfaces, contact, and exchange amid entities.

For Schneemann and for Nietzsche, the abyss is a mode of connect-ing rather than dividing humans from animality. For Nietzsche, the primary concern is how the abyss becomes the site for the production of Dionysian

rituals and foundations for art. The human–animal satyr works as a figure for transmuting the material world into artistic ritual. Unlike Nietzsche, Schneemann works with both metaphysical and physical abysmal depths. The raw physicality of her body negotiates physical space in a way that Nietzsche can glance over with myth and metaphor of Dionysus and the satyr (and later figures such as Zarathustra and the Overman). It is the raw and seemingly alinguistic collapse of physicality in Schneemann's work that pushes her beyond Nietzschean meditations on the body.

As if to rein in Nietzsche, Heidegger calls him the last metaphysician because Nietzsche remains concerned with the "problem of beings" rather than the "question of being." Such a distinction between *beings* and *being* becomes manifest in the contrast between satyr and shepherd, each of whom manages the "abysmal bodily kinship to the beast" very differently.[37] For Heidegger, maintaining kinship with brutes misses the unique essence of man:

Are we really on the right track toward the essence of man as long as we set him off as one living creature among others in contrast to plants, beasts, and God? . . . We will thereby always be able to state something correct about man. But we must be clear on this point, that when we do this we abandon man to the essential realm of *animalitas* even if we do not equate him with beasts but attribute a specific difference to him.[38]

To think of man as animal, even *animal rationale,* is to miss the unique essence, the particular calling, of man. Our role, according to Heidegger, is one of "uprightness," which no other creature possesses: "living creatures [other than man] are as they are without standing outside their Being as such and within the truth of Being."[39] Humans are then *out*-standing, and in their verticality they are able to get outside of their own being (or stand out) to contemplate the question of being as well as shepherding other beings. In contrast, caught within the series of relations that is their world, animals simply cannot hoist the ladder of thought above their surroundings to have a look around.[40]

Nietzsche and his satyr explore the problem of beings and being differently. Far from the *animal rationale,* the satyr's divided nature echoes man's own division between a kinship with the beast and human uprightness. Yet unlike Heidegger's shepherd, for whom the division remains outside of man and initiated by a call or destiny, for Nietzsche, the satyr carries the split within himself, and it is this intimate caesura that creates the satyr's unique state. This split functions as the very center from which Dionysian revelers admire and emulate the satyr. Furthermore, it anticipates the splitting open that remains the fate of their god. Rather than an outside calling—a call that shepherds the shepherd and allows the shepherd to manage a distance from his flock—for Nietzsche, the very relations within ourselves—our animality—introduce a novel ontology and epistemology.

Giorgio Agamben's *The Open* serves as an extended meditation on this "intimate caesura":

> The division of life into vegetal and relational, organic and animal, animal and human, therefore passes first of all as a mobile border within living man, and without this intimate caesura the very decision of what is human and what is not would probably not be possible. It is possible to oppose man to other living things, and at the same time to organize the complex—and not always edifying—economy of relations between men and animals, only because something like an animal life has been separated within man, only because his distance and proximity to the animal have been measured and recognized first of all in the closest and most intimate place.[41]

The split within humans, "the mobile border [living] within living man," opens up both human and beast, as well as human as beast, to a unique mode of thinking and knowing. Knowledge, including self-knowledge, occurs as the "inside" or privileged interiority of the human becomes divided and opened. Such an opening moves the interior and its depths to a surface for examination and consumption. The split exposes the inside as another outside, a surface for study. The split operates as a different sort of opening than Heidegger's

notion of the open as a sphere outside which is managed by the shepherd. The constitution of the "who" (which comes "after" the subject) ruptures in this epistemology of epistemology.

VEILS

For Nietzsche, the rending of flesh in Dionysian transports simply doubles the space of the caesura and "the abysmal bodily kinship with the beast." Cutting the flesh of animals, turning their insides out, repeats a division felt by the Dionysian revelers metamorphosed into satyrs. Making the animal into only a surface, flesh exposed and feasted upon—visible and knowable— happens not because the animal is "poor in world" (as Heidegger claims in *The Fundamental Concepts of Metaphysics*). Rather, the feasting happens because it allows those eating to recognize their own bestial nature and the nature of Dionysus, their friend who will be rent asunder.[42] The surfaces in the "feast and frenzy" reveal nothing behind them, no privileged interiority of the human; instead, there are only more and other surfaces—a play of "material" appearances that concurs with Dionysus as the master illusionist and artist in *The Birth of Tragedy*.

Surface and appearance perform an important role in *The Birth of Tragedy*. It is the veil of appearance that allows the Greeks their "pessimism of strength"; it permits them the strength to look into the abyss and forge tragic drama despite the darkness of a life without a transcendental truth or meaning.[43] For Nietzsche, the strength of the Greeks comes from the power of surfaces, with their sensuousness and illusions, by which they are able to face the abyss and produce meaning in confrontation with the abysmal. Appearance rather than transcendent truth becomes the means of knowing the state of affairs in the world: "For both art and life depend wholly on the laws of optics, on perspective and illusion; both, to be blunt, depend on the necessity of error."[44] The god Dionysus offers the play of surfaces as veils for further production of appearances. In *The Birth of Tragedy*, Dionysus' art is opposed by its opposite, Apollo's realm of truth, light, and reason. There remains, however, an asymmetry to the dialectic because illusion authorizes and legitimizes

its opposite—Apollonian light and truth. Further, Nietzsche suggests that Apollo's light is merely illusion in disguise.

Appearances allow Nietzsche a means of overturning Platonism. Indeed, even as early as *The Birth of Tragedy,* it is Socrates who stands out as the real counter to Dionysus. Nietzsche inverts Platonism by positing appearance as more true and more real than the eternal essences and forms. As Will McNeill explains in his important analysis of Heidegger's Nietzsche, "the sensuous becomes the true and the suprasensuous idea is merely the apparent."[45] In his late work *Twilight of the Idols* (1895), Nietzsche returns to the problem of appearances authorizing the known world, but he finds that even the stability of the sensuous must give way. It is important that Nietzsche not simply inverts Platonism, because to stand Platonism on its head would simply maintain a metaphysical order, the only difference being that the inversion would place material objects in the world as "true" and ideal forms as illusions. Nietzsche finds a means of twisting free from this polarity. As Heidegger explains in his lectures, Nietzsche accomplishes this exit from the polarity in "How the 'true world' finally became a fable."[46] The twisting free comes when Nietzsche asserts that "[t]he real world—we have done away with it: what world was left? the apparent one, perhaps? . . . But no! with the real world we have also done away with the apparent one!"[47] The world is a continual series of appearances that flash before us in an ongoing becoming; yet in order to capture this becoming, we give it a sense of being. Nevertheless, the being of that which appears to be is itself mere appearance and illusion. The true is no longer what *is,* but rather unfettered *becoming.*[48] If, as we saw in chapter 1, nature loves to veil itself, then here Nietzsche claims that there are only veils hiding behind the veils. He pushes his overcoming of Platonism further by proposing that even the veils are an illusion, which stand in for the slipperiness of becoming.

Veil upon veil, reality becomes the dark and disorienting world of the Dionysian abyss: the abyss between the revelers' intoxicating revelations and their mundane world; the abyss between the inaccessible animality and the humanness of the human. In both cases, the satyr straddles the abyss. Yes, he

is a fictional creature and as such another veil, but it is exactly this status as veil and fiction that makes him so very meaningful. The satyr functions as the site where human interiority bumps against the forces that would unravel it.

Schneemann leverages the Dionysian in her art by embracing the satyr. She uses surfaces to create veils that are not Apollonian illusions—art as mimesis or expression of inner creativity. Rather, her work of surfaces levels the mundane world and drags it into the abyss. To repeat an earlier comment: the surfaces in the "feast and frenzy" reveal nothing behind them, no privileged interiority of the human. There are instead only more and other surfaces—a play of "material" appearances. Schneemann repeats time and again the manipulation of material surfaces, including the human body as material and surface. For her, desire is not something interior to the human subject; rather, it is what manifests on haptic, sensual surfaces and becomes pronounced through contact and frictions.

Schneemann plies the use of veils in several ways. Not only is this a matter of surfaces and illusions, but also for her it is a feminist form of art. Even as far back as Heraclitus' claim that nature veils itself, nature is figured as a woman whom the male investigators unveil or open up to expose her hidden value. Rather than allow the male gaze to denude her and her work, Schneemann's veils provide glittering and disorienting surfaces from which there is no depth for the observer to gain an orienting grounding. As the eighteenth-century essayist Mary Wollstonecraft observed in her *Vindication of the Rights of Woman*, culture has attributed to women only a surface and superficial knowledge, while men have depth of thought. In the veils and surfaces of her work, Schneemann turns this negative stereotype against itself. Veiled and superficial, these works shimmer with the productivity of surfaces without depth.

It is possible to think of Schneemann's work as other than surface—to think of it as depth of *human* desire and more particularly female desire. Indeed, critics comfortably place Schneemann within the lineage of early female performance artists who use their bodies as sites for inquiry into the role of gender and sex within the prevailing social community. This approach

to Schneemann's work by way of depth and identity relegates the animal flesh in *Meat Joy* and the animality or satyr nature of the human body into props for a particular human discourse of human interiority. Schneemann herself occasionally talks about her work in this way. It is sometimes difficult to tell whether Schneemann sees her work as expressing an "inner" self with depth of being or if this too is another veil plied by the artist. Thinking of the work as surfaces opens up a larger field on which animality might roam.

Schneemann plies the body as surface by making it function as canvas and brush. In these instances, the canvas as medium does not mime the real or become the site for expressing the artist's creativity; rather, it is the artist, and the artist becomes the canvas that has no further end than its play of material appearances. While in her early work *Eye Body* (1963) she is both artist and sculptural and painted art object, later works further develop the body as a site of flashing appearances and surfaces without recourse to interiorities. There is no shepherd herding the work, but rather the satyr-artist as both agent and object, artist and medium. *Meat Joy* uses the body in relation to paper and paint as the collapse of artist and medium into mutual surfaces, which is further realized in works such as *Body Collage* (1967) and *Illinois Central* (1968).

Body Collage began as a rehearsal of body movements for *Illinois Central*, which used similar gestures but incorporated local sounds and images. The rehearsal became a productive sketch piece documented in photography and 16mm film. In this work, Schneemann shreds white printer's paper, covers herself with wallpaper paste and molasses, and then runs "back and forth around the pile of papers until the momentum of the runs provoked a fall into it." Now amid the paper, she rolls in the heap until paper affixes to her in "random shape and proportion."[49] The result is an active, temporal collage (Figure 11). Amid all of the running and rolling, Schneemann calls forth an image later used in *Illinois Central*:

> Standing up [after rolling in the paper] led to an impulse to fly. I stood on three
> iron steps leading from the loft to the fire-escape, my arms moving up and

down like wings until I "took off" in a flying-run down the steps. The figure poised on the steps, the sense of elevation and lightly attached papers produced a propulsion, an alighting.[50]

Several years later, Schneemann finds confirmation of her flying impulse in a reproduction of the Cretan Toreador fresco in which athletes vault over the back of a bull, who itself is stretched out as if leaping or straining in space. Schneemann's "alighting" corresponds to the ethereal summersault of the Minoan athlete as well as the lightness of the paper that covers her body. Yet importantly, the sensation of being airborne is intoxicating not because the artist is leaving her body behind, but because she is taking it with her. Her corporality is the site of this leaping. The flight has all the weight and power of the ancient bull coupled and coupling with the leaping human. The coupling produces a hybrid form—like the minotaur—or, to recall the central figure of this chapter, like the satyr.

In *Illinois Central*, there is a transmutation of the body that becomes ripped, torn, and changed into the "painterly mess" collage such that "there was as well a tactile and sensory extension of flesh into paper—malleable, expressive, sculptural." The energy of bodies, flight, surfaces contacting, combining, and recombining in the dynamic collage creates an event and spectacle for the viewer. As the body changes, the artwork beckons to the body of social thought where the audience "grasp[s] a conscious and realizable wish to replace the performers with themselves."[51] The individual bodies and the social body are joined in a dithyrambic reorientation of what it means to be linked to one another and to material nature.

In his 1980 essay on Schneemann for *Art in America*, Lawrence Alloway characterizes her work as a "dionysiac cul-de-sac."[52] In other words, there is nowhere to go once the artist and audience reach their orgasmic leveling of human interiority into an exterior materiality. Yet what Schneemann's work provides is a way of producing art that is not a shepherding but a corporeal incorporation of the artist in the process of the art. As we shall see in the following chapters, this gesture of the satyr allows for a way of being with and

FIGURE 11 Carolee Schneemann, *Body Collage,* 1967. Performance. Paper, wallpaper paste, molasses. Photograph by Michael Benedikt. Copyright Carolee Schneemann.

alongside animals that evades human hierarchical relationships to the animal. The satyr as a figure gives artists and philosophers a place to stand while initiating an inquiry into animals. This place or ground is without ground; rather, it is an alighting over an abyss by the use of veils and veils upon veils. It is precisely the fragility and tentative nature of alighting that legitimizes the inquiry into the animal as something other than an imposition. As we will see in subsequent chapters, more than a "dionysiac cul-de-sac" is tread by animal artists who go off-road to meet up with the animal world on unpaved terrain.

In other words, rather than having nowhere to go, the art take us off-road or off what Heidegger calls the pathway, *der Weg*. For Heidegger this *Weg* is a path of thinking in the wake of metaphysics. Yet as Agamben claims, and as I've traced in this chapter, Heidegger's path leads to an "anthropological machine" whose goal is the "total management of its own animality."[53] As we will see, these artists leave the path both literally and figuratively, and in doing so, they abandon total management and consumption of the animal. Literally, they are off-road using unusual settings for their studio spaces, ranging from housing complexes for the elderly to the oceans of the Antarctic. They deploy unique materials including bear skins and fishing chum. Figuratively, they take us far from the cultural economies of the shepherd and into zones of contact with the nonhuman. Some of the artworks produced in these contact zones press the limits of culture and intelligibility in order to move thought to the unthought of thought. In doing so, they develop other (non)human languages—what I will call pidgin languages—and creative modes of comportment. In uncharted terrains with other languages and other modes of being, these artists and their works challenge what it means to be human and draw us closer to the satyr in the abyss.

Making Space for Animal Dwelling

Worlding with Snæbjörnsdóttir/Wilson

The creature gazes into openness with all
its eyes. But our eyes are
as if they were reversed, and surround it,
everywhere, like barriers against its free passage.
We know what is outside us from the animal's
face alone
—RAINER MARIA RILKE, "Eighth Duino Elegy"

In the "Eighth Duino Elegy," poet Rainer Maria Rilke describes the animal's space that overlaps and haunts our own as a "nowhere without the no."[1] We do not have access to this space, this nowhere, and yet it lingers in our presence "without the no." Rilke points to the limit of knowing the animal and its world. His poem indicates a place without (human) knowing and yet not quite a nowhere. It is this same space that the artists Bryndis Snæbjörnsdóttir and Mark Wilson pursue in their collaborative artwork:

In general we aim to use our work to create debates and highlight awareness about the environments humans and animals inhabit and to create platforms to actively engage in a discourse on anthropocentric hierarchies in our societies with a view to open a space for what [Anne] Brydon quoting [Bruno] Latour calls "multinaturalism. Multinaturalism he posits as a collective community made up of both, human and non-humans."[2]

Snæbjörnsdóttir and Wilson examine moments of friction between the animal and human worlds and frictions evident within cultural perception of how to negotiate the nonhuman, including hunting, urban development, and conservation. By examining moments of friction between us and animals, these artists make visible the space of the Other that resides as an open secret. We have seen this secret in chapter 1, where nature's "veil consists in having no veil; in other words, she hides because we do not know how to see her, although she is right before our eyes."[3] Snæbjörnsdóttir and Wilson reveal the parameters of the animal world while maintaining its unknowability.

In recent theoretical work, animal agency has been described as the look of the Other—a reversal of human optical supremacy by granting that animals look back at us from their own world and their own interiority or selfhood. While Snæbjörnsdóttir and Wilson employ vision in their work—particularly in their photographs—they have come upon a more fundamental mode of discourse by working with animal worlding that is over and against the primacy of vision. Too much of the discourse on vision carries with it cultural signification that reappropriates the animal and its agency according to anthropocentric valuing of sight and coding of vision. It is worth examining how this coding takes place, and how Snæbjörnsdóttir and Wilson both use it and break free of its limits.

THE CREATURE GAZES

Animals look back at us, and in this look, the center and periphery as well as the interiority (of the human) and exterior (of the animal) gets misplaced. Traditionally, sight is possession at a distance: we take in to human interiority and reason the object of our gaze. When the animal looks back, the hegemony of human vision becomes confounded. The implication is that there is an "interior exterior" to the human, and that we are the subject now made object of an alien look.

John Berger, in "Why Look at Animals," and more recently Jacques Derrida, in his autobiographical "The Animal That Therefore I Am (More to Follow)," leverage the look of the animal toward a rethinking of the human arena:

The animal scrutinizes him [man] across a narrow abyss of non-comprehension. This is why the man can surprise the animal. Yet the animal—even if domesticated—can also surprise the man. The man too is looking across a similar, but not identical, abyss of non-comprehension. And this is so wherever he looks. He is always looking across ignorance and fear. And so, when he is *being seen* by the animal, he is being seen as his surroundings are seen by him.[4]

Animals look at us, and we are confounded by their radical otherness as well as the fact that we may be objects in their world as much as they are objects in ours. When animals look back at us, we must grant that there may be something of the animal's "self" we do not know. Derrida, in "The Animal That Therefore I Am (More to Follow)," uses the look from his cat as the point where thought begins. The reflection emerges from a moment when the philosopher is naked and his cat looks at him.[5] In the exchange of glances between himself and the animal, and through reflection on his own nakedness, Derrida begins a bridge in thought across the human–animal divide. The cat under his roof reminds the thinker of the otherness of all animals, and moreover for the philosopher without clothes, it reveals the otherness that seems forgotten within the human.

Nakedness and the animal body of the human work as a necessary supplement. As Steve Baker explains in *The Postmodern Animal:* "Precisely as an alternative to Descartes's 'I think therefore I am,' Derrida proposes the formulation: 'The animal looks at us, and we are naked before it. And thinking perhaps begins there.'"[6] The "there" in Derrida's statement works as a deferral and displacement of the ground that authorizes thought by holding thought in abeyance until one can resolve the placement of the there and here—the placement of the animal outside man that serves as the traditional foil to the interiority of human thought, and the problematic "here" of the human that is both rational and animal. Yet this holding of thought in abeyance is itself the gesture of thought in which Derrida must consider the role of the animal in philosophy and the place of his own disrobed human animality. In the look of the animal, the center of the environment moves outside the human and

gets placed upon the multiple centers of the many "eyes" out "there." As a consequence, human identity finds its "I" in the eyes of the Other. By using the language of "the look," however, we reinscribe the animal interior and its Otherness within the domain of visual culture. Unfortunately, the look already points to human interiority: the depths and heights of our coded special languages from linear perspective to Cartesian perspectivialism and on to the Lacanian imaginary and symbolic.[7]

Even more pressing than the look from animals is their physicality and surfaces of contact. An actual encounter with an animal means physical proximity and (near) contact with the flesh of the animal Other. Humans consider the raw physicality of contact to be a most animal characteristic and one least intelligible within human cultural codes. If for Derrida human thinking begins in the regard of the animal, to move this notion further, contact with animals provides a possibility to think *with* them.[8] Donna Haraway has begun to explore the implication of contact with animals in *When Species Meet*. In reading Derrida's encounter with his cat, she comments:

> Positive knowledge of and with animals might just be possible, knowledge that is positive in quite a radical sense if it is not built on the Great Divides. Why did Derrida not ask, even in principle, if a Gregory Bateson or Jane Goodall or Marc Bekoff or Barbara Smuts or many others had met the gaze of living, diverse animals and in response undid and redid themselves and their sciences? Their kind of positive knowledge might even be what Derrida would recognize as a mortal and finite knowing that understands "the absence of the name as something other than a privation." Why did Derrida leave unexamined the practices of communication outside of the writing technologies he did know how to talk about?[9]

Haraway suggests there is much to be gleaned from the physicality of encounters. The shock of physicality in contact with animals turns against the distance of visual enframing of animals; physicality enlivens the surface of the animal body as something other than an object enframed by human

desires. The question pursued in the following pages is how art might evade the primacy of visual hegemony in order to employ the shock of the physicality and what Haraway calls "positive knowledge." As a consequence, art may come to the aid of philosophy in rethinking the space of multinaturalism where, as Derrida claims, "thinking perhaps begins."

While I want to pursue the physicality of encounter for art in the manner Haraway develops it for science and cultural studies in *When Species Meet,* it is worth providing some nuance to Haraway's demands vis-à-vis Derrida. Her investigation—and my own as well—has been opened up (rather than evaded) by Derrida's work. Haraway takes to task Derrida for not focusing on a "positive knowledge" of animals and cites examples of such knowledge by listing a number of scientists. It is not clear why Derrida should be tasked to address scientific engagement with animals—which is Haraway's interest—when his own interest is a philosophical inquiry into animality. In terms of philosophy and with reverberations well beyond the philosophical, Derrida has provided steps toward thinking alongside animals. In "On Eating Well" and "The Animal That Therefore I Am (More to Follow)," he develops the moral voice of animals; those that suffer communicate through their suffering and function as moral agents whose voice should be recognized by the human community. More broadly, Derrida's work on the opacity and multivalent modalities of communication provides a groundwork for Haraway's own pursuit of interspecies communication as well as my interest in human–animal hybrid language and modes of comportment. His insistence on breaking a singular mode of discourse opens the possibility for thinking nonhuman communication, the contact zones and pidgin languages developed in this and subsequent chapters.

From Sight to Site

Consider Thomas Nagel's curious question—"What is it like to be a bat?"—from his 1974 essay of the same title. Nagel's work is primarily in philosophy of mind and ethics. In this essay, he confronts the problem of foreign subjectivities: What it is like to be a bat—or, for that matter, any other animal? With

this question, he sets a horizon for human knowing. We can describe bat life and behavior, but "we can be compelled to recognize the existence of such facts *without being able to state or comprehend them*."[10] That is to say, there is something it is like to be a bat, but what that something is remains beyond our comprehension. What we fail to comprehend is the subjective character of the experience. We can know what it is like for a human to imagine being a bat, but not know what it means for a bat to be a bat—the concern under question. Nagel continues: "existence of facts like this whose exact nature we cannot possibly conceive" does not mean "there is not anything precise that it is like" to be a bat or a human or a Martian.[11] Nagel's point here is "there are facts that do not consist in the . . . move from subjective to objective character."[12] The problem is that while most facts move from sense impressions to objective general effects and properties (independent of the senses), "experience itself, however, does not seem to fit the pattern."[13] The move to objectivity does not take us nearer to the phenomena of a subjective experience, "what it is like," which is the very thing we want to know and the thing closed off by objectivity.

We can translate experience of an object between species only through the objective character of the object; however, as Nagel notes, "we cannot ignore [the species-specific point of view] permanently, since it is the essence of the internal world."[14] In short, translation and representation fail at some point: we do not have the conceptual schema to make sense of the subjective facts of this other creature nor to comprehend its "internal world."

Jakob von Uexküll seems to circumvent the problem of inaccessible animal experience discussed in Nagel. Uexküll is a founding figure in ethnology; later, biosemioticians claim him as a key thinker in their field.[15] In his 1934 monograph *A Foray into the Worlds of Animals and Men*, Uexküll moves beyond mechanistic biology to develop a line of inquiry into the animal's sense of its surroundings, something close to an animal phenomenology.[16] He tries to push the limits of the limit of what we can know; that is, he challenges not simply the limit—claiming we can know more—but also the schema that delimits or sets the parameters for understanding another creature. He does

this by more or less bracketing out the interiority of the animal: he doesn't want to know "what it is like *to be* . . . ," nor is he interested in the subjective being in the same way Nagel is. He asks instead, in *A Foray into the Worlds of Animals and Men* and then in *A Theory of Meaning*, what is the earth like for a tick, a fly, or a chicken, to mention just a few of the animals he considers in his essay. Uexküll begins by explaining that humans and animals occupy the same earth but live in different worlds. Observation of what matters to other animals can give us a sense of their world. He gestures toward an animal phenomenology.

Uexküll can make inquiries about animals' worlds by noticing what the animal responds to, and how it responds. What is the world of a tick? In this well-known example, he points out that the tick responds to three items, each of which is referred to as a "mark" or "carrier of significance" in its world: the odor of butyric acid found in mammal sweat; the temperature of mammal blood; and the texture of mammal hair.[17] Each of these three items is a carrier of significance for the tick, a mark in its world. Anything outside of this set does not register for the animal. For example, the tick will eat any liquid that is the temperature of mammal blood, of roughly 98 degrees Fahrenheit, but other properties of the liquid are not registered by its preceptors. Uexküll's terminology specifically evades issues of intentionality and subjectivity: the animal notices elements of the earth through preceptors and reacts to this world through its effectors. He explains, using a gastronomical example: "We are not interested in what taste sensations the raisins produces in the gourmet but only in the fact that they become perception marks of his environment because they are of special biological significance for him."[18] Contra Nagel's inquiry, Uexküll explains: "The relations of the subject to the objects of its surroundings, whatever the nature of these relations may be, play themselves out outside the subject, in the very place where we have to look for the perception marks."[19]

Consider, then, two brief examples from Uexküll that are suggestively rich in what shall be turned to next, the role of surfaces in human–animal relations as deployed by Snæbjörnsdóttir and Wilson. The first addresses the

immanence of the animal's world, and the second the wonder of such a world: "All animal subjects, from the simplest to the most complex, are inserted into their environments to the same degree of perfection."[20] One example is the spider and its web: "Every subject spins out, like the spider's threads, its relations to certain qualities of things and weaves them into a solid web, which carries its existence."[21] Giorgio Agamben, in *The Open*, comments on this passage by saying:

> The spider knows nothing about the fly, nor can it measure its client as a tailor does before sewing his suit. And yet it determines the length of the stitches in its web according to the dimensions of the fly's body, and it adjusts the resistance of the threads in exact proportion to the force of impact of the fly's body in flight. . . . [T]he most surprising fact is that the threads of the web are exactly proportioned to the visual capacity of the eye of the fly, who cannot see them and therefore flies toward death unawares. The two perceptual worlds of the fly and the spider are absolutely uncommunicating, and yet so perfectly in tune that we might say that the original score of the fly . . . acts on that of the spider in such a way that the web the spider weaves can be described as "fly-like."[22]

To call the spider and fly relationship "absolutely uncommunicating" misses the shifts in species over time and limits what we call communication. Arguably, the physical relationship is an important means of communicating that the spider seems quite satisfied with, the fly less so.[23] However, Agamben's larger point is well taken: the spider does not measure the fly's body, it just does its spinning. The animals are in a world that Georges Bataille characterizes as "like water in water," or a world so closely tied to the animal that it cannot hoist a ladder of transcendence and climb out. It cannot attain a verticality by which it would get outside its world to have a look around; in other words, the spider does not think "fly." The animal is trapped in "captivation" according to Uexküll; it lives on the surface of relations without self-conscious reflexive thought.

PLATE 1 Snæbjörnsdóttir/Wilson, *Jóra*, from *(a)fly*, Lambda print, 2005.

PLATE 2 Snæbjörnsdóttir/Wilson, *nanoq: flat out and bluesome,* installation at Spike Island, Bristol, 2004. Photograph by Woodley & Quick.

PLATE 3 Snæbjörnsdóttir/Wilson, *Halifax*, Eureka Museum for Children, Halifax, from *nanoq: flat out and bluesome*, Lambda print, 2004.

PLATE 4 Olly and Suzi, *Cheetahs,* 1998. Photograph by Olly and Suzi of their work, *Five Cheetahs.* Courtesy of Olly and Suzi.

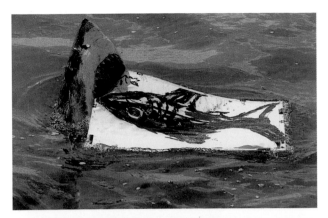

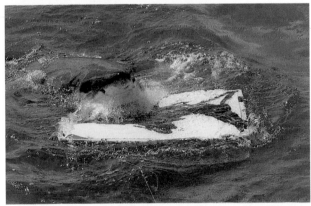

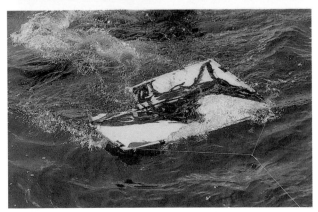

PLATE 5
Greg Williams,
*Shark I, Shark II,
Shark III,* 1997.
Photograph
of Olly and
Suzi's *Shark Bite.*
Courtesy of
Olly and Suzi.

PLATE 6 Olly and Suzi, *Fisi,* aquarelle and oil stick, 2006. Courtesy of Olly and Suzi.

PLATE 7 Marcus Coates, *Journey to the Lower World,* 2004. Video. Photograph by Nick David. Courtesy of the artist and Kate MacGarry, London.

PLATE 8 Marcus Coates, *Dawn Chorus,* 2007. Stills from the videos. Courtesy of the artist and Kate MacGarry, London.

Moving from immanence of the world for a fly, an immanence like water in water, to wonder, consider a passage from the opening of Uexküll's monograph on walking between human and animal worlds:

> The present booklet does not claim to serve as the introduction to a new science. Rather, it only contains what one might call the description of a walk into unknown worlds. These worlds are not only unknown; they are also invisible. . . . We begin such a stroll on a sunny day before a flowering meadow in which insects buzz and butterflies flutter, and we make a bubble around each of the animals living the meadow. The bubble represents each animal's environment and contains all the features accessible to the subject. As soon as we enter into one such bubble, the previous surroundings of the subject are completely reconfigured. Many qualities of the colorful meadow vanish completely, others lose their coherence with one another, and new connections are created. A new world arises in each bubble.[24]

In what reads like a hallucinatory vision, the animal world remains a place that can be translated to the human, but in doing so, it will be distorted. The translation is never quite right, and parts of the animals' worlds seem stubbornly resistant to our understanding. There is an important friction between our attempt to assimilate the animal world and its foreignness; moreover, should the animal world be taken seriously as meaningful rather than of lesser value than human worlding, then the hallucinations in this opening passage become quite disturbing for the human because it puts ontology and human valuation off balance.

Not all of Uexküll's work evades anthropocentrism. In fact, as we shall see in chapter 4, Heidegger (who borrows the term *Umwelt* from Uexküll) deploys precisely the anthropocentric moments in Uexküll that I am consciously omitting for strategic reasons in this chapter. Uexküll and Heidegger assume that the human world is larger than the animal world: "The animal's environment [*Umwelt*], which we want to investigate now, is only a piece cut out of its surroundings, which we see stretching out on all sides around the

animal—and these surroundings are nothing else but our own, human environment."[25] If only Uexküll had said that our perceptual space was "nothing but our own animal world," then things could have been different. Second, the illustrations for Uexküll's essay imply a privation on the part of animals. The beautiful image at the opening paragraph, where we step into a bubble, is a bit misleading: we are already in the animal's *Umwelt*, but don't see from its perspective; if we could, the "strangeness" that is suggested by Uexküll is not there. It is only there if the translation between *Umwelts* is not complete; that is, the animal's world is strange if we "see" it (that is, understand it) with human eyes and a human mind. Such human understanding brings us back to questions of interiority, human interiority, and comprehension.[26]

Overall, several lessons can be learned from Uexküll that will lead us along our own stroll:

- The world can be assessed through effects outside the subject. We can look for perceptual cues to understand the animal's world.
- The animal is fitted to its world such that there is no poverty of world for the animal as perceived within its *Umwelt*.
- The animal's world creates for us a sense of wonder. It is suggestively familiar and translatable, while in crucial ways remains stubbornly remote. Failures in translation create opportunities for reevaluating the privileged interiority of the human subject.

Based on Uexküll, I would like to suggest a particular means of inquiry for animal studies and assess its utility in relation to other ways of engaging animals. Readers will notice that in Nagel and Uexküll, the concern has been the meeting of two worlds, two *Umwelts*, two phenomenologies: the animal and the human. It is this site—the meeting, abutting, and jamming of two worlds—that is under investigation in each case: a site that produces thinking and that stretches the limits of thought and representation in novel ways. This is a move specifically contrary to a hegemony of vision and a privileged interiority of the subject.

Worlding

Philosophers Gilles Deleuze and Félix Guattari warn against figuring domesticated animals as oedipalized members of the family:

> individuated animals, family pets, sentimental, Oedipal animals each with its own petty history, "my" cat, "my" dog. These animals invite us to regress, draw us into narcissistic contemplations, and they are the only kind of animal psychoanalysis understands, the better to discover a daddy, a mommy, a little brother behind them.

We have socialized other species, brought them into our world, our *Umwelt*, and into our (psychological) dramas. We have, in brief, domesticated them. Snæbjörnsdóttir and Wilson's project *(a)fly* (2006) tugs at the tethers of domestication by which we bind select animals to ourselves.[27] Their work makes strange and unfamiliar the domestic scene where pets and humans live together. By re-presenting us with animal and human dwelling, the project invites viewers to think of the world of the animal, and to imagine the life of the animal in itself. How do these animals among us live, dwell, and think? What is their space—uniquely undisclosed—outside the confines of human narcissistic appropriation of the animal's world? Unlike wild animals or farm animals, pets live distinctly both within our world and in a space that is their own. *(a)fly* is poised at the horizon between these two worlds.

The way we think about animals establishes a particular way of seeing them in the world, in our world. What are its "secrets" that remain inaccessible to us? Domestic animals, "pets" as we are fond of calling (to) them, house for themselves seething multitudes of points of view that work below the surface of our own seeing like an open secret. An encounter with the animal is a moment in which we come to recognize an animal world, a moment when we are the object "over there." In this look from another species, we realize there are more points of view than our own, and that there are other optical and spatial phenomenologies than our all-too-familiar human ones; indeed, animals and humans occupy the same earth and spaces but have different

worlds, different *Umwelts*. *(a)fly* makes the issue of worlds even more pronounced because these animals physically share a very intimate place on earth with humans: the home. These animals, these pets, reside in our home, like a fly in our soup; but seen from other (animal) eyes, are we not in theirs?

In *(a)fly*, Snæbjörnsdóttir and Wilson photograph domestic spaces in Reykjavík though from a unique perspective. The photographs are of the spaces in people's homes where "their" animals dwell; these spaces may be a dog bed, a cat corner, a fishbowl, a pile of clothes under the stairs, and so on. The photographs do not include the animals—only their settings (Plate 1 and Figure 12). The absences of the actual animals haunt this work. We wonder, what sort of beast is it that would live here? Does it have claws or paws or fins, beak or muzzle, shell or fur or feathers or scales? Such musings invite

FIGURE 12 Snæbjörnsdóttir/Wilson, *Mosi*, from *(a)fly*, Lambda print, 2005.

us into the world of the animal. We begin to consider how the claws, paws, and tails maneuver in this venue and what they think about the environment around them. We ponder the animals' "interface" with the earth and in so doing, grant animals a face and a dignity of being. Therefore in these images, viewers must negotiate the often oedipalized human expectations of pets with the question of what the animals perceive. There is an uncomfortable fit between the animal's residual space in the human's habitat and the photograph that makes the animal's place central. Snæbjörnsdóttir explains that when they are invited into a home, they do not photograph the well-kept family rooms or the front facade of the house; rather, they photograph seemingly inconsequential corners, washrooms, stairs, and ledges—the places of the animals.[28] If the animal is considered to be at the margins of the family picture, then the images provided in (a)fly reverse the center and periphery: now, in (a)fly, these beasts that we let live with us begin to take over; they are the centers of their worlds, for which our domiciles are the periphery. Snæbjörnsdóttir and Wilson thus force the question: "From whose world (Umwelt) are we seeing this place?" No longer are we keeping the animal at a safe and objective distance for artistic representation and natural history observation; knowledge comes instead from the displacement of perspective, and from the uncomfortable haunting provided by the surface of another world that lingers as a remainder in our own.

Snæbjörnsdóttir and Wilson work in the margin between the animal world and the human world. They do not provide a perspective from the animal's point of view, nor solely from the human's. In this they differ from artists such as Per Maning, whose black-and-white video Breather (2000) depicts cattle in a field seemingly videoed from a grazing cow's point of view. With the photographs from (a)fly, we are suspended and left to wonder, to question what it means to dwell and just who is dwelling with whom? To appreciate the liminal in their work, it is worth considering how this art opens up the world of the animal but refuses to represent, to speak for, other species.

The diligent reader of Uexküll's work and the attentive viewer of (a)fly perceive the loss of unitary space and time and come to see that our own human

world is yet another bubble with distortions and omissions (Figure 13). Uexküll presents an infinite variety of perceptual worlds that are "manifold and varied as the animals themselves"; each animal species holds its own point of view and its own distortions of the actual earth. These perspectives reflect how the body of the animal has evolved over ages to adapt to the earth and meet the animal's needs. We are left with the understanding that there is no single unitary world, and no unified space or time; instead, time moves differently for each species, and each animal senses and shapes space quite differently. For our "pets," how long is the time between our going to work and our coming home? How are corners and ledges shaped for a cat, and shaped by it? Here in our most intimate place—our home—we find that our bubble and our world overlaps with another's.

FIGURE 13 Snæbjörnsdóttir/Wilson, *Snúlla Púkapúk,* from *(a)fly,* Lambda print, 2005.

There is an important reversal at work in the overlap of domestic *Umwelts.* Even as we have tried to domesticate animals, *(a)fly* looks into their dwellings and recalls the very animality within the human. These "pets" have animalized us as—in a perspectival shift—our homes become cultured animal dwellings in which we human animals bed with the fur and flesh of other beasts. Human dwelling is the joining of cultural refinement and basic animal needs. Fine furnishings reflect social decorum and (good) taste; yet at their most funda-mental level, the human bed, the fireplace, the kitchen all center around our animal nature. Introducing animals within the space of human dwelling com-plicates our own sense of place and sense of identity, of what it means to be a human animal. Displacement of perspective and disorientation provided by these images go to the heart of what it means to dwell. In English, the origin of the verb "to dwell" is the Old English word *dwalde,* meaning "to go astray." Perhaps Snæbjörnsdóttir and Wilson show us more clearly what it means to dwell by these seemingly stray pictures, these observations of the everyday-ness of animals' places among us. It is the familiar made wild, or the blurring of animal space and cultural space, that fits with these artists' overall projects.[29] Dwelling becomes "a stroll into unfamiliar worlds," including our own.

The haunting of this animal world, its spectral presence woven within our lives, is manifest not only in the images from *(a)fly,* but more so within the larger choices, interventions, and parameters of the project. Initially, the artists had conceived an *Animal Radio*—a proposed twenty-four-hour radio broadcast with the sounds of animals cutting through the airwaves. Snæbjörnsdóttir and Wilson describe this cycle of the project as

[a] programme of events [that] will include interviews with animal specialists in Reykjavík, from the pest-control department, to veterinary practices, hunt-ers, etc. It will also feature live interviews with passers-by, whom it is hoped will relate anecdotes about their relationship with their pets and indeed any other animals in their experience. At such times when there is neither a scheduled programme nor an interview going on, the station will air the sounds of indige-nous and non-indigenous beasts to be found in the City.[30]

The *Animal Radio* project was put off for logistical reasons, but it has returned (slightly renamed) in their latest work, tentatively titled *Pests, Pets, and Prey* (2008–9). The sounds of animals move through the airwaves as we sleep, and the noise can be heard if one has proper instruments and knows how to tune in and listen. Indeed, these bubbled worlds of the animal are already among us, and the one-night broadcast (like a temporary coup) simply highlights their presence. The dialogue with those who heal or kill animals—from veterinarians to hunters—extends the conversation. We hear from other humans in our language what it is like to be intimately tied to the life of animals. Layer upon layer of a multinaturalism builds. One can imagine how a hunter must enter into the animal world and the animal mind in order to stalk them, or how a veterinarian understands the curious habits of local beasts. The project takes on a sociological dimension as we hear the various and contradictory approaches to animals within the citizenry.

Later in his essay on the stroll through animal worlds Uexküll explains: "Through the bubble we see the world of the burrowing worm, of the butterfly, or of the field mouse: the world as it appears to the animals themselves, not as it appears to us. This we may call the *phenomenal world* or the *self-world* of the animal. To some, these worlds are invisible."[31] Inasmuch as the animals' worlds are unknown to us they remain a "nowhere," but as explored and recovered by *(a)fly*, the images reveal a "nowhere without the no." We cannot know this "no" through direct investigation and interrogation of the animal or its dwellings (its "going astray"); indeed, only by upending the groundedness of home and recalling the stray (animal) in our own dwelling can we obliquely glimpse another's abode. Tracking the animals' worlds, we can begin to understand an "outside us" that is in our very midst.

FLAT OUT

Snæbjörnsdóttir and Wilson's most ambitious project has been to hunt down all of the taxidermied polar bears of the United Kingdom, photograph them in situ, catalog their providence, and then gather as many of these bears as possible into a contemporary gallery space. They found thirty-four stuffed

bears (and have since uncovered a few more in private collections), and exhibited ten of them at Spike Island Gallery (Plate 2). As a project, *nanoq: flat out and bluesome* extends from the searching for and photographing of the bears, to the gallery exhibition, to gallery talks, and to publishing their work and the ongoing cataloging of new finds.

The work's title is a poetic pidgin language: *nanoq* is the Greenland term for "polar bear"; "flat out" has a double meaning, first referring to "the pace of the project and the particularity of trips we were making across and up and down the country in pursuit of the polar bear specimens," and second, "to the skin of the animal, after the killing or death and before the taxidermic process has been undertaken, which in respect of the project, constituted a pivotal space between 'nature' and 'culture.'"[32] The skin of the animal functions as a surface of contact and resistance. It is a veil: on one side is a living bear with its depth of world and life that remains unknown, while on the other side is the bear as perceived, captured, and killed by humans. The veil is torn, removed from its animal and placed within a cultural economy of meaning, geopolitics, and capital. Its very flatness as a surface marks the negotiation of *Umwelts* and the mixing of nature and culture. The skin will be appropriated as an object of natural history—a figure for science and education as well as for trophies and displays of power. The bear flattened in death—down and out and "bluesome"—is then hoisted into a cultural life through the scaffolding of the sculptural stuffing of the animal.

The taxidermied bear poses in the nineteenth century were often of the animal fully vertical, on hind legs and showing teeth and claws in a sign of power, or power conquered by human hunters. Such, for example, is the case with the two bears shot by Sir Savile Crossley, the first Lord Somerleyton, and that are on display as "guardians" of the vestibule of the Somerleyton ancestral home in Suffolk (Figure 14). The fur is no longer the flat surface of contact between human and animal worlds, with all the abrasiveness and frictions and productivity of such an encounter; it is now an object made vertical to match the metaphysical uprightness of human transcendence outside the world of animals and into the world of nature and rational thought.

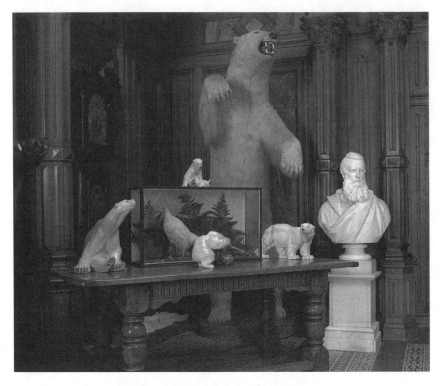

FIGURE 14 Snæbjörnsdóttir/Wilson, *Somerleyton* (one of a pair of polar bear mounts at Somerleyton Hall), from *nanoq: flat out and bluesome,* Lambda print, 2004.

These polar bear forms become "things trying very hard to be polar bears" or "renewed objects representing polar bear–ness" to and for a culture.[33]

At the same time that the skin is given a vertical (metaphysical) architecture, it is gutted from any animal interior and any animal worlding. The bear's world and worlding are replaced with straw, hay, wood timbers, and hollow sculpted forms. Over time, these manufactured interiors change to match cultural perceptions of the animal—from the beastly vicious and wild, to mimicking the stance and musculature of actual bears, to the Disneyesque (as with Lord Puttnam's bear of 1999). Baker unpacks the valences of these works:

It is also a space with both surfaces and interiors; as the artists have written, the spectacle of the bears presented a beautiful veneer beneath which lay a conundrum oscillating backwards and forwards between nature and culture, taking in all manner of aspects of human achievement, endeavor, cruelty and folly on the way.[34]

Through contact with this "veneer," the artists find a site of production:

Much has been written on the hollowness of souvenirs, their intrinsic sadness and the ultimate futility of collecting things by which we seek to remember places and events. . . . If we handle or knock expectantly on the surface of something stolen long ago, we can expect to hear the dull thud of its disembodiment, its unmediated physicality, in short, what it is—not what it was or what we think or thought it was. Or, if we listen more closely we may hear the ring and echo of a much larger set of truths, only one of which will be indicative of its current condition and only one of which will be, or correspond in part with what we thought its significance to be. We may find a multitude of narratives and interlocking fragments, redolent not only of what has transpired, its dislocation, journey and its second life, but inevitably, if only by implication, of what else might have been.[35]

The whole of *nanoq: flat out and bluesome* is this knocking at the surface of an animal world. In the case of these polar bears taxidermied over the last 200 years, the rap against the world produces a hollow sound. It is the "bluesome" sound of "what else might have been" in the now-inaccessible past of this particular animal's world and the uncertain future of the species. The "multitude of narratives" is possible only through preventing the "unmediated physicality" of the animal surface from being appropriated by any particular cultural narrative—as trophy, conquest, science, violation, or even kitsch.

By not giving in to any particular set of narratives, Snæbjörnsdóttir and Wilson show a restraint that allows space for the "nowhere without the no" of an animal world. They happen upon glimpses of such a world throughout

their hunt for stuffed bears from 2001 to 2004. Particularly haunting are the lantern-slide images from Sir Savile Crossley's 1897 polar venture unearthed by the present Lord Somerleyton and first printed for the *nanoq* project. While at Wiches Land near Spitsbergen, Norway, the expedition killed fifty-five bears and captured two for zoos. In the slides, light contacting the film has exposed a moment of another space and time and a foreign (seemingly alien) way of being in an extreme environment. Shooting the bears with a camera captures and preserves them and their moment of contact with humans.[36] The images foreshadow the more deadly rifle shots that will subsume the animal life—consume its life within the human world.[37] The concept of *exposure* here is crucial: the animals are exposed through photography, but also they carry a physical exposure and vulnerability that haunts all that happens to the animal body—from the event of the photograph, to the shooting, skinning, taxidermy, and afterlife as sculptured remains.

In several of the bears cataloged by Snæbjörnsdóttir and Wilson, the bullet holes are still evident.[38] The scars of the event by which they enter into our cultural life—their entry into a human world—become unseemly reminders that they occupied a space and a worlding outside of human culture. As Gary Marvin notes in his essay for the *nanoq* project:

> Prior to the shots which kill hunted polar bears they had a corporeality of their own—one which was their own concern—the hunter intrudes and attempts to make them his own. . . . The embodied bear was necessary for there to be a hunt but now its body is unnecessary for the next transformation and for the beginning of its new, cultural life. The organic, fleshy body stands in the way of that transformation and must be removed and discarded. All that is needed to create or recreate the polar bear is its surface—taxi (arrangement)—dermi (skin). It emerges from a disembodied bear with its "bear-ness" somehow hovering close to its skin.[39]

The surface yields witness to the animals' exposure. Indeed, the surface has always been the site of exposure, the place of interface for the polar bear and

its world. It is not that the animals have "a corporeality of their own" in the sense of self-reflexive possession. An interiority of the animal world serves as a pitfall for the animal as much as it does for humans. Rather, it is on the surface that the polar bear's worlding and terrain develops. In the case of *nanoq*, the surface of the animal and the animal's *Umwelt* has abutted the asymmetrical force of the hunter's world. Of the bears amassed in the United Kingdom, the more tattered and worn ones, the unseemly ones and ones with seams undone, rupture the taxidermic illusion of a liveness and recall the history of their production (Figure 15). They unravel to another time and space that is no longer—a nowhere, but yet a haunting of "what else

FIGURE 15 Snæbjörnsdóttir/Wilson, *Blair Atholl* (polar bear skin over wooden support), dated 1786, from *nanoq: flat out and bluesome*, Lambda print, 2004.

might have been" and what elsewhere in the globe still is—an animal world unfathomed by human huntings.

Snæbjörnsdóttir and Wilson photograph the polar bears in their afterlife in natural history museums and private collections. Some gather dust in attics; the bear at the Eureka Museum for Children in Halifax is covered by a rug and props up a bicycle (Plate 3); the Somerset bear stands in an alcove while holding a basket of flower-shaped lights and wearing a fez. Their worlding has gone "flat out and bluesome." Unlike the lantern slides of Victorian explorers, the artists' photographs, as well as their staging of the exhibition at Spike Island, not only expose the bears, but also expose the humans. We become aware of how we enframe animals within our world. The adept viewers see their vulnerability in the rough seams and the unseemly enframing. Without the didacticism of Hirst's work, viewers quietly become aware of "the physical exposure to vulnerability and mortality that we suffer because we, like animals, are embodied beings."[40] It is in such moments of disorientation—a dwelling and wandering—that we find a space for animal worlding amid our own world.

One of the trademarks of Snæbjörnsdóttir and Wilson's work has been that while they engage with the question of animals, they do not produce representations of living animals in their work. So, for example, in nanoq there is no animal but representations made by hunters and taxidermists. By omitting any interaction with live animals, the artists put aside the most difficult of questions—how to discuss the event of encounter itself—and leave in its place a series of anthropological investigations of human representations of animals. Their work is, perhaps, less about animal encounters than the human representations in the wake of such an event. The potency of the event itself is mourned in these works where we see the poverty of the taxidermied skin (in nanoq) and the emptiness of the pet's home without the animal in the picture (in the (a)fly project).

COMMUNITY

I should like to end this chapter with a brief reflection on the issue of community, a concern developed in subsequent chapters' discussion of pidgin

languages. Snæbjörnsdóttir and Wilson's work is process driven. They log many long days talking with a variety of people whose lives intersect those of the animals under investigation. Certainly in *nanoq* they talked with museum curators and taxidermists, but also with hunters, anthropologists, and private collectors. In their more current work, *Uncertainty in the City* (2010), they talk to a range of people in Morecambe Bay, from a man who feeds pigeons, to pest exterminators, to city planners and architects. This work, shown at the Storey Institute and Gallery in Lancaster, considers the variety of discourses and physical effects of wild animals living in urban environments. In their conversations with a range of concerned citizens and animal experts, it becomes evident that the urban animals are perceived variously as pests by some, and as wildlife to be enjoyed or preserved by others. This friction of the animal world bumping against the human is highlighted by the differences within the community, which is aired on the *Radio Animal* (2009–10) full-day program broadcast locally and online. Amid these differences in discourse and their material and policy implications, the world of the animal fractures as much as it draws together the human world. Snæbjörnsdóttir and Wilson work in the openings created by this abrasive abutting and overlapping of worlds. Their art is a rope across an abyss of differences between the various human and animal worlds.

Ralph Acampora characterizes the urban animal environment as a "somatic society of species." In his essay on phenomenology and animals, "Bodily Being and Animal World," he uses what phenomenologist Maurice Merleau-Ponty calls "world flesh" to describe what it would mean to "be in the world" with other species. Shared climaticity, or general feel of space (flesh of the world), creates a living with, or *Mitsein*. In his example, he describes the sensate and aural sharing of a New York park with cicadas in the "sweaty hours of afternoon" when space is indeed thick and fleshy; yet there is little exchange between cicada and human. There is no contact, and there are no marks or remarks on each other's worlds. Rather, the human hears the animal at a distance, and the animal remains stubbornly oblivious to the human. They share a space and a climate, but they do not negotiate an economy of

signs or physicality. While both human and cicada feel the weather in their own way—with sweat or song—neither barters with the other.

Acampora's phrase "somatic society of species" then deserves some adjustments.[41] Societies are founded on exchange. The term itself—*society*— purports a unity among citizens. Acampora admits that this unity is rather tentative, or what he calls a "fractious holism," borrowing the term from Jane Bennett. He goes on to qualify his claim by explaining that "terrestrial carnality (world–flesh/earth–home) is not experienced as an undifferentiated or placid whole. Rather it is fraught with all the existential tensions arising out of its spatio-temporal division into relatively individuated organisms and biomes."[42] He suggestively extends this existential tension to the "skin-boundary" as a "surface of contact."[43] Yet while Acampora points to the cracks or fractures evident between what Uexküll would call different animal *Umwelts,* he does not explain how this results in a holism as a society, a community and its operations. It is worth investigating how raw physicality can be more than proximity; it can be an economy of exchange, a notion I'll pursue further in chapters 4 and 5.

We have seen the internal division and fracturing in the figure of the satyr. At the level of community, the *communis*—or that which circulates or is held in common—itself fractures around the rapport with animals and the abysmal interiority of what Derrida calls "the animal that therefore I am." Snæbjörnsdóttir and Wilson expose these fault lines as their art presents the haunting specter of animal worlding and our negotiations with these animal worlds. Be it domestic pet, beastly polar bear or urban critter, the artists record and reflect on the various human discourses and discords these animals and their *Umwelts* stir within the community. Snæbjörnsdóttir and Wilson risk a certain fragility in their opening to an animal worlding. They risk folly of pursuing spaces of the nonhuman and bringing these worlds into dialogue with the *communis.* And they risk the social discord that follows in the wake of introducing and highlighting the animal worlds among us—alien worlds on an earth we share with them. The artist work reveals as well that the animals risk and are at risk through a variety of ways human dwell among them—be it in the arctic, in urban streets, or at home.

﹥[4]﹤

Contact Zones and Living Flesh

Touch after Olly and Suzi

This chapter pursues the following premise: that which is most animal, in-cluding the biological element of the *animal rationale,* lives on the surface of things, and the animal with its surfaces is an overlooked site of productive meaning. Animals are said to be poor in thought; they have little interior reflection and consequently little by way of selfhood and no means of attain-ing transcendental thought. Therefore, to take up the animal means valu-ing that from which we differentiate ourselves: the animal and its life on the surface. I am interested in imagining how the surface as a theoretical space occupied by the animal has a productivity and meaning different from the privileged self-reflection of the human subject; in other words, how does the animal and its noninteriority produce thought differently? How might we value surfaces, despite the overvaluation we place on the transcendental heights of culture and the well-being of our interiority? As a means of inves-tigating this problem, I will make a place for two surfaces over the course of this chapter: the surface of canvases, and the surface of animal bodies.

Surface includes material surfaces: canvases, paper, the visible and tactile exteriors of animal and human bodies. Surface also refers to the means of thinking and productivity removed from the interiority of the subject. Taking surfaces seriously reevaluates the derogatory claim that animals have only im-poverished interiority and thus live on the surface without the self-reflexivity

of thought. Traditionally, the human subject is either valued according to a transcendental—as in the Good for Plato—or through an interiority—such as Descartes's *cogito* or Kant's Copernican revolution. Thinking along surfaces yields a different sort of ontology from heights, depths, and interiors: it is thought without recourse to a transcendental method of valuation (what I am calling human heights and depths) and without privileging the interiority of the human subject (but rather situating the exteriority of surfaces against the interiority of the subject).

For artists Olly and Suzi, the exterior animal surface is a site that refuses to be blithely subsumed as content for expression or consumption; in its sheer physicality, the surface of the animal body resists taking part in the functional structure of human meaning. Their art suggests alternative economies of relation to animals. In the work of Olly and Suzi, sheets of paper and body surfaces are the place where animals leave their marks by biting back, as it were, and provide a glimpse at a world other than our own—a world outside of human enlightenment and enlightening. Rather than paint in a studio, the artists work in the "wilds," the domain of the animal where they paint the animal's form on paper; they encourage the animal to interact with the paper as well.[1] Their paintings offer a surface for human–animal exchange, where the human animals and animal animals trade marks (Plate 4). These works on paper counter traditional animal portraits used to discern and promulgate the cultivation and enculturation of animals within human culture. Animals move from being enframed by art and culture to being unframed. At the outermost limits in thinking of their work, Olly and Suzi's paintings suggest a rethinking of what marks of significance mean within the economy of art, language, and culture. This chapter addresses how their work suggest another sort of writing, another (minor) language, and a unique means of (re)presenting animals.

Inside Out

Vision mediated by cultural codes enables the circulation between canvas and the animal bodies. Because the fundamental means of evaluating and

categorizing animals for natural history and agriculture from the sixteenth to the twentieth centuries is by their lines and surfaces—that is, by what can be seen—artists have a privileged position in translating the wilds to culture.[2] With a primacy placed on line and form by breeders, the artist is able to employ his skills toward creating a visual argument for the value of an animal. In painting, the animal's qualities become evident at one glance: one can simply look at animal portrait paintings to see the desired traits. Natural history inquiries were conducted not only through pelts and specimens, but also through illustrations that featured the primary characteristics of the animal. Of course, it was the various human classification systems for animals that decided what constituted the primary and secondary traits of an animal as, for example, in the Linnaean system. In agriculture, animals were bred according to traits determined to be valuable by both the breeder and market where the animal was to be consumed. Artists' portraits of the beasts provided proof of these traits. You doubt that an ox can weigh 2,400 pounds? Why, simply look at the neck, the shoulders, the dewlap, the fine ribs, and so on (Figure 16). Lest the two-dimensional image not convince, the inscription of dimensions at the bottom of many paintings and prints will advance the point.

Yet more important than the visual representation itself is the *spacing* that takes place in the act of codifying the animal. The artists, scientists, and farmers judge the animals while maintaining distance between themselves and their objects of inquiry. Furthermore, the eye as window positions the viewing subject as a human with privileged interiority, in contrast to the outward surface of the viewed object—the beast's corpulence. Through sight, we possess in our minds the animal that is seen from a distance.[3] The animal surface is contrasted with and co-opted by the human, who uses his own reflexive interiority (that is, "thinking") to divide the animal surface into categories and traits of interest. These traits are then projected schematically onto the body of the beast. In the example of cattle bred for slaughter, the animal becomes the meat chart, and so turns the animals inside out as so much flesh for (intellectual and physical) consumption. Because these animals are

FIGURE 16 Whessel, after John Boultbee, *The Durham Ox*, 1802. Engraving. Museum of English Rural Life, University of Reading.

not considered to have an interiority, which is the unique quality of humans, and because they do not speak in our language, their inside is already made an outside, a mere surface to be exposed for human use.[4] How might the surface be rethought in a way that does not simply maintain the distance between the knowing human (artist, natural history scholar, farmer, and consumer of animal flesh) and the object of study?

Outside Out

Again, let us suppose that it all takes place on the surface—that is, after all, what we are told about animals, isn't it? They have no eternal soul and no substantial interiority; they are, as Heidegger says, "poor in world."[5] Because

they supposedly have no interiority and thus no place for philosophical thought, animals don't think like we do; in their life without depths, they don't know they are going to a slaughterhouse—they don't even know they are animals! Of course, why should they be required to know these things?[6] *Animal* is our word, a human word for all that crawls, slithers, creeps, stalks, and walks the earth—other than ourselves, of course, or at least that part of ourselves that is not the least—namely, that which is culturally recoverable from our animal bodies.[7] I would like to think through—no, *with*—the animal surface, the literalism of the surfaces and the material bodies both as they have been used historically to determine the animal's being from the distance of culture and how surfaces collapse the heights (and transcendental impositions) of cultural appropriation of the animal. If, as the Nietzschean aphorism goes, truth is a metaphor of which we've forgotten it is a metaphor, then surfaces deflate both the cultural scaffolding of metaphor and of truth by returning thought to the site where bodies meet. In this collapse of cultural cache, material surfaces offer a means of thinking about humans and animals outside the hegemony of the privileged interiority of the human subject. The suggestion here is that surfaces offer no retreat to an Archimedean point within the human that is removed from exterior events and used to leverage (in thought) the rest of the world. Without such a distance or remove, there is nowhere else to go, no chance to remove ourselves in ways that rationalize our superiority "over" or "above" other animals. In brief, the long-standing philosophical assumption that animals live only on the surface, and the negative valuation that follows from this, can be turned as a positive site for production.

Heidegger's work on the notion of world proves an important starting point where we can cut our teeth before moving elsewhere. His sense of a limited animal world—animals "poor in world" compared to human world building—encapsulates much of philosophy's history with the animal question. Agamben situates Heidegger as "the last to believe (at least up to a certain point, and not without doubts and contradictions) that the anthropological machine, which each time decides upon and recomposes the conflict

between man and animal, between the open and the not-open, could still produce history and destiny for a people."[8] Heidegger shepherds the animals through an "anthropological machine" of thought, or Dasein, that "decides upon and recomposes" animal being by selection and division, a cutting up not evident—offstage—in his laying out of his position. He has decided the results of his philosophical gambit in advance by the grounding in anthropocentrism.

Heidegger's most discussed topography of the animal's world appears in his 1929–30 seminar published as *The Fundamental Concepts of Metaphysics*: "the stone is worldless; the animal is poor in world; man is world-forming."[9] Animals certainly have environments (*Umwelt*), but they are not aware of their environments in the same way that humans are. Derrida summarizes Heidegger's position by explaining: "As for the animal, it has access to entities, but, and this is what distinguishes it from man, it has no access to entities *as such*."[10] Heidegger's lizard, for example, sits on a rock and enjoys the sun, but it does not know the rock as rock, nor sun as sun. Heidegger goes so far as to explain that "[w]hen we say that the lizard is lying on the rock, we ought to *cross out* the word 'rock' in order to indicate that whatever the lizard is lying on is certainly given *in some way* for the lizard, and yet is not known to the lizard *as* a rock."[11] The animal is caught up in its series of relations to other entities without an ability to remove itself from the "captivation" that such a series presents.

Heidegger draws his notion of an animal world from Jakob von Uexküll, a founding figure in ethnology and semiotics who was discussed in the previous chapter. In his work *A Foray into the Worlds of Animals and Humans*, Uexküll moves beyond mechanistic biology to develop a line of inquiry into the animal's sense of its surroundings—something close to an animal phenomenology.[12] For Uexküll, the animal's environment is constituted by the "carriers of significance," or "marks," which captivate the animal. All other elements in the world drop off and have no place in the animal world, or what Uexküll calls *Umwelt*.[13] Thus Heidegger's lizard may know a warm surface though he does not register the rock as rock nor the sun as sun; instead, the

animal functions within a world that has carriers or marks of significance. Caught within the series of relations that is their *Umwelt,* animals simply cannot get outside their surroundings to look around.[14]

By way of contrast, the human world has manic-depressive heights and depths—from Plato's ascent out of the cave to Empedocles's refusal to climb out and instead to dig in, and dig deeply.[15] It is human uprightness—ver-ticality—that sufficiently dis-places us from our surroundings so that we can see the rock at a distance—a rock as rock. Animals do not have this dis-tance: "Their whole being is in the living flesh," as J. M. Coetzee explains.[16] As Derrida has explicated in *Of Spirit,* "world" is for Heidegger only possi-ble for humans—those beings who have spirit. As much as they are poor in spirit, animals are left "poor in world." The "uprightness" of humans is both physical and metaphysical, while the animal world is decidedly flat. Without heights and depths, the animals are left with marks on the surface; these marks are a "cross out" that (re)marks in our language the place of their relations.[17] To consider animals and take seriously the role of surfaces to thought and language means to reevaluate the physical and metaphysical uprightness of humans.

Gilles Deleuze, in *Logic of Sense,* counters the verticality of Plato and Empedocles with the horizontal animality of Diogenes: the cynic philoso-pher "is no longer the being of the caves, nor Plato's soul or bird, but rather the animal which is on the level of the surface."[18] Known as the dog of Athens, Diogenes lived on the surface. If he wrote anything, none of it survives. We have only anecdotes: he ate without discernment whatever he happened upon in the streets, masturbated in public, took to insulting his contempo-raries, and lived in a tub. Plato could not coax "the dog" into a dialogue, a conversation meant to invite Diogenes within the Academy, where he would be refuted by the masters of language, Plato and Socrates. Fed up with words, always more words, Diogenes would offer his detractors food—something to stuff their mouths with and stop the babble of culture. Food could stop the philosophical abstraction and recall the animal body of the speaker. Fredrick Young, in his essay "Animality," explains:

Plato had no *idea* how to deal with Diogenes. For Diogenes refused to argue on Platonic grounds, refused dialectics and the rational "voice" that goes with it by means of which "man" speaks. With Diogenes, there's a different modality of argumentation, if we can even call it that, the performative and animality. The Diogenic is more than a literal abject attack on Plato. More significantly, Diogenes' strategies are irreducible to any modality of dialectics or philosophy proper. Again, what we have is the problematics of the surface, of animality— a physiognomic performance that unleashes the performativity of animality into the Platonic landscape and architecture.[19]

The performative *is* thought for Diogenes; his actions with his body in space are his thinking. This is the literalism of surfaces without retreat to a Platonic architecture. In like manner, Coetzee, in *The Lives of Animals,* explains that "the living flesh" of the animal is its argument. When Coetzee's protagonist Elizabeth Costello is asked if life means less to animals than to humans, she retorts that animals do not respond to us in words, but rather with gestures of the living flesh. Its argument from its flesh is the animal's "whole being."[20] Like Coetzee's animals, the world for Diogenes is not that of the culture that surrounds him and that seeks to incorporate his corpus, if he would ever get around to writing one. Instead, he offers corporality—bodies and surfaces that evade the manic depression, the heights and depths, of his contemporaries. It comes then as no surprise that Diogenes lived his life in exile from Sinope, his birthplace.

Diogenes' performative thought indicates an-other world, something other than the distanced observation by which humans understand an environment through a privileged interiority and reflexive consciousness.[21] Collapsing heights and depths to surface, there is no space for interiority and reflexivity. In this collapse, Diogenes sides with the animals. While for Heidegger animals are benumbed to the possibility of seeing objects in themselves, the animals *do* see and interact with the world around them; if not a Heideggerian clearing—reserved for humans—then is it possible that animals have some other sort of clearing and revealing available to them and not to humans?

Even Heidegger, in addressing the poverty of the animal, must admit this. The living flesh of animals is not "something inferior or that it is at a lower level in comparison with human *Dasein.* On the contrary, life is a domain which possesses *a wealth of being-open, of which the human world may know nothing at all.*"[22] If human knowledge is that of distances and interiorities (our heights and depths), it is possible that one way of knowing that has been closed off to us is that of surfaces—a space where animals have often been relegated in their "poverty."[23]

The gambit in this chapter is that there is an animal clearing or "open"on the surface of things and the performance of surfaces. Stated in another way, I am experimenting with the possibility that the "poverty" of the animal and its lack of interiority or depth is a site of productivity and a different economy of meaning. While it remains stubbornly difficult to enter into the perception of animals, humans can come to know the world of the animal through their own contact with the corporality of beasts and humanity's own animality. Amid human worlding, a raw physicality can pull us away from the privileged interiority of the subject and point the way to an-other relationship. Uexküll marks out the terrain of this relationship with his notion of animal *Umwelt* and its carriers of significance. Within this terrain are two facets that I have outlined in this chapter: an animal "open" of which, as Heidegger says, "the human world may know nothing at all," and, despite the unknowable, positive interactions expressed by Donna Haraway (as mentioned in chapter 3) and explored by Bateson, Goodall, Bekoff, and Smuts. The unknowable has its economies, relations, and productions such that Haraway and Heidegger, in this case, can find a meeting point. The figure of this meeting point could be Diogenes, who refused to engage in a mastery of language found in the Academy—where language and thought distance us from the object of study, and from this distance allow us to evaluate beings. Despite his refusal to enter the Academy, Diogenes still "speaks" through positive interactions of silences and performance.

It is under the context of physicality, surfaces, and performance that the work of contemporary artists Olly and Suzi gains currency. Their paintings

jostles the *Umwelt* of the animal and the world of the human through the particular set of parameters under which these paintings are executed. This British artist team works in the environment of animals under conditions that threaten and impede on the human as they execute drawings of the animals. From the arctic to African deserts, the two artists place themselves in extreme environments—sites that are at the limits of human dominion, and are more likely the center of the animal's domain and world. In a shark cage, squatting within range of a polar bear, a few paws' length from a lion, the artists work "hand over hand" with one artist's hands over top the other's while creating sparse, strong, moving lines in the shape of the animal before them.[24] The artists feel "helpless" and "out of our depths" by working within the environment of the animal, rather than in the familiar terrain of an artist's studio.[25] Working in the animal's terrain produces a sense of fear that becomes important to Olly and Suzi's art: "Fear plays a vital role in our art-making process. We are constantly challenged by and confronted with environments and animals, especially predators (polar bears, white sharks, big cats), that trigger adrenaline, a primal response that alerts us to the potential of imminent danger." They further explain: "The knowledge we gather [about the animal] arms us, but fear is still present; a warm glow, keeping us warm."[26] Fear is something that rises to the surface that keeps the artists in contact with that surface, preventing them from slipping into an interiority of selfhood that would provide a safe haven and at the same time a danger to their bodily well-being while in the realm of beastly animals.[27]

As Olly and Suzi work at the surface, their physical presence becomes one of the marks within the animal domain. They are one of the carriers of significance, captivating the animal from within its world. From the animal's world the artists are a marked surface, while from the human's world the animal body is a surface to be illustrated. One surface meets the other, between which paper is spread out. The blank space of the paper is fair game from within the worlds of both humans and animals. The artists draw from within the domain of the animal and "encourage the animals to interact" with the paper.[28] A white shark bites off a corner, a leopard tears at the cloth, an

anaconda slithers across the surface, leaving a mud-stained track (Plate 5 and Figure 17). The animal as surface and human as surface leave their marks on a mutual environment of paper that has become the outside, the outer margin or limit of each domain, where the outside finds a way out of a limited *Umwelt* and becomes evidence of a much larger world. The outside limit becomes the site of production and possibilities.[29]

Their work is a performance. The making of their art is part of the art itself and gets documented in photographs taken by Greg Williams, Olly's brother, who accompanies the artists in their travels. The paintings are not something to be executed at a distance from the "object" of study, as in natural history

FIGURE 17 Greg Williams, *Anaconda on Painting*, 2000. Photograph of Olly and Suzi's *Green Anaconda*. Courtesy of Olly and Suzi.

animal portraits; instead, the artists are caught within the world of the animal, and the spacing of space or distance is collapsed. Furthermore, like Diogenes, their actions disavow the linguistic markers of the dialectic and the academy, with humans on one side and the animals (caged) at the other.[30] Up close to the animal, another language develops through a repetition in drawing a muzzle, ears, a paw: "Once we've done many, many, many drawings of the same subject, we suddenly get our own language and focus on certain areas."[31] The posture and face of the wild dogs drawn in Tanzania, for example, develop over the course of encounters. Rather than focusing on detail— the art of natural history—Olly and Suzi develop caricatures that highlight and heighten features such as facial markings that are prominent within the moment of drawing (Figure 18). The language of these drawings take place within the immediacy of an encounter with its particular animal and human

FIGURE 18 Ron Broglio and Fredrick Young, from *Animality,* detailing Olly and Suzi's studio *Wilddog Works,* 2007. Still from video.

poses and forms; it is less the cutting up of the animal into parts, and more the development of noticing the animal's comportment alongside the artists' comportment in this space and the handling of materials in this zone of contact between species.

CONTACT

The larger world that humans and animals create in alliance with one another can be considered a "contact zone." The term comes from Mary Louise Pratt's *Imperial Eyes,* where she uses it to describe the "social spaces where disparate cultures meet, clash, and grapple with each other, often in highly asymmetrical relations of domination and subordination."[32] The grappling between humans and animals forms a topography much like the space described by Pratt. With Olly and Suzi, for example, such topography is an actual relation between bodies—a marker or carrier of significance of each other's body from within their respective domains. The marks cross, and cross out, until there is a space negotiated and shared between human and animal through their re/marks. Such re/marks take on the character of a hybrid language similar to the origins of Pratt's term:

> I borrow the term "contact" here from its use in linguistics, where the term contact language refers to improvised languages that develop among speakers of different native languages who need to communicate with each other consistently, usually in context of trade. Such languages begin as pidgins, and are called creoles when they come to have native speakers of their own. Like the societies of the contact zones, such languages are commonly regarded as chaotic, barbarous, lacking in structure.[33]

It is exactly the asignifying scrawls across the paper spread out by Olly and Suzi that bear witness to and constitute the pidgins and forked tongues of the animal–artist alliance.[34]

It is not that Olly and Suzi have drawn animals; rather, they have formed alliances that become the agents of painting.[35] Most importantly, the artists

talk about respect for the animal—a respect that makes alliances possible. They glean from experts in the field the various information needed to survive within the *Umwelt* of the Other: How far to stand from a polar bear? How to not look afraid in front of a large cat? How to handle an anaconda is a knowledge leading to physical comportment, a manipulation of their own body surface in relation to the animal's. Olly and Suzi's physical bearing in the world of the animal, and how the animal reacts to their actions, serves as a syntax for the pidgin language between species.

It is certainly possible to read the work of Olly and Suzi as a naive, hopeless effort to engage animals in a project of which the animals have no interest. Is the paper really a contact zone, or is this a naive view of transspecies communication? Perhaps they are simply baiting the unwilling animal participants for a theatrics of value only (or mostly) to the humans concerned in the project. While the art and artists are vulnerable to such critique, their interests lie with other questions. The artists themselves consider their work with predator species as a way of bearing witness to endangered ecological chains that sustain the predators and that the fierce animals help constitute; as such, it is a project of ecological awareness. Increasingly, their work has highlighted the environmental landscape that bears the weight of these predators, and suffers under the weight of human incursion.

Perhaps the hazy romanticism of engaging animals resides in the notion that the art is an alliance. Baker counters this argument in part by considering the authenticity or earnestness of the project, a sincerity that produces something new rather than taking refuge in art as satire or irony.[36] My own interest is in how this art shows a concern for human and animal phenomenologies. Humans and animals share the same earth but live in different worlds. What, then, are the possibilities of thinking at the edge of the human world, at the place where it bumps up against the animal's world? What happens where the surface of skin and scales meet? Negotiating this meeting place, this contact zone, requires that the artists momentarily suspend or leave behind much of the world of culture and acquire new gestures and a different awareness of their bodies before the body of the Other. They do not place

themselves in absolute danger as a sort of stunt; rather, they negotiate the space by using some technological elements of culture (wet suits, shark cages, special paints, and so on) and some cultural awareness of various animals' behaviors, but also, as I'm emphasizing here, by relying on bodily movements and the physicality of the environment. Thus, for example, when encountering a polar bear, the artists have the technological equipment of transportation, warm clothing, paints that will not freeze too quickly, and a camera to document the event. However, they also must rely on knowing the proper proximity to the animal, how to crouch down, and how to maneuver in the snow.

Each of the sections in *Olly and Suzi: Arctic Desert Ocean Jungle* is filled with tales of how they navigated extreme environments. Details of bodily motion—buoyancy underwater, cautious wading in the marshy domain of an anaconda, rapid brushstrokes in the −40°C weather of the polar bear's icy habitat—are more than adventurous tidbits meant to titillate admirers back home; motion and environment contribute to the individuality of the pidgin language, and the space in which this language is formed. Rather than an imposed form, pidgin language created between species arises from tentative gesturing, assertion of ground, meanings conveyed or missed; the lack of structure creates possibilities, but also threatens collapse of all meaning. Contact zones bring together physicality and linguistic exchange in order to create new tentative meanings and temporary societies.

Density and lightness, slowness and speed, thick and thin are states of being inhabited by the lines on paper, the flight and repose of the animals, and the corporality held by the human–animal alliance. The surfaces and bodies refuse signification, and in doing so they take us elsewhere, to the "poor in world" of the animal that is rich in its own textures: "*signification may be undone,* with both literal and metaphorical attempts to fix meaning giving way to 'a distribution of states'; and that *individual identity may be undone,* with both human and animal subjects giving way to 'a circuit of states.'"[37] The paintings bear witness to the "distribution of states." The hand-over-hand method of the artists, along with the interaction of the animal, diffuses the agency of the artwork and creates an event structure.

ECONOMY OF RELATIONS

Crossing and marking: the artists' bodies cross into the animal's world and become carriers of significance in that world. The privileged interiority of the human subject unfolds, unravels, becoming more like paper spread out than a selfhood and more like an element than a person. Following Uexküll, Olly and Suzi can say that *we are markers of significance in a world that is not our own* as a whale shark glides along the length of Olly's body, a great white shark bumps the diving cage, an alligator's tail pushes against Suzi's hand, a snake's scales rub against their skin. The animals leave their marks. Double-crossing: being astute to the way animals work within their terrains, Olly and Suzi do not give in and give themselves up to the animal. They understand enough to maneuver in the animal world; they also know how to use a blank white surface. Let the shark bite the paper and the anaconda slither across it (Figure 19);

FIGURE 19 Olly and Suzi, with Greg Williams, *Anaconda on Painting,* 2000. Photograph of an unidentified Olly and Suzi work. Courtesy of Olly and Suzi.

the paper will record one of the many crossings in the "inky, impenetrable darkness." The recording becomes the double cross, the betrayal and portrayal of an event that cannot be fully captured but that leaves traces of its passing. The paper bears witness to the event. In a gallery, it functions like a map indicating an experiential terrain that has been traversed. The painting on paper is both presence and absence, a production and a loss of the actual event. It points to the animal's "wealth of being-open, of which the human world may know nothing at all." The artists have extended themselves to the limits of the human world to bump up against this wealth. As viewers, we stand in the shadows of this Other and foreign openness, and we wonder at its surfaces.

Who is making the work of art? Who signs it, and in that signature invests the art with language and value? Contrary to Heidegger's insistence, one does not need "hand" to write. For Heidegger, the hand (in the singular and in its singularity) functions like the distance of the artist's gaze and the natural historian's eye in animal portraiture: hand allows humans both to be in touch with things and to manipulate them from a transcendental distance. Derrida explicates Heidegger's hand in "*Geschlect* II":

> The nerve of the argument seems to me reducible to the assured opposition of *giving* and *taking*: man's hand *gives and gives itself, gives* and *is given*, like thought or like what gives itself to be thought and what we do not yet think, whereas the organ of the ape or of man as a simple animal, indeed as an *animal rationale,* can only *take hold of, grasp, lay hands on the thing.* The organ can *only* take hold of and manipulate the thing insofar as, in any case, it does not have to deal with the thing *as such*, does not let the thing be what it is in its essence. The organ has no access to the essence of the being *as such*.[38]

The shark biting into a canvas certainly seems to want to take hold of the thing, to grasp it. The animal organs, including the human animal's organs, fail for Heidegger to "give" and allow themselves to be given over to thought. The nudging and bumping and gnawing of animals show a relationship between

an animal and its environment. Heidegger wants to cut short this relationship and cut off any opportunity for the claw or paw to be hand—for Heidegger, relationship is not thinking. As Derrida figures Heidegger's hand, the hand becomes shorthand for metaphysical thinking, an investment in the human's ability to speak in our language. Heidegger's hand writes itself as human only. Yet what is thought if it is not the relationships among things made visible? Or even the ability to ask this question about relating, the ability to think of the distance between objects? The animal, in marking a canvas, doubles the double crossing: its mark is both the relationship between teeth and canvas, fur and white surface, scale and paper, and is the visible sign of this relationship. It is both mark and re/mark at once. The canvas is made useful and purposeful within the *Umwelt* of the animal. As such, the animal uses the canvas as "hand" to write and think with and to think on, like a scratch pad.

After a decade of working together, in 2003, Olly and Suzi expanded their art to include some studio painting. While still painting in the wilds, their *New Elements* work allowed them to use paper and canvas as a palimpsest of ecological elements encountered in various excursions. As they explain these works:

> The "elements" relate to the key similarities and incongruities we have experienced whilst working in a wide variety of remote habitats with indigenous peoples and endangered animals. They include the key elements of survival, hunting, shelter and the fragile coexistence of man and beast. As with our ongoing site-specific work, New Elements utilise both clarity and ambiguity to convey the storytelling of an experience.[39]

The best of these works create a temporal duration of an excursion and layer scenes that reveal an event as well as the veil of its passing and inaccessibility. The viewer cannot reason out all the iconography of this pidgin language, but as bits and pieces make narrative sense, the painting intrigues and resists; in short, the painting conveys the wonder of an animal and an environment (Plate 6). A number of these works include the death of animals or

destruction of an environment. Guns, bullets, hooks, arrows, and knives all cut through these canvases as an imprint of human encroachment. Viewers see worlds collide and the struggle for domination over and against another *Umwelt*. When some of the *New Elements* bring a too-easy narrative closure for the viewer, the works become didactic. The balance of translatability and the untranslatable makes the best of these works an extension of Olly and Suzi's experiments in *Olly and Suzi: Arctic Desert Ocean Jungle*.

Contact zones and pidgin language leverage a rift within the human between the cultural humanity of man and our animality. It is our cultural humanity that creates manic-depressive heights and depths that distance us from surroundings. Nevertheless, the animality of man beckons:

> It is possible to oppose man to other living things, and at the same time to orga-
> nize the complex—and not always edifying—economy of relations between
> men and animals, only because something like an animal life has been sepa-
> rated within man, only because his distance and proximity to the animal have
> been measured and recognized first of all in the closest and most intimate
> place.[40]

Olly and Suzi circulate within this "economy of relations between men and animals." They are able to cross over to the "wealth of being open" in the "poor in world" of the animal, because of the "diabolical art" by which their animal bodies mingle with other elements in the animal *Umwelt*. As part of the event structure that is their art, the artists ply their animality: they think orca, great white, and anaconda in order both to be a part of the animals' worlds and to double cross these worlds while bringing something back, a scratch pad of animal–human surfaces that circulates in a double economy as a marker of significance for animality and culture.

Throughout this chapter, surfaces are shown to have a power of production by leveraging their negative place in philosophy to think outside of typical philosophical architecture, which privileges human interiority over and against objects of inquiry. At the heart of this chapter is a claim by Coetzee's

character Elizabeth Costello, who explains that animals don't think like us or speak like us, but rather "[t]heir whole being is in the living flesh."[41] I have employed Uexküll's biosemiotics of *Umwelt* to further Costello's claim about the flesh of animals, as well as the visceral and tactical qualities implicit in the notion of "living flesh." If, as Coetzee claims (through Costello), there is something meaningful in the living flesh of the animal, and if Uexküll's work bears this out, then what are the implications for the visual arts?

Turning to a notion of *living* flesh changes the animal from an object of cultural consumption into a meaningful agent with an *Umwelt*. One way of exploring this *Umwelt* is by taking philosophy at its word and thinking with the poverty and "mere" surface of the animal. Because the world of the animal as a world remains foreign to humans (or as Thomas Nagel says, we will never know "what it is like to be a bat" from the bat's perspective), we can only know the animal through surfaces. We know it through contact with the surface of the animal and the surface of the animal's world, or "bubble," as Uexküll explains. Olly and Suzi work with the animal surface, its living flesh, as well as the surface of the animal bubble as it meets our own in contact zones. Their resulting marks on paper are instructively different from animal portraiture and the history of animal painting. These pieces of paper have circulated in a human–animal economy and bear witness to an animal world. This witnessing is not a knowing and consuming like cattle portraits that subsume the animal and its world and subsequently deprive animals of a space outside of human understanding. These works leave the mystery of the animal and its world intact while calling attention to its existence.

⇥[5]⇤

A Minor Art

Becoming-Animal of Marcus Coates

Past chapters have traced a path from the satyr to animal worlds and the pidgin language that develops when these worlds mark and re/mark upon each other. Having gone thus far in meeting the animals and their worlds, it would seem folly to go further. Of course, it is exactly this folly against reason, as laid out in the opening chapters, which now legitimates an inquiry into becoming-animal. The human–animal hybrid of the satyr explored in chapter 2 seems to necessitate a becoming. The potency of becoming-animal is evident in chapter 4, where Diogenes—the Dog—and his performative philosophy counters Plato's dialectics by a thinking with the living flesh. Thought emanating from the Dog troubles the civil relationship represented by Plato's Academy—it invokes an unsightly animality within the human. Diogenes risks becoming *bête*, bestial and dumb, the village idiot; however, it is a knowing idiocy that will dupe common sense and lead thought elsewhere.

A "knowing idiocy" is the topic of this chapter; it will bring us to "becoming-animal" as expressed in the philosophy of Deleuze and Guattari. Such becoming leads through issues of civility and the common sense that binds community. The artwork of Marcus Coates juxtaposes civility and animality in a way that elucidates and furthers the concept of becoming. It is now rather commonplace to describe his work in relation to the terms of Deleuze and Guattari,[1] though rarely do such descriptions provide an extensive

look at "becoming," and few notice how Coates has extended the terms in ways unforeseen by philosophy. Of particular interest are his revival of a Scottish and Scandinavian folktale of seals becoming human, his various shaman ritual works of descent into "the lower world" of animal spirits to answer human dilemmas, and *Dawn Chorus* (2007), in which various humans as "local birds" of a community make bird noises.

Idiocy and the Abyss

Derrida, in "The Animal That Therefore I Am (More to Follow)," explains what it means to follow the animal. As one might expect in this philosopher, the term *to follow* has several valences: he is in pursuit of, or following, how animals affect philosophy; further still, he is interested in and so follows the animality of the human—"the animal in me and the animal at unease with itself."[2] He is also after—pursuing and belated to—"the ends of man": the humanist subject has already fallen from its heights under the pressing relationship to our animal nature, by which "[c]rossing borders or the ends of man I come or surrender to the animal."[3] Fundamental to Derrida's essay on animals is the concept of "crossing borders" between animals and humans, and between the humanist notion of the subject (agent) and the loss of such a metaphysical position.

The fissure or abyss between us and the animal figures is central to Derrida. He insists that such a border between us and other animals, and even our own animality, is a common proposition that itself need not be explored:

> For there is no interest to be found in a discussion of a supposed discontinuity, rupture, or even abyss between those who call themselves men and what so-called men, those who name themselves men, call the animal. Everybody agrees on this, discussion is closed in advance, one would have to be more asinine than any beast *[plus bête que les bêtes]* to think otherwise. . . . The discussion is worth undertaking once it is a matter of determining the number, form, sense, or structure, the foliated consistency of this abyssal limit, these edges, this plural and repeatedly folded frontier. The discussion becomes interesting

once, instead of asking whether or not there is a discontinuous limit, one attempts to think what a limit becomes once it is abyssal, once the frontier no longer forms a single indivisible line but more than one internally divided line, once, as a result, it can no longer be traced, objectified, or counted as single and indivisible.[4]

Initially, I would like to focus on the spoken assumption that "[e]verybody agrees on this, discussion is closed in advance, one would have to be more asinine than any beast to think otherwise." The sentence brings out some key terms. There is a tautology to this argument that says that everyone agrees there is an abyss except for those who disagree, but they do not counts because they are "more asinine than any beast." Derrida uses "everybody" as a figure for common sense. Anyone who fits within this culture and its un-articulated values held in common is sufficiently sensible to know there is a difference between humans and animals. We might say that "common sense" throws itself—that is to say, it projects itself as its own ground by which it then makes claims that everyone knows and so remain unquestioned.

In *Difference and Repetition,* Deleuze explains how common sense throws itself: "conceptual philosophical thought has as its implicit presupposition a pre-philosophical and natural Image of thought, borrowed from the pure element of common sense. According to this image, thought has an affinity with the true; it formally possesses the true and materially wants the true."[5] Derrida notes that the discussion is "closed in advance"; in other words, there is a hermeneutic circle surrounding the question of the animal. One either possesses common sense and so is in the circle, or is without sense, is "more asinine than any beast" and so outside the circle of thought about the animal. What is closed to the bestial and asinine humans is any "discussion" of animal nature. This discussion is closed because anyone speaking without common sense would be speaking nonsense—one would have to be an idiot to think otherwise, to think differently. It is the role of such a village idiot to help those who have common sense measure their sensibility against the yardstick of his idiocy: "we" are not like him; therefore, we are sensible.

The idiot's stubbornness and wrong-headedness recalls Diogenes, who refuses to dialogue with Plato in the Academy because the master of dialectics will have a home field advantage against the Dog as an outsider and one who refutes common sense as a ground that grounds itself.[6] In *The Postmodern Animal,* Steve Baker calls such idiocy the "creativity of nonexpert thinking." The expert knows and follows the rules for correct thinking and production; because the nonexpert does not know the rules he or she is breaking, such an out-of-sorts person can create something new and different. Baker summarizes the power of the outsider by quoting Derrida on invention: "An invention always presupposes some illegality, the breaking of an implicit contract; it inserts a disorder into the peaceful order of things, it disregards the proprieties."[7] Baker goes so far as to claim that such a nonexpert can blur the expert lines between "human completeness" and the unraveling or "opening up" of the human, the "self."[8] In breaking common sense and the sensibility that holds us as a community in common, one already is an idiot—*bête,* a beast.

To follow the possibility of creativity by way of idiocy incurs risks. There is the possibility that such nonsense is just that—inarticulate and meaningless blather. It is always possible that such a collapse of distinction between inside the hermeneutic circle and outside, between meaning and nothingness, will produce an undifferentiated noise, a worthless heap. The gambit heightens the fragility of the artist, who becomes vulnerable to forces both within the social circle and outside in the wild. If the artist's work works, it shifts the fragility from the artist and the art to the unstable nature of the hermeneutic circle and its investment in a language of common sense and reason.

Minor Art

As seen in the last two chapters on animal worlding, the difficulty set upon by artists has been that humans and animals share the same earth but occupy different worlds. This difference—what Derrida calls an abyssal fracturing between human and animals—serves as the site of productivity for the artwork of Bryndis Snæbjörnsdóttir and Mark Wilson, as well as for Olly and

Suzi. As examined in the last chapter, the friction between the human and animal worlds, and the abyss between them, serves as a contact zone or "social spaces where disparate cultures meet, clash, and grapple with each other, often in highly asymmetrical relations of domination and subordination."[9] Mary Louise Pratt uses the term "contact zone" to describe "improvised languages that develop among speakers of different native languages who need to communicate with each other consistently."[10] The concept of "becoming-animal" extends how an improvised language and pidgin language might develop in the contact zone between humans and animals.

Gilles Deleuze and Félix Guattari can provide a way of thinking about pidgin language. Their book on Kafka introduces the concept "minor literature" in ways that will be useful for thinking about a contact zone. They view Kafka as a writer who "marks the impasse that bars access to writing for the Jews of Prague." He must negotiate the zone between the Austrian, German-speaking majority and his Jewish community. Kafka has found a way to turn "their literature into something impossible—the impossibility of not writing, the impossibility of writing in German, the impossibility of writing otherwise."[11] As a Jew in Prague, Kafka is out of sorts; he does not quite fit into the German-speaking Austrian world. This is his "impasse that bars access"; it is the bar of common sense, civil sensibility, that prevents Kafka from entering into the hermeneutic circle of good citizenship and sensible writing. According to Deleuze and Guattari, Kafka takes this weakness and from it, forges a "minor literature" to work against the linguistic and social bar that makes his writing impossible.

One of the features of this minor literature is the move from metaphor to metamorphosis. Later, in A Thousand Pleateaus, Deleuze and Guattari will prominently characterize this shift as "becoming." The good metaphor and obedient literary image works because of a social agreement based on selection, which signals the proper relationship between vehicle and tenor. The well-regulated metaphor manages elements to be included and those to be discarded in the relationship between vehicle and tenor. Thus, for example, we understand the phrase "words cut like razors" because common sense

selects the "sharpness" of words and razors as a trait shared between the two terms, the tenor and the vehicle. Good sense—the sensibility of selection—prevents us from suggesting that if words are like razors, one could shave with words. Literature, the "good" literature that uses metaphor properly, is the luxury of an established class and political group. Undermining metaphor becomes the revolutionary gesture of minor literature because it seeks to overturn implicit social values.

Pidgin languages botch or misplace the proper relations of metaphor between vehicle and tenure. By doing so, "we are no longer in the situation of an ordinary, rich language where the word dog, for example, would directly designate an animal and would apply metaphorically to other things (so that one could say 'like a dog')."[12] The result is the death of

> all metaphor, all symbolism, all signification, no less than all designation. Metamorphosis is the contrary of metaphor. There is no longer any proper sense or figurative sense, but only a distribution of states that is part of the range of the word. The thing and other things are no longer anything but intensities overrun by deterritorialized sound or words that are following their line of escape.[13]

Sound or words—or even, one might add, gestures and bodies—lead us away from established social configurations, away from metaphors that we have forgotten are metaphors and are now inscribed as social truths. We are led instead to meanings and marks of signification whose selection is based on the hybridity of two worlds being negotiated tentatively and temporally. Whereas metaphor puffs up meaning, making it redolent with multiple values, a minor literature flattens meaning; it is the site of the surface of one world meeting another, and is immanent to a particular place and time within a particular set of quasi-social exchanges. Most powerfully, "[l]anguage stops being representational in order to now move toward its extremities or its limits."[14]

Deleuze and Guattari provide an example that is useful for the purpose of "becoming-animal":

It is no longer a question of resemblance between the comportment of an animal and that of a man; it is even less a question of a simple wordplay. There is no longer man or animal, since each deterritorializes the other, in a conjunction of flux, in a continuum of reversibility. Instead, it is now a question of a becoming that includes the maximum of differences as a difference of intensity, the crossing of a barrier, a rising or a falling, a bending or an erecting, an accent on the word. The animal does not speak "like" a man but pulls from the language tonalities lacking in signification; the words themselves are not "like" the animals but in their own way climb about, bark and roam around, being properly linguistic dogs, insects, or mice.[15]

Man and animal are linguistic subjects only within a properly established language. Once a "minor literature" begins dismantling the common-sense ground on which meaning is established, man and animal become fragile signifiers that may run astray or "deterritorialize." They become available for "asignifiying intensive utilization of language."[16]

Animals challenge language and representation that too often purports to be disembodied thought. To think alongside animals means to distribute the body of thinking, creating a distribution of states or plural centers for valuing, selecting, and marking/making a world. Deleuze, in *Difference and Repetition*, works against the power of representation, the power of major literature, and, one might add, established aesthetics:

> Representation has only a single centre, a unique and receding perspective and in consequence a false depth. It mediates everything, but mobilizes and moves nothing. Movement, for its part, implies a plurality of centres, a superposition of perspectives, a tangle of points of view, a coexistence of moments which essentially distort representation.[17]

Here, representation is a false depth that coincides with the false depth of human interiority, both of which serve as a retreat from contact so as to stage a coup. In other words, representation and interiority attempt to assimilate

difference, and to value and select from the Outside or the Other on the basis of their own criteria. Representation tries to *eat* the Other, as Hegel or Hirst might say. To make thought move and to do real work at the horizon of the unthought, representation should, following Deleuze, create a friction, reciprocity, and exchange between the human symbolic system of representing and the physical world shared with other creatures—the marks and re/marks of various *Umwelts*. In *Kafka: Toward a Minor Literature,* Deleuze and Guattari chart out how metamorphosis flattens language, and consequently how words can be retooled to disassemble social valuation and hierarchy.

If it is not already obvious, it is worth mentioning that while Deleuze and Guattari focus on literature and words, their concept of a minor literature can be used equally well in terms of art—with its established major art, its metaphors, its hierarchies of signification, and its privileging of the singular artist and his expression of the interior humanist subject. If, unlike literature, art has abandoned representation, it does not abort a mission for human expressiveness and the value of well-articulated ideas. Becoming *bête,* becoming the idiot and animal, creates a site or zone outside of major art and its grounding.

Much of Coates's artwork involves community. More specifically, he examines small or marginal communities through disrupting social conventions with animal worlds. While the role of community is clearly evident in his shaman rituals, in light of the role of animals and becoming, it is worth first turning to his earlier work, *Finfolk* (2003). In this video, Coates emerges from a sea bank dressed in athletic wear; he dances, gesticulates wildly, and spouts an inarticulate stream of words that sound something like a hybrid of Scottish, a Scandinavian language, and English cursing (Figure 20). When he spots a human family strolling along the quay, he zips up his coat and descends back into the water. Moments later, the family spots a seal bobbing in the ocean.

Coates is revising folklore about amphibious creatures who change form and interact with humans. According to Scottish folklore, the finfolk are mysterious shape-shifters who travel from their underwater world onto land in order to cause havoc. They are said to abduct humans and force them into servitude; they take young women and make them brides in their underwater

FIGURE 20 Marcus Coates, *Finfolk,* 2003. Video. Photograph by Mark Pinder. Courtesy of the artist and Kate MacGarry, London.

world. The myth of finfolk is related to that of the selkie, a creature found in Icelandic, Irish, and Scottish mythology. The Scottish word *sealgh,* or *selch* or *selk(ie),* means "seal." These creatures take on human form by shedding their seal, or selkie, skins, and conversely become selkie by resuiting into their skins. Many selkie stories are romantic tales of a lover knowingly or unknowingly marrying a selkie. In "The Secret of Roan Inish," a farmer captures a selkie for a wife and locks away her sealskin in order to keep her in servitude and prevent her from returning to the sea. "The Grey Selkie of Suleskerry" is one of many ballads collected by Francis James Child and printed in his Victorian collection, *The English and Scottish Popular Ballads.* Coates's athletic suit is a wry stand-in for the seal skin. Unlike in the legends, Coates as a finfolk is rather awkward on land: some moments he seems uncomfortably out of place, while at others he dances haphazardly on the shoreline. He is neither threatening like the finfolk nor seductive like the selkies.

Coates looks like an idiot; his words as a finfolk do not make sense: "Frik frak fuk fuk fo," and on he goes; the story line of the piece does not match the myths. In short, what is he doing out there, out on the quay, on the shoreline where the human-made walkway meets the beating of nature's waves? It is precisely this nonsense that is the fulcrum by which Coates leverages and jostles the human and animal worlds—a leveraging not through verticality of reason, but rather by immanence and mixture between *Umwelts.*

Recall Deleuze and Guattari on metamorphosis:

> It is no longer a question of resemblance between the comportment of an animal and that of a man. . . . The animal does not speak "like" a man but pulls from the language tonalities lacking in signification; the words themselves are not "like" the animals but in their own way climb about, bark and roam around, being properly linguistic dogs, insects, or mice.[18]

Coates puts out a very poor imitation of a seal designed to deflate metaphor and analogical comparisons. The work flattens meaning by baffling the viewer's ability to make sense of how the piece fits within analogy and within

Scottish folklore. And yet the title insists that indeed this is *Finfolk*. The insistence of the title becomes its own ground and jabs at the hermeneutic circle, which grounds itself while erasing its tracks. If Coates looks foolish, if his yammering tells us nothing, and if the work itself remains inscrutable, it is all to the purpose of creating an "asignifying intensive utilization of language."[19] His words do not signify "like" the animals, but do roam and bark and climb. Their value is in the intensity of the performance. The camera focuses on just his mouth frothing with spit, spitting out nonsense syllables, showing his not-so-vicious teeth and tongue (Figure 21). The sounds become "intensities overrun by deterritorialized sound or words that are following their line of

FIGURE 21 Marcus Coates, *Finfolk*, 2003. Still from video. Courtesy of the artist and Kate MacGarry, London.

escape."[20] By the end of the work, the sounds and wild antics lead back to the sea and its dark veil from which Coates emerged. The whole of the video work is but a glimpse at the unintelligibility of the Other and a wonder at its wandering.

Throughout *Finfolk* the idiocy makes us laugh, but in this laughter we are caught: we stand within the hermeneutic circle that gets the joke, and outside the circle through a sympathy with the wayfaring seal-man who seems decidedly outside the social and hermeneutic circle. The sympathy is necessary to get the joke but is abandoned to be able to stand within the circle by which we laugh. The audience is on a quay—a borderline between the unintelligible waves of nature and the manmade banks hoisted against erosion of the landscape. The laughter becomes a moment of deterritorialization (an abandonment of being inside or outside the social terrain) that works against reason and echoes the frothing, spitting mouth, and asignifying language of Coates the seal-man. Refusal to laugh acquiesces to the tyranny of reason; inability to laugh signals our own idiocy at not getting it, not being in the strange and stretched circle that contemplates human and animal worlding simultaneously. A laughter from the belly trumps the consumption of the world by reason.

Yes, "[e]verybody agrees on this [abyss between humans and animals], discussion is closed in advance, one would have to be more asinine than any beast to think otherwise."[21] Yet the minority who are not counted within the social circle of "everyone" remain sufficiently *bête* to "think otherwise." Yes, it is a "thinking" to "think otherwise," but a thinking sufficiently dull-witted to cleverly flatten the major literature, major art, and major language upon which "everybody" depends. The sublation, or *aufhebung*, of reason never counted on being outwitted by that which it rejects outright—idiocy, dullness, and the animal. The animal, Diogenes the Dog, and Coates will never beat reason at its own game, and therefore Coates has taken his toys and tools and moved elsewhere. In doing so, he makes language move, deterritorializes it. He repurposes the mouth, the tongue, the athletic suit, even his glasses (so commonly a sign of nerdish knowledge).

Deleuze and Guattari conceive of minor literature as political. Because the minority cannot win at the majority's game, those not within the circle of "everyone" must go elsewhere. Unlike the liberal democracy that authorizes the power of the individual subject, a minor literature and minor art work by "[a] movement from the individuated animal to the pack or to a collective multiplicity. . . . There isn't a subject; *there is only a collective assemblages of enunciation.*"[22] In global politics, Iceland, Ireland, and Scotland are not the major players, being important only insofar as they abandon any past that would link seafaring with sea creatures and humans with animals. Coates calls up this collective and selectively tucked-away past not as a nostalgic ballad, but as a site of intensity that can trouble the political majority by "thinking otherwise," by thinking with another minority, the animal.

ECOLOGIES OF THE FUTURE

It would a bit of idiocy to think of Coates's work only under the placeholder of the *bête.* The artist makes use of quite a few character/concept positions. Complementary to the blunt surface of thought, a thinking without depth, this nonexpert also takes on the role of shaman in *Journey to the Lower World* (2004)—a role that coincides with Deleuze and Guattari's notion of becoming and the role of the sorcerer.

Throughout their chapter "Becoming-Intense, Becoming-Animal, Becoming-Imperceptible . . . " in *A Thousand Plateaus,* Deleuze and Guattari write a series of "memories" from different perspectives, including those of "a Naturalist" and "a Sorcerer." The two characters are played out against each other in order to illustrate their concept, "becoming." Throughout the chapter, the juxtaposition between these characters concerns issues of structure. The naturalist maintains a transcendent structure for sorting out the various flora and fauna he encounters: "Natural history can think only in terms of relationships (between A and B), not in terms of production (from A to x)."[23] Differences between the two items, A and B, are mediated by a standard held by the naturalist from a transcendent position outside of the system of divisions by which A and B are compared. In contrast, the sorcerer works against

the ideal type (of natural history) by using packs of animals and by promoting unnatural conjunctions and hybrids. We have seen a similar dynamic in chapters 1 and 2, where Francis Bacon's natural history in the first chapter contrasts with the hybridity of the satyr in the second.

The sorcerer displays a new mode of agency that differs from the objecthood of animals dissected by the naturalist:

> There is a mode of individuation very different from that of a person, subject, thing, or substance. We reserve the name *haecceity* for it. A season, a winter, a summer, an hour, a date have a perfect individuality lacking nothing, even though this individuality is different from that of a thing or a subject. They are haecceities in the sense that they consist entirely of relations of movement and rest between molecules or particles, capacities to affect and be affected. When demonology expounds upon the diabolical art of local movements and transports of affect, it also notes the importance of rain, hail, pestilential air, or air polluted by noxious particles, favorable conditions for these transports. Tales must contain haecceities that are not simply emplacements, but concrete individuations that have a status of their own and direct the metamorphosis of things and subjects.[24]

Haecceity is a Latin term for "thisness," which Deleuze and Guattari borrow from the medieval philosopher Dun Scotus as a way to express "nonpersonal individuations."[25] The sorcerer is one who is haunted by the "capacities to affect and be affected." With *haecceity,* the philosophers set up the thickness of an event with its complex relationships in time and space: "Climate, wind, season, hour are not of another nature than the things, animals, or people that populate them, follow them, sleep and awaken within them. This should be read without a pause: the animal-stalks-at-five-o'clock."[26] A whole ecology resides in the moment of an event—crucially, not a foreseeable event, but one that arises through "demonic" or diabolical arts; that is to say, it is not an event within the common sense of the community, the consensus. It is an alternative sensibility that assembles these affects and allows something new

to appear, which is not quantifiable or comparable as a series of known or knowable elements "in terms of relationships (between A and B)"; instead, the event as truly something other than the predictable line of causes and affects produces something new that takes us away from the familiar, creating a line of flight "in terms of production (from A to x)."[27]

Not unlike Deleuze and Guattari's sorcerer, in *Journey to the Lower World*, Coates plays the role of the shaman. He dons a deerskin complete with head, gleaming eyes, and prominent antlers. When a Sheil Park building in Liverpool is set to be destroyed, he offers to talk with the animal spirits of the lower world on behalf of the residents. Coates is not looking to save the building— newer homes will be built for the residents; instead, he seeks a communal cohesion amid the turmoil by consulting the wisdom of the animal spirits of the lower world. He creates an event that helps the displaced citizens think outside of the known status of their fate and consider a larger economy of relationships between humans and the nonhuman world.

Wrapped in his shaman's deerskin, Coates roams the streets and park near the housing complex and cleanses one of the building's apartments as a sacred site by vacuuming it with a Hoover and spitting water from a Safeway bottle. He dances with jingling car keys tied to his shoes while a cassette tape of drums plays in the background. His antennae-like antlers knock against a lamp and almost get caught in a curtain. He stumbles in a trance state from spinning in circles (Plate 7). To the "sensible" "everyone," to the Western Everyman, he looks like an idiot. Again he subsumes the role of the non-expert outsider, "the artist who insists on the fidelity of his amateurism"[28]; again he is on the margins—in this case, between the world of humans and that of the animal spirits; again he performs unintelligible gestures that are meant as a pidgin language; again he is vulnerable, at risk.

On the night before the ritual, Coates ponders the risks:

Lots of things worried me, such as questions of ethics, appropriating rites from another culture, setting myself up as a medium, my lack of training. And would it work as an event: Were the residents [of the housing complex] going to turn

up? What would their reactions be? Some of them were elderly, they might be seriously scared. Would they be insulted, call me a charlatan, think I'm taking the piss? Even worse, would they think they were being duped? They might tell me to fuck off. What sort of questions were they going to ask me? How the hell would I explain the ritual. What if I can't get down to the Lower World, should I just make something up?[29]

Coates bravely places himself in these fool-hearted positions; the audience feels this same tension. As in *Finfolk,* the audience is caught between the seriousness—the authenticity of the endeavor—and the sheer absurdity of a postmodern, new-age, weekend shaman.

Upon emerging from his journey, Coates tells the residents what happened. In his spirit walk, he descended in the elevator at the center of the building complex; it reached the ground floor and kept descending. The doors opened onto a cave complex where, one after another, he met various animal spirits. He carried with him the questions given by the residents: "Do we have a protector for this site? What is it?" One after another, the animals rebuff his approach, pointing him elsewhere. He calls out to them: the moorhen ("prr prr prr"), a coot ("ouw ouw ouw ouw"), a stag ("oargghhh oargghhh oargghhh"), and a fallow deer hind ("á á á á á á á"), even a curlew ("wwwhhhhhaaa") and a rook ("jrr' jrr' jrr'"). Despite the calls, none of them want to know the questions. Finally, he finds a sparrow hawk and calls to it: "kek kek kek kek kek." The bird shows him one of its wings, but oddly, its feathers are moving independently so that it cannot fly. The bird begins to shrink and becomes long like a snake or stick until it disappears. Coates as shaman surmises that "these feathers were you, and you should really get as close knit as you can. It was like they were saying[,] well: your protector is the group in a way, that is the thing that's going to look out for you."[30] During the trance and the animal callings, the expressions of the residents looking on vacillate among awe, surprise, and laughter. When the conversation turns to what Coates saw, the residents earnestly try to fit his vision into their understanding of the community and its future. It seems that the risk Coates took in this ritual has paid off.

Coates is able to assemble an environment by his disarming demeanor and the oddity of his new-age shamanism, yet also by the strikingly eerie and earnest otherworldliness. Coates's cameraman explains: "Marcus whirls and writhes oblivious to our world, shaking and screaming the noises of life. I am not ready for this; I feel shocked at the rapid transformation; the animal noises are guttural and real and don't belong in a block of flats in Liverpool."[31] The performance suggests that there is another world parallel to ours though out of our reach—veiled, but very much alive with creatures. The shaman translates between these worlds and brings to our awareness the possibility of a future other than the one contained "in a block of flats in Liverpool." It is not that Coates looks to solve the residents' problems, but instead points to the future's future; that is, he points to a future that is impossible within the circumstances of the life we have assembled. Yet it is a future imaginable to the one who is able to assemble diverse elements into a haecceity.[32] It is not simply intended to inspire hope in the residence nor serve as an opiate of the masses to help them forget their unfortunate circumstances; rather, it suggests that there is a world and a way of being that has yet to be co-opted by the current state of affairs. Its nature is that of an event—that which is absurdly different from our mundane lives and the oppression of common sense. Coates in his deerskin with antlers stands at attention on a street corner, walks through a park, waits for an elevator, infusing these everyday sites with an otherness and with an impossible future (Figure 22). His art invites us to join him in this line of flight "in terms of production (from A to x)." The opacity yet possibilities of this unknown x capture participants' imaginations and help them to think otherwise.

Becoming-animal is not about Coates taking on characteristics of any particular beast; becoming is not an exercise in mimesis: "These are not phantasies or subjective reveries: it is not a question of imitating a horse, 'playing horse,' identifying with one, or even experiencing feelings of sympathy or pity."[33] Becoming is the opening up of a general economy, a flow of powers and relations—what Deleuze and Guattari call "assemblages and affiliations." It is not that Coates ever becomes a particular animal, a moorhen, coot, stag,

FIGURE 22 Marcus Coates, *Journey to the Lower World*, 2004. Video. Photograph by Nick David. Courtesy of the artist and Kate MacGarry, London.

curlew, or sparrow hawk; rather, the environmental economy of relations is opened up so that he is able to pass through these states and attributes. "The self is only a threshold, a door, a becoming between two multiplicities," such that Coates as the nonexpert is able to occupy various sites or thresholds and pass through them in an ongoing becoming.[34] The grunts, whines, and whimpers are moments of intensity—a circling of the sphere of various animals.

Deleuze and Guattari warn not to be trapped into a false naming and know-ing about animals—the claim made by natural history: "We fall into a false alternative if we say you either imitate or you are. What is real is the becom-ing itself, the block of becoming, not the supposedly fixed terms through which that which becomes passes."[35] Spinning away from the human and navigating various animal identities, the artist has more of a sense of the fragility of fixed terms than we do in our mundane world. *Journey to the Lower World* tugs at the worn threads of our restricted economy of relations with the world around us.

It is just such a restricted economy that Coates seems to knowingly manip-ulate. The most common question audiences ask him is whether or not he actually sees and talks with animal spirits or whether it is all just a show and veils of theatrics. Is his becoming-animal simply a sly wink-and-nod game in which he leverages cultural desires for communication to advance his own artistic ends? In doing so, the artist is well aware of the social econ-omy in which he functions. Yet put under question, Coates never fully admits that the shaman ritual is only a show. By all appearances, something seems to be going on, and according to most of Coates's conversations, there is at least a glimmer of a "journey" taking place. The undecidability could be blithely dismissed as inauthentic showmanship for the consumer, yet Coates is sin-cere in is ambivalence. That is to say, he wants to have it both ways and wants to keep his audience in the state of unknowing as long as possible.

Coates continues to don the deerskin and journey to the lower world in *Radio Shaman* (2006) and *Kamikuchi "The Mouth of God"* (2006). In *Radio Shaman,* Coates visits the town of Stavanger, Norway, and asks its citizens what problems he might help them solve through his shaman ritual. More than any other issue, residents were concerned about the recent influx of prostitutes from Nigeria and West Africa. Coates performs a shaman ritual at the city's cathedral, then another at the political council offices, and finally on the streets frequented by the prostitutes. In these rituals, the vision of a seal becomes important. On a local radio program, he announces the results of his ritual. In going to the lower world, he saw a stranded baby seal wanting

to return to its parents in the water; it is too frightened, however, to allow Coates near enough to help it. This unsolved problem of the animal spirit echoes the problem for Stavanger's citizens, though it is not a simple analogy in which the seal equals citizens or the seal equals prostitutes. Instead, it is an alternate world where an animal suffering and estrangement calls to Coates, and through him, to the citizens of the town. In feeling the animal's pain and confusion, citizens can then emit and extend empathy within the social realm of the human world. The solution is not clear, but Coates has unleashed a pathway of affect that otherwise remained hidden.

In *Kamikuchi "The Mouth of God,"* Coates visits the Ikebukero district of Tokyo and stages a shaman ritual as part of the Ikebukero Arts Festival. After consulting with the local arts council and the government, he presents this question to the animal spirits: What should be done regarding illegal bicycle parking? For this ritual, Coates dons the postmodern wardrobe of contemporary Tokyo by merging both Japanese and American pop culture (Figure 23): he wears a white Marilyn Monroe dress, high heels, and blonde wig; a taxidermied rabbit protrudes from the wig; he sports large 1970s rock-star sunglasses; around his neck is a ruffled collar made of Japanese yen. The drumbeats of his shaman trance are mixed with trance house music. Behind him on a large screen is a video of his shaman dancing to house music, along with stills of the stuffed rabbit. The performance seems absolutely absurd, yet hauntingly authentic. In his shaman event, Coates assembles the environmental economy of cultural mash-up that is Tokyo. In his trance, he sees a thousand deer locking antlers as part of their social bonding. Coates tells his arts festival audience that bicycles should be allowed to be parked anywhere. This friction of illegal bicycles is part of the social negotiations that make the community stronger.

In his shaman rituals, as in *Finfolk* and his many other animal-becoming video performances, Coates is seeking out a problem as means of reshaping the common sense of social values. In other words, it is not through what is held in common and agreed on that makes the community strong; rather, the problems it poses to itself reveal and even help constitute the structure of the

FIGURE 23 Marcus Coates, *Kamikuchi "The Mouth of God,"* 2006. Video. Courtesy of the artist and Kate MacGarry, London.

community. Coates lets the community see itself obliquely through his vision quests with the animal world: he shows the community of Sheil Park their struggle for solidarity through the feathers of a sparrow hawk; he reveals the issues of inclusion for Stavanger's citizens by presenting them with the stranded baby seal; and he reveals the role of community within the problem of illegal bicycle parking. Coates is not looking for solutions that, like an on–off switch, can neatly solve the problems and assimilate the issues within communities, within their hermeneutic circle and their circle of intelligibility; he reveals instead how problems are fragments from an outside that function within culture to propel it elsewhere. Taking these fragments seriously, Coates provides a voice from an inaccessible or impossible space and time—

the space of the animal spirits, and the time of their speaking to and with humans. As shaman, Coates balances the heterogeneity of culture and animality through his performance of becomings.

ECOLOGIES OF THE SURFACE

Coates provides heterogeneous ecologies and otherworldly possibilities that seem impossible within our world, yet we still make this distinction between these other worlds and our own. Even if he has tried to plant fragments of the Other in our world, there is a hermeneutic circle to contend with. Perhaps it might be possible to think of this problem differently: What if the bubble of the human world and the bubble of the animal worlds (what Uexküll calls a "bubble [that] represents each animal's environment") were flattened and took place on the same plane?[36] While previous chapters discussed the surfaces of intersection between the human and the animal, in Coates's *Dawn Chorus,* the spatial thinking is changed: instead of heterogeneous worlds, Coates imagines a single plane in which human and animal traits spread out across vast distances and occasionally intersect.

Dawn Chorus is a video installation with fourteen large screens in a gallery. Each screen shows a person going about mundane tasks while twitching and bobbing and singing like a bird in the wilds (Figure 24). The project began with Coates observing birds in a field in England's Northumberland countryside. With the assistance of wildlife sound recordist Geoff Sample, Coates set up microphones in trees, bushes, and brush frequented by various birds. As though an almost daily ritual, the birds seemed to return to the same spots to sing. With fourteen microphones recording from three to nine in the morning for six days, they logged some 576 hours of birdsongs, including songs of robins, whitethroats, wrens, blackbirds, song thrushes, yellowhammers, and greenfinches.

Using audio equipment, Coates slowed down the songs so that they easily could be sung or whined or groaned by humans in their natural habitats: the bath, the kitchen, in a taxi, at work, and so on. He recruited members of amateur choirs in Bristol to sing these songs and filmed the results. He then sped

FIGURE 24 Marcus Coates, *Dawn Chorus,* 2007. Installation at Baltic Gallery. Photograph by Colin Davison. Courtesy of the artist and Kate MacGarry, London.

up this film to match that of the birds' singing in nature. It is then that the videos come to life, as if birds and humans had sloughed off hierarchies and different worlds to cross attributes: "Blue Tit is a woman lying in bed, fluttering her eyes and whistling through a puckered mouth. Linnet is an osteopath, nodding and blinking furiously and puffing up his chest in his consulting room."[37] Piers Partridge is the blackbird filmed working in his garden:

> The blackbird had one or two favorite riffs, so I'd think "OK, here he goes." I imagined myself as a blackbird on a spring morning, very early in a high place, having that freedom not to think but just to let the sound come out. With that came some interesting movements—I was cocking my head to look around. I felt really spaced out. When it finished I was miles away.[38]

Mr. Partridge, with his fortuitous name, becomes part of a general economy; not unlike Coates's shaman in a trance, the amateur singer is transported in time and space.

In approaching animals and "becoming-animal," Coates occasionally refers to a common ancestry we have with other beasts, a common remote past that he is tapping into. He could as easily have referred to a common phenomenology, a shared sense of breathing, moving, and sensing. There are dangers in such talk: it can overlook massive differences between humans and animals, which result in not giving animals their due in being different from us; it can evoke a psychological unconscious, which then moves the conversation from surfaces and interactions to the privileged interiority of the human subject as *the* animal with greatest depth of conscious and unconscious; it can lead from Sigmund Freud through Jacques Lacan to the privileging of language. Rather than following this tack, my gambit is that the commonality is a product of leveling heterogeneous worlds onto a plane of immanence. This does not mean creating a homogeneous and singular world for humans and animals; instead, it scatters properties held properly under the name and world of "human" and "animal." As Steve Baker explains in one of his series of essays on art and becoming-animal, "such performances appear to necessitate the sloughing of preconceptions and of identities."[39] Amid this dispersal of properties, squawking, grunting, and bobbing occasionally align with gardening, driving a taxi, or taking a bath (Plate 8). By leveling worlds, this artist as sorcerer has revealed a becoming within the "local birds" of Northumberland. While previous works allowed Coates to become animal and bring the otherworldly to culture, here the community itself unravels into a becoming: the commonsense and daily routine is leveled so as to be reconfigured within the animal world.

If we could think without an inside and outside, if we could be blunt and idiot enough to think without an abyss between humans and animals, we would arrive at another sort of site and productivity—another sort of thinking. Rather than eating the Other through sublation, rather than taking the animal within oneself and digesting its more tasty bits, this leveling of worlds

suggests a continual transfer of attributes. Sometimes these transfers do real work by their creative jostling of terms and forms: Mr. Partridge becomes spaced out and sails miles away; Coates bears witness to the spirit of a baby seal, which helps the people of Stavanger think "fragility" rather than "domination." At other times, this transfer of properties fails as a one-off piece, with no grip or friction with which to work. Such are the risks in a nonstratified mix of worlds. In loosing the tethers of what it means to be human, we find new avenues and lines of flight by which to traverse the un-thought of thought.

.

Coda

Human, Animal, and Matthew Barney

It is perhaps fitting to end this book on animals and art with a coda on becoming: a tale and a tale of tails. Mathew Barney's *Drawing Restraint 9* centers around a series of events on a Japanese whaling ship, the *Nisshin Maru*. The activities that unfold in this video work and the figural forms established in the piece serve as a coda to this book, which is to say that *Drawing Restraint 9* (2005) reveals and extends the concepts developed in other chapters. As a closing, this coda recaps figures and concepts, but it also opens new directions for exploration beyond this book and on to other art. Rather than discuss the breadth of Barney's elaborate works, I am interested in how *Drawing Restraint 9* takes up and provides inflection to concepts that I have laid out. This artwork serves as a field and testing ground for these ideas.

Drawing Restraint is a series of works that explore a fundamental tension: the body as creative organ builds itself and produces only by imposition of resistance or restraints on it. Barney began the *Drawing Restraint* series in the 1990s with works in which the artist sets up elaborate contraptions that required him to climb, pull, and push with great exertion in order to make inscriptions upon a writing surface. The restraints and harnesses in these pieces recall Carolee Schneemann extending her body on a harness to make marks on the walls just beyond her reach in *Up to and Including Her Limits*. For both artists, the body is the fundamental artistic instrument. The body as

instrument meets resistance as it abuts other worlds, other *Umwelts,* and the frictions become the site of production.

As explained by the artist and critics alike, *Drawing Restraint 9* explores how restraint functions upon desire, how it bends and transforms desire, and what happens to bodies as the barriers of resistance are removed. The work unfolds as Barney's character in the video is taken aboard the whaling ship and then joined by another guest, his female counterpoint played by Björk. Immediately a guest–host relationship is established between these visitors and the crew. The two worlds negotiate the space of the ship. Occident and Orient, land and sea, fur-bearing humans and smooth-skinned ones develop a language of give and take, a pidgin language of hospitality and exchange. The guests are bathed and dressed, shedding their land clothes for period Japanese costumes. When Barney first comes on board, he wears a large fur coat and sports a dramatic beard. His transformation begins as the ship's barber shaves him. Later his head is shaved, and he wears hornlike protrusions from his skull. His garb is a mix of arctic fur and a Japanese ceremonial robe. Björk's character also takes on a transitional form by wearing an obi but with fur trappings and elaborate fur headgear. After the guests work their way through a maze of hallways, they find a tearoom at the bottom of the ship. They are greeted by a tea master, and a tea ceremony unfolds with ritual dialogue of questions and response.

The story line of the guests is paralleled by the creation and transformation of a twenty-five-ton petroleum sculptured form on the ship's deck. The Vaseline solidifies in a mold shaped like a whale, but also shaped like Barney's field emblem used throughout the *Drawing Restraint* series. The emblem is an oval form with a vertical bar or restraint across the middle of it. As Barney explains:

> Our story is the removal of the arm from the field and the oval of the field is the body. And the bar is an external resistance that is self imposed. So, the symbol represents restraint or resistance that is imposed onto the body. *Drawing Restraint 9* is about removing the resistance from the body and there being a

potentiality for a sensuality or eroticism or something that then the project hasn't allowed itself to have before. So there is the sense that removing the restraint can allow for something emotionally positive but that puts the body in a state of atrophy somehow.[1]

In *Drawing Restraint 9,* the field emblem looks like an abstract whale form with the bar serving as flippers. In a ritual consuming as knowing (an activity I have previously detailed in chapters 1 and 2), the crew eats small emblem/ whale forms in a ceremonial hunting meal. Later, once the large petroleum field emblem form on deck has congealed, the braces are removed, revealing the black whale "skin," grooves, and ridges of its outer body. Workers wield long staves with sharp knives on the end to cut at the outer "skin" of the mold until it sheers away and reveals the inner white petroleum, which stands thick like whale blubber. The crew slices into the form, and layer by layer, the mold breaks apart and, glacierlike, slides across the surface of the deck.

As this transformation and cutting take place above deck, another set of changes has begun at the bottom of the ship. After the tea ceremony, the tea master leaves, and the two guests are alone for the first time. An ensuing storm draws them together. The tea ritual served as a constraint that allowed communication between guest and host; it provided rules of engagement and respect of difference. Yet such ritual defines and constrains expression through arbitrary limits. When the host leaves and the ritual rules fall away, the guests begin to explore expression in tentative and sometimes awkward new ways. The tea ceremony's ritual formalism is broken, and an erotic and passionate embrace unfolds.

It is a strange and slightly alien intimacy with gestures of romance that are familiar but exaggerated and oddly contorted. The lovers gesture as if tentatively forming a new ritual and syntax for communication. Above on the deck, the crew carves up the form of the whale. Below deck, the tearoom begins to flood with a mix of seawater and petroleum from the emblem/ whale. The human as a homogeneous subject over and against the animal becomes divided between the above-deck Japanese hosts who would consume

the whale and the below-deck Western guests who seek a knowing (one another) without devouring. With the below-decks room half flooded, and amid a passionate embrace, the two guests draw carving knives. Placing the blades under the water, they begin to cut at one another's flesh, slicing away the human legs. Rather than blood and gore, the cutting reveals another surface, one of inhuman form. The legs are sliced in a fashion similar to that of flensing whales, with strips of fat and flesh peeled away one after another all the way to the bone. An odd assemblage of gestures and affects ensue by which this cutting without consuming, this passion of flesh—layer upon layer—this transformation of ritualized slaughter of whales transforms the lovers themselves. Eventually the legs are cut off completely. Used up. Whale tails appear from the layers of flesh, and blowholes appear on their necks. Finally, the ship survives the storm and rolls into the Antarctic seas accompanied by two whales swimming like spirits behind the ship.

The cutting to reveal whale tails establishes a dialogue between Hirst's use of cutting as in *Mother and Child, Divided* and Coates's becoming-seal in *Finfolk*. In Hirst's work, the animal becomes a consumed object appropriated for human knowledge. The animal as object, as meat, functions as layers of flesh, veils of nature, to be opened up and investigated. In Hirst's work, the animal bodies preserved in formaldehyde recall his fascination with scientific inquiry. Rather than use the scientific scalpel—with its connotations of reason, intellect, and dispassionate engagement for knowledge—Barney makes use of ritual flensing knives and turns them not toward the whale alone but more particularly toward the human form, where he literally cuts away at a conception of privileged interiority of the human subject. The artist transforms the rituals of whale slaughter. Barney's character as guest is set within Japanese rituals, but as foreigner is far enough removed to reutilize these rituals toward other ends. He makes use of whale slaughters' syntax and form as a language of death and consumption but turns it toward transformation. Unlike Hirst's cuts with a chainsaw, which establish subject–object relations, Barney's erotic cutting undoes human subjectivity and the myth of human interiority. There is no interiority there, no Dasein or being-there below or

within the human body. Instead, there are layers of flesh and organs that shift in shape and function according to different assemblages.

Whereas Hirst posits a safe distance between viewer and object, in Barney's world, it is the collapse of distances that ignites the dynamics of the work. When the bar is lifted from the field emblem and the restraints are removed from the form, it spills across the ship. The viscous mess fills the space between viewer and viewed like a flesh of the world (to use Merleau-Ponty's phrase) that engulfs and implicates all beings as participants. There is no safe position, no outside or transcendent space from which to stand and judge or observe. Instead, tactile form, touch of surface upon surface, becomes the mode of comportment. The friction of contact between surfaces propels the work.

The transformation in the tearoom recalls Schneemann's erotics and body surfaces meeting in a ritual that breaks open into Dionysian myth of flesh cut, dispersed, and transformed. In Schneemann and Barney, these are not an erotics of interiority manifesting itself but rather desire on the surface of things, one surface against another. Unlike the crew that comes to know the Other through the violence of consumption, for Barney, the blades are pointed toward the humans, and becoming-whale functions as a different sort of knowing. One comes to know the Other through fragility of the human subject, which is stretched beyond its limits not to incorporate the other but to transform the self beyond itself. To recall what I have said earlier about Schneemann's *Meat Joy,* the messiness of the work derided by Schneemann's formalist critic is this problem of organizing the organs—ours and the animals'—so as to hold together the human organism rather than allowing bodies and body parts to mix across individuals and species. When the field emblem's bar is lifted and the erotic embrace begins, the "mess" of contamination between bodies is unleashed.

As art critic Luc Steels observes, Barney's work is driven by the artist's fascination with morphogensis.[2] The petroleum form fluctuates between its initial liquid state and eventual cooling and solidity, only to be cut open and sheer onto the floor in a semiliquid, quasi-solid state. Meanwhile Barney and

Björk undergo their own transformations as they become part of a larger event structure, a haecceity or nonpersonal individuation that coordinates with the surrounding environment. The bodies of the guests have undergone a series of changes that lead to this event, each time becoming more aware of the capacity of bodies to affect and be affected by other surfaces and materials.

I have traced the Dionysian and satyr qualities of Schneemann's work earlier, but Barney also has an interest in satyrs, as is evident in *Drawing Restraint 7* (1993). In this earlier video work, a dapperly dressed satyr drives a limousine by crawling through the seat to chase his tail. Two satyrs in the backseat wrestle one another. One has turned into a ram (where his horns are turned around, curving inward). The horns become drawing instruments as the satyr wrestles the ram and uses the ram's horn to draw a ram horn on the car's sunroof as the car consecutively crosses the six bridges into Manhattan. Barney is consciously using the myth of Marsyas, in which the satyr challenges the god Apollo to a musical competition and is punished for his hubris by being skinned alive. *Drawing Restraint 7* highlights the relationship between creativity and bodies risking their limits. Desire, creativity, and flayed skin from the myth of Marsyas and from *Drawing Restraint 7* get reworked into the tearoom scene in *Drawing Restraint 9.*

Above, on the deck of the *Nisshin Maru,* the crew tries to keep the whale flesh at a distance. The long cutting implements recall Heidegger's shepherd's staff—a staff to corral beings into the open, an opening or appearing that is foundationally humanist. This is a crew that prefers consumption of animals over a becoming—devouring and using the animal for human purposes rather than repurposing themselves. Of course, Barney's field emblem/whale does not comply; rather, it spills out onto the deck, invoking and instigating the erotic transformations of skins and flesh from the Occidental guests. Recall that Coates plies good sense and common sense as foils in his becomings. With the bars of resistance lifted, civility morphs into other forms and codes. Organs and organization are repurposed. The guests are caught between worlds: between their former land lives and the crew's life at sea,

between Occidental and Oriental, as cultures, languages, and modes of comportment, and between the lives of humans and the life and death of whales. With the bar of resistance lifted, barriers of containment between worlds become porous. Bodily being spills out in new ways, in a pidgin language of surfaces, worlds, and desires. Like the closing of *Finfolk,* in *Drawing Restraint 9,* Barney leaves us out to sea, afloat and caught between forms of being. The works provide a tentative closure, ending the work but doing so on the waves of the high sea—the alien realms and possibilities of other worlds.

NOTES

INTRODUCTION

1. David Clark, "Kant's Aliens: The *Anthropology* and Its Others," *New Centennial Review* 1, no. 2 (2001): 201–89.

2. For an overview of human "interiority," see Hilary Putnam, "How Old Is the Mind?," in *Words and Life* (Cambridge, Mass.: Harvard University Press, 1994), 3–21.

3. Georges Bataille, *Theory of Religion,* trans. Robert Hurley (New York: Zone Books, 1989), 21. Quoted in Tom Tyler, "Like Water in Water," *Journal for Cultural Research* 9, no. 3 (2005): 265–79, quote on 267. Tyler provides an insightful reading of Heidegger in this essay.

4. Obviously, the animal rights movement has listed these cruelties. In terms of Continental philosophy, Matthew Calarco, in *Zoographies: The Question of the Animal from Heidegger to Derrida* (New York: Columbia University Press, 2008), outlines how contemporary philosophy has boxed in the animal. Of particular interest here is his chapter on Derrida and the issue of rights. Later, in chapter 3, I will pursue the question of rights through Cary Wolfe's edited collection, *Philosophy and Animal Life* (New York: Columbia University Press, 2008).

5. Issues of the "real" as appearance, and the association of appearances with art, are taken up in chapter 2 in the discussion of Nietzsche's *The Birth of Tragedy.*

6. Jean Baudrillard, *Jean Baudrillard, Selected Writings,* ed. Mark Poster (Stanford, Calif.: Stanford University Press, 1988), 174–75.

7. Gilles Deleuze, *Difference and Repetition* (New York: Columbia University Press, 1994), 62.

8. Steven W. Laycock, "The Animal *as* Animal: A Plea for Open Conceptuality," in *Animal Others: On Ethics, Ontology, and Animal Life,* ed. H. Peter Steeves (Albany: State University of New York Press, 1999), 271–84, quote on 272.

9. David Clark, private correspondence. I am indebted to Clark for his sincere and generous conversations on this topic.

10. Wolfe, *Philosophy and Animal Life.*

11. Michel Serres, *The Natural Contract* (Ann Arbor: University of Michigan Press, 1995), 41.

12. William Wordsworth, "Tintern Abbey," in *The Lyrical Ballads, and Other Poems, 1797–1800,* ed. James Butler and Karen Green (Ithaca, N.Y.: Cornell University Press, 1992), 120.

13. Cary Wolfe, "'Animal Studies,' Disciplinarity, and the (Post)Humanities," in *What Is Posthumanism* (Minneapolis: University of Minnesota Press, 2010), 99–126.

14. Readers may find Britta Jaschinski's art and Randy Malamud's texts on the art a useful example of such a mode of inquiry.

1. Meat Matters

1. Luke White, *Damien Hirst and the Legacy of the Sublime in Contemporary Art and Culture* (London: Middlesex University, 2009).

2. Damien Hirst, *I Want to Spend the Rest of My Life Everywhere, with Everyone, One to One, Always, Forever, Now* (New York: Monacelli Press, 1997), 298.

3. Pierre Hadot, *The Veil of Isis: An Essay on the History of an Idea,* trans. Michael Chase (Cambridge, Mass.: Belknap Press, 2006), 8.

4. Carolyn Merchant, *The Death of Nature: Women, Ecology, and the Scientific Revolution* (San Francisco: Harper & Row, 1980), 168–69.

5. Francis Bacon, *The New Organon,* ed. Lisa Jardine and Michael Silverthorne (Cambridge: Cambridge University Press, 2000), 81; Hadot, *Veil of Isis,* 93.

6. Francis Bacon, *The Works of Francis Bacon,* vol. 4, ed. James Spedding, Robert Leslie Ellis, et al. (London: Longman, 1875), 296.

7. Merchant, *Death of Nature,* 168–69.

8. Simon Lumsden, "Hegel, Derrida and the Subject," *Cosmos and History: The Journal of Natural and Social Philosophy* 3, no. 2–3 (2007): 32–50, quote on 34. Emphasis in original.

9. Genesis 1:28, *The New American Bible* (New York: Catholic Book Publishing Company, 1986).

10. In contemporary animal training, Vicky Hearn has invoked the story in Genesis as a negotiated respect created between humans and animals in *Adam's Task: Calling Animals by Name* (New York: Knopf, 1986). In *Companion Species Manifesto* (Chicago: Prickly Paradigm Press, 2003), Donna Haraway invokes Hearn in her own training with dogs but respectfully distances herself from the hierarchy implicit in Adam's naming. Instead, she sees the human–dog relationship as one of co-evolution. Richard Nash outlines this issue of naming (and includes Carl Linnaeus and Comte de Buffon) in his essay "Animal Nomenclature: Facing Other Animals," in *Humans and Other Animals in Eighteenth-century British Culture: Representation, Hybridity, Ethics*, ed. Frank Palmeri (Aldershot, UK: Ashgate Publishing, 2006), 101–18.

11. Quoted in Michael Gaudio, "Surface and Depth: The Art of Early American Natural History," in *Stuffing Birds, Pressing Plants, Shaping Knowledge: Natural History in North America, 1730–1860*, ed. Sue Ann Prince (Philadelphia: Transactions of the American Philosophical Society, 2007), 55–73.

12. Quoted in Erica Fudge, *Perceiving Animals: Humans and Beasts in Early Modern English Culture* (New York: Macmillan/St. Martin's Press, 2007), 103–4.

13. Ibid., 108.

14. Francis Bacon, *The New Atlantis* (Hoboken, N.J.: Bibliobytes, NetLibrary, 1998), 19.

15. Hirst, *I Want to Spend the Rest of My Life Everywhere*, 298.

16. Hirst exhibition program quoted in "Are Modern Animal Mommies Art?," Animal Mommies, http://www.mummytombs.com/mummylocator/animal/hirst.art.htm (accessed May 15, 2008).

17. Correspondence with the Gagosian Gallery and Hirst's studio has confirmed that both cattle in *Some Comfort Gained from the Acceptance of the Inherent Lies in Everything* are females—namely, cows. While Hirst and many critics discuss this piece as desire and the impossibility of union between two cattle separated from each other though interlaced, the sculpture becomes increasingly complicated by the often-overlooked biological nicety of the animals' sex. Biological sex of the animals affect their being and world, which is under consideration in this chapter. Millicent Wilner, "Technical Specs Inquiry for Hirst's Cattle," May 20, 2008, http://www.gagosian.com/exhibitions/soho-1996-05-damien-hirst (accessed May 20, 2008).

18. Lumsden, "Hegel, Derrida and the Subject," 34.

19. Fudge, *Perceiving Animals*, 108. Hirst continues the theme of Eden as a haunted cultural past in *Adam and Eve Banished from the Garden* (2000), *Adam and Eve Together at Last* (2004), and *Adam and Eve Exposed* (2004), among others.

20. Mario Codognato, "Warning Labels," in *Damien Hirst, the Agony and the Ecstasy: Selected Works from 1989 to 2004,* ed. Damien Hirst, Eduardo Cicelyn, Mario Codognato, and Mirta D'Argenzio (Naples: Museo Archeologica Nationale, 2005), 24–46, quote on 35.

21. Ibid., 25; William Shakespeare, *Hamlet* 1.2.

22. Much more could be said of Hirst's use of Christianity to suggest spiritual or failed spiritual teleology. He continually invokes Christian symbols in his works, from a piece in which twelve cattle heads are named after Christ's disciples to a skeleton stretched on a glass crucifix.

23. Lumsden, "Hegel, Derrida and the Subject," 37.

24. George Wilhelm Friedrich Hegel, *Hegel's Logic: Being Part One of the Encyclopaedia of the Philosophical Sciences (1830),* trans. William Wallace (New York: Oxford University Press, 1975), 34–35.

25. Ibid. In his foreword to this edition, John Niemeyer Findlay notes that Wallace's translation veers slightly from the spirit of Hegel's work: "Wallace's words 'of the object' are wrongly placed: Hegel does not hold that the mind alters its object, but that by altering the manner in which that object is given to it, it penetrates to its true, its universal nature" (ix). Wallace exchanges *penetration* for *alteration.* In his next paragraph of *The Logic* (23), Hegel goes on to say: "The real nature of the object is brought to light in reflection, but it is no less true that this exertion of thought is *my* act. If this be so, the real nature is a *product* of *my* mind, in its character of thinking subject—generated by me in any simple universality, self-collected and removed from extraneous influences—in one word, in my Freedom" (35).

26. Findlay, foreword to Hegel, *Hegel's Logic,* v–xxvii, quote on ix.

27. Lumsden, "Hegel, Derrida and the Subject," 35.

28. David L. Clark, "Hegel, Eating: Schelling and the Carnivorous Virility of Philosophy," in *Cultures of Taste/Theories of Appetite: Eating Romanticism,* ed. Timothy Morton (New York: Palgrave Macmillan, 2004), 115–40, quote on 128. Also see Mark C. E. Peterson, "Animals Eating Empiricists: Assimilation and Subjectivity in Hegel's Philosophy of Nature," *The Owl of Minerva: Quarterly Journal of the Hegel Society of America* 23, no. 1 (1991): 49–62, quote on 56–57.

29. George Wilhelm Friedrich Hegel, *Hegel's Philosophy of Nature: Part Two of the Encyclopaedia of the Philosophical Sciences (1830),* trans. Arnold V. Miller (Oxford: Oxford University Press, 2004), 367. The reference here is to the "Organics" section. In discussing the animal body and the concept of assimilation, Hegel takes up the role

of ingestion and internalization. The physiology of animal eating doubles the role of sublation for the human subject, where the outside is internalized materially and mentally with nothing lost or destroyed.

30. Howard P. Kainz, *Paradox, Dialectic, and System: A Contemporary Reconstruction of the Hegelian Problematic* (University Park: Pennsylvania State University Press, 1988), 93.

31. Ibid., 94.

32. Clark, "Hegel, Eating," 129.

33. See chapter 1, "Hirst and the Contemporary Sublime," in Luke White, "Damien Hirst and the Legacy of the Sublime in Contemporary Art and Culture," http://home page.mac.com/lukewhite/diss_wip.htm (accessed May 15, 2008).

34. Carol Vogel, "Swimming with Famous Dead Sharks," *New York Times,* October 1, 2006, http://www.nytimes.com/2006/10/01/arts/design/01voge.html (accessed May 1, 2008).

35. Ibid.

36. Quoted in Hadot, *Veil of Isis,* 32.

37. Johann Wolfgang von Goethe, *Faust: Part One,* trans. David Luke (New York: Oxford University Press, 1998), 1.4.672–75.

38. Hadot, *Veil of Isis,* 148.

39. Renaud Barbaras, "Perception and Movement: The End of Metaphysical Approach," in *Chiasms: Merleau-Ponty's Notion of Flesh,* ed. Leonard L. Fred Evans (Albany: State University of New York Press, 2000), 77–88, quote on 78.

40. Ibid., 78.

41. Maurice Merleau-Ponty, *The Visible and the Invisible; Followed by Working Notes,* trans. Alphonso Lingis (Evanston, Ill.: Northwestern University Press, 1969), 109.

42. Barbaras, " Perception and Movement," 80.

43. Ibid., 82.

2. BODY OF THOUGHT

1. Carolee Schneemann and Bruce R. McPherson, eds., *More than Meat Joy: Complete Performance Works and Selected Writings* (New Paltz, N.Y.: Documentext, 1979), 63.

2. Amy Newman, "An Innovator Who Was the Eros of Her Own Art," *New York Times,* February 3, 2002, http://query.nytimes.com/gst/fullpage.html?res=9500E3DA 103AF930A35751C0A9649C8B63 (accessed June 13, 2008).

3. Laura Muvey, "Visual Pleasure and Narrative Cinema," in *Issues in Feminist Film Criticism*, ed. Patricia Erens (Bloomington: Indiana University Press, 1990), 28–40, quote on 33.

4. Paul Schimmel et al., *Out of Actions: Between Performance and the Object, 1949–1979* (London: Museum of Contemporary Art/Thames & Hudson, 1998), 296; see also Thomas McEvilley, "Carolee Schneemann (What You Did Do)," in *Split Decision*, ed. Carolee Schneemann (Buffalo, N.Y.: Dual Printing, 2007), 38–49, quote on 41.

5. Schneemann and McPherson, *More than Meat Joy*, 63–87.

6. Jonas Mekas, "In Praise of the Surface," in Schneemann and McPherson, *More than Meat Joy*, 276–77, quote on 276.

7. Schneemann and McPherson, *More than Meat Joy*, 65.

8. Rebecca Schneider, *The Explicit Body in Performance* (New York: Routledge, 1997), 31.

9. Mekas, "In Praise of the Surface," 277.

10. Ibid., 276.

11. Lawrence J. Hatab, "Human-Animality in Nietzsche," in *A Nietzsche Bestiary*, ed. Christa Davids Acompora and Ralph R. Acampora (Lanham, Md.: Rowman & Littlefield, 2004), 211–19.

12. It is worth noting here at the outset of this chapter that Nietzsche and Heidegger both use the generic *man* for human. The grammatical gesture is part of Schneemann's own disappointment with the social status quo by which the male gender is the default operator that subsumes the female. Moreover, given Nietzsche's misogynist aphorisms throughout his career, he may appear to be an odd coupling alongside Schneemann. I hope readers will forgive my own selection and cutting of Nietzsche in this case: I am interested in, and limiting myself to, a particular aspect of his work that coincides with issues of surface, flesh, consumption, and subjectivity in Schneemann's art.

13. Hatab, "Human-Animality in Nietzsche," 213.

14. Friedrich Nietzsche, *The Birth of Tragedy* and *The Genealogy of Morals*, trans. Francis Golffing (Garden City, N.Y.: Doubleday/Anchor Books, 1956), 52–53.

15. Carolee Schneemann, *Imaging Her Erotics: Essays, Interviews, Projects* (Cambridge, Mass.: MIT Press, 2002), 165.

16. Schneemann and McPherson, *More than Meat Joy*, 233.

17. This sense of possession should not be taken as a force that counters female agency or the agency of the female artist (see Schneider, *Explicit Body in Performance*,

37); rather, this sense of possession works as a part of an extended nervous system of bodies on a plane of immanence.

18. Schneemann and McPherson, *More than Meat Joy*, 238.

19. Carolee Schneemann, in conversation (May 28, 1975) with Daryl Chin regarding *Up to and Including Her Limits*, in Schneemann, *Carolee Schneemann: Early Work, 1960/70* (New York: Max Hutchinson Gallery/Documentext, 1982), n.p.

20. David Farrell Krell, *Intimations of Mortality: Time, Truth, and Finitude in Heidegger's Thinking of Being* (University Park: Pennsylvania State University Press, 1986), 136.

21. Martin Heidegger, *Nietzsche*, vol. 1, trans. David Farrell Krell (San Francisco: Harper San Francisco, 1979).

22. Rodolphe Gasché, "*Ecce Homo* or the Written Body," in *Looking after Nietzsche*, ed. Laurence A. Rickels (Albany: State University of New York Press, 1990), 113–36.

23. Jacques Derrida, "'Eating Well,' or the Calculation of the Subject: An Interview with Jacques Derrida," in *Who Comes after the Subject?*, ed. Eduardo Cadava, Peter Connor, and Jean-Luc Nancy (New York: Routledge, 1991), 114–15. Emphasis in original.

24. Martin Heidegger, "The Thing," in *Poetry, Language, Thought* (New York: Harper & Row, 1971), 165–66.

25. James George Frazer, *The Golden Bough* (1922; reprint, Oxford: Oxford University Press, 1998), 396–401. For links to Schneemann along these lines, see Jay Murphy's "Assimilating the Unassimilable: Carolee Schneemann in Relation to Antonin Artaud," *Parkett* 50/51 (1997): 224–31.

26. Heidegger, *Nietzsche* 1:5.

27. Ibid.

28. Martin Heidegger, "Letter on Humanism," in *Basic Writings*, trans. David Farrell Krell (New York: HarperCollins, 1993), 234.

29. Martin Heidegger, *Being and Time*, trans. Joan Stambaugh (Albany: State University of New York Press, 1996), 209.

30. Ibid., 196.

31. Martin Heidegger, "The Question Concerning Technology," in *Basic Writings*, 330.

32. Heidegger, "Letter on Humanism," 230.

33. David Ferrell Krell, *Daimon Life: Heidegger and Life-Philosophy* (Bloomington: Indiana University Press, 1992), 202.

34. Krell salvages this abyss for Heidegger by showing how the philosopher tentatively attempts to fill the abyss with "the question of a fundamental relation to the

living" (*Daimon Life,* 207). Yet even here, Krell must turn the question away from bodily being and living amid other animals to Heidegger's concern for the unique relationship humans have to death (including our animal death).

35. Mekas, "In Praise of the Surface," 276.

36. Schneider, *Explicit Body in Performance,* 31.

37. Heidegger subsumes Nietzsche's thinking under the guiding question regarding beings, rather than the grounding question that addresses the truth of being. McNeill summarizes Heidegger's argument as follows: "That which now is, the sensuous in its coming-into-appearance, is still understood by Nietzsche as that which *truly* is; being as expressed in the 'is' continues to be understood implicitly as truth, and such being as truth remains entangled in a Platonic conception of ἀλήθεια [*aletheia,* truth; unconcealment], a conception in which ἀλήθεια is drawn into a λογος [*logos*] of ομοιωσις [*omoiwsis,* the good and upright]" (196). Heidegger finds in Nietzsche an appeal to truth, the truth of illusions, and the truth of beings in their becoming. Heidegger has effectively tried to herd Nietzsche into the sheepfold of metaphysics, even if he is the last to enter the fold and lingers at the gate to escape. Will McNeill, "Traces of Discordance: Heidegger–Nietzsche," in *Nietzsche: A Critical Reader,* ed. Peter R. Sedgwick (Oxford: Blackwell Publishers, 1995).

38. Heidegger, "Letter on Humanism," 225.

39. Ibid., 229.

40. Jakob von Uexküll, "A Stroll through the World of Animals and Men: A Picture Book of Invisible Worlds," in *Instinctive Behavior: The Development of a Modern Concept,* ed. Claire H. Schiller and trans. D. J. Kuenen (New York: International Universities Press, 1957), 5–80; see also Giorgio Agamben, *The Open: Man and Animal* (Stanford, Calif.: Stanford University Press, 2004), 52–55.

41. Agamben, *The Open,* 16.

42. Martin Heidegger, *The Fundamental Concepts of Metaphysics: World, Finitude, Solitude* (New York: Doubleday, 1961), 185.

43. Nietzsche, *Birth of Tragedy,* 4.

44. Ibid., 10.

45. McNeill, "Traces of Discordance," 189.

46. Friedrich Nietzsche, *Twilight of the Idols,* trans. Duncan Large (Oxford: Oxford University Press, 1998), 20; see also McNeill, "Traces of Discordance," 191.

47. Nietzsche, *Twilight of the Idols,* 20.

48. Heidegger, *Nietzsche,* 1:213–18.

49. Schneemann and McPherson, *More than Meat Joy,* 165.

50. Ibid.

51. Ibid., 167.

52. Lawrence Alloway, "Carolee Schneemann: The Body as Object and Instrument," *Art in America* (March 1980): 19–21, quote on 21.

53. Agamben, *The Open,* 77.

3. MAKING SPACE FOR ANIMAL DWELLING

1. Giorgio Agamben, *The Open: Man and Animal* (Stanford, Calif.: Stanford University Press), 57. See also Rainer Maria Rilke, "Eighth Duino Elegy," in *Duino Elegies,* trans. A. S. Kline (privately printed, 2000), 31; translated in the A. S. Kline edition as "Nowhere without the Not" (31) and "Nowhere without the No" in *The Essential Rilke,* trans. Galway Kinnell and Hannah Liebmann (New York: HarperCollins, 1999), 125. Kline's thinking about this translation is illuminating. The following is from my private correspondence with Kline, October 28, 2010:

> What Rilke says is: *"niemals Nirgends ohne Nicht"* which does *not* have the form of Mitchell's "never the Nowhere without the No," i.e. you can't imply a German "where" by subtracting *Nicht* from *Nirgends.* . . . It doesn't work in German . . . though it sounds so neat in Mitchell's English you kind of expect the German to have the same form, and are surprised when it doesn't.
>
> I thought long and hard about it. If I translated *Nicht* as No, which is a perfectly valid alternative to Not, I had to go with Mitchell's English which inevitably implies to the alert reader: subtract No from Nowhere and get an expansive "Where," a *location,* a space but unlike our own space, in which the flowers simply exist . . . a very nice idea . . . but is it what Rilke wanted? . . . whereas my reading simply suggests, as Rilke simply says, I think, that the flowers exist (in themselves and unlike us), in a Nowhere, a *Nirgends,* a *non-location,* but one without any Not, any *Nicht,* i.e. without any craving e.g. "I do *not* wish to be in this place" or ignorance e.g. "I do *not* understand this place." Which has similarities with the Buddhist *Nirvana,* which is the end of craving and ignorance! Rilke certainly studied Buddhism.
>
> So I had to choose "Not" in order to foil the Mitchell reading which arises from a quirk of English I think, though I do like the way his English flows and maybe the end result is not philosophically so different. Hopefully, though my "Not" jars where Mitchell's "No" doesn't, it might alert the reader to consider deeply what Rilke is trying to say.

2. Bryndis Snæbjörnsdóttir, "Spaces of Encounter: Art and Revision in Human–Animal Relations" (doctoral dissertation, Valand School of Fine Arts, University of Gothenburg, May 29, 2007); Anne Brydon, "The Predicament of Nature: Keiko the Whale and the Cultural Politics of Whaling in Iceland," *Anthropological Quarterly* 79, no. 2 (2006): 225–60.

3. Pierre Hadot, *The Veil of Isis: An Essay on the History of an Idea,* trans. Michael Chase (Cambridge, Mass.: Belknap Press, 2006), 148.

4. John Berger, "Why Look at Animals," in *About Looking* (New York: Vintage, 1991), 3–30, quote on 3.

5. Jacques Derrida, "The Animal That Therefore I Am (More to Follow)," *Critical Inquiry* 28, no. 2 (2002): 369–80.

6. Steve Baker, *The Postmodern Animal* (London: Reaktion Books, 2000), 186.

7. Martin Jay, "Scopic Regimes of Modernity," in *Vision and Visuality* (Seattle: Bay Press, 1988), 4–11.

8. Derrida, "The Animal That Therefore I Am," 370.

9. Donna Haraway, *When Species Meet* (Minneapolis: University of Minnesota Press, 2007), 21.

10. Thomas Nagel, "What Is It Like to Be a Bat?," *Philosophical Review* 83, no. 4 (1974): 435–50, quote on 441, emphasis added.

11. Ibid., 440.

12. Ibid., 443.

13. Ibid., 444.

14. Ibid., 445.

15. For a study of how biosemiotics deploys Uexküll's work, see Wendy Wheller's *The Whole Creature: Complexity, Biosemiotics and the Evolution of Culture* (London: Lawrence & Wishart, 2006), and also the special issue of *Semiotica* 134, no. 1–4 (2001).

16. Jakob von Uexküll, *A Foray into the Worlds of Animals and Humans,* trans. Joseph D. O'Neil (Minneapolis: University of Minnesota Press, 2010). For a much earlier translation, see "A Stroll through the World of Animals and Men: A Picture Book of Invisible Worlds," in *Instinctive Behavior: The Development of a Modern Concept,* ed. Claire H. Schiller, trans. D. J. Kuenen (New York: International Universities Press, 1957), 5–80; Tim Ingold, *Perception of the Environment* (New York: Routledge, 2000), 176.

17. Uexküll, *Foray into the Worlds of Animals and Humans,* 45.

18. Ibid., 53.

19. Ibid., 54.

20. Ibid., 50.

21. Ibid., 53.

22. Agamben, *The Open*, 41–42.

23. Mark Wilson aptly points out the missing evolutionary component in Agamben's reading of Uexküll's spider: "[T]he spider therefore too is fly-like. As in that which we as humans are attuned to make us what we are—our environment, our immunities, our predilections and our survival mechanisms, instincts, physical abilities, etc. The 'surprise' in this example has always troubled me because it is coined in such a way that suggests a (coy?) ignorance or denial of the mechanisms of evolution ... e.g., Dawkins' 'arms race'" (Wilson to author, personal correspondence, August 19, 2008).

24. Uexküll, *Foray into the Worlds of Animals and Humans*, 41, 43.

25. Ibid., 53.

26. See Geoffrey Winthrop-Young, "Afterword: Bubles and Webs: A Backdoor Stroll through the Readings of Uexküll," in *A Foray into the Worlds of Animals and Humans*, 209–43; see especially 218–21, and on Rilke and Uexküll, 230–35.

27. It is worth noting that the project began under the working title *(a)fly*. The question of whose soup or whose world one occupies is central to the work.

28. Conversation with the artists, June 25, 2005.

29. Bryndis Snæbjörnsdóttir and Mark Wilson, "Artist Statement," http://www.snaebjornsdottirwilson.com/artiststatement.php (accessed June 25, 2008).

30. Bryndis Snæbjörnsdóttir and Mark Wilson, *(a)fly*, http://www.snaebjornsdottirwilson.com/afly.html (accessed August 3, 2006).

31. Uexküll, "A Stroll through the World of Animals and Men," 5.

32. Bryndis Snæbjörnsdóttir and Mark Wilson, interviewed by Giovanni Aloi, "Nanoq: In Conversation," *Antennae* 6 (2008): 28–34, quote on 29; http://www.antennae.org.uk/ (accessed June 27, 2008). Another interview worth noting is: Bryndis Snæbjörnsdóttir and Mark Wilson, interviewed by Steve Baker and Ross Birrell, "On Animals, Death and Derrida's Cat," *Art and Research* 1, no. 2 (2007); http://www.artandresearch.org.uk/v1n2/baker.html (accessed June 4, 2007).

33. Steve Baker quoting Michelle Henning, in Baker, "What Can Dead Bodies Do?," in *nanoq: flat out and bluesome*, ed. Bryndis Snæbjörnsdóttir and Mark Wilson (London: Black Dog Publishing, 2006), 148–55, quote on 152; Lucy Byatt, in Bryndis Snæbjörnsdóttir, Mark Wilson, and Lucy Byatt, "Flat Out and Bluesome," *Antennae* 6 (2008): 21–27, quote on 24; http://www.antennae.org.uk/ (accessed June 27, 2008).

34. Baker, "What Can Dead Bodies Do?," 154.

35. Snæbjörnsdóttir, Wilson, and Byatt, "Flat Out and Bluesome," 22.

36. In discussing the moment of encounter between humans and polar bears in the arctic, Snæbjörnsdóttir and Wilson have noted that this becomes the moment of an "event"—a unique and noniterable moment for this animal—when it enters human history. Citing Erica Fudge's "A Left-handed Blow: Writing the History of Animals" (in *Representing Animals*, ed. Nigel Rothfels [Bloomington: Indiana University Press, 2002], 3–18), they have explored how the encounter is the moment of human narrative over and against the animal. (From the question-and-answer session of the artists' talk, "Engaging Animals," at the conference "Visualizing Animals," University Park, Pennsylvania State University, April 3, 2007.)

37. See Michelle Henning, "Skins of the Real: Taxidermy and Photography," in Snæbjörnsdóttir and Wilson, *nanoq: flat out and bluesome*, 136–47.

38. Notable among the specimens is the bear housed in the National Museum of Ireland in Dublin. The bear was shot by Sir Leopold McClintock in 1851, and the animal sustained between six and nine shots before being killed; see Snæbjörnsdóttir and Wilson, *nanoq: flat out and bluesome*, 102.

39. Gary Marvin, "Perpetuating Polar Bears: The Cultural Life of Dead Animals," in Snæbjörnsdóttir and Wilson, *nanoq: flat out and bluesome*, 156–65, quote on 163.

40. Cary Wolfe, "Exposures," in *Philosophy and Animal Life* (New York: Columbia University Press, 2008), 1–42, quote on 8.

41. Ralph R. Acampora, "Bodily Being and Animal World: Toward a Somatology of Cross-Species Community," in *Animal Others: On Ethics, Ontology, and Animal Life*, ed. H. Peter Steeves (Albany: State University of New York Press, 1999), 117–32, quote on 120.

42. Ibid., 123.

43. Ibid.

4. Contact Zones and Living Flesh

1. Olly and Suzi worked in the field during the 1990s and early 2000s. Currently, they are producing paper and canvas paintings in their London studio. These canvases weave together real and imaginative narratives of the various animal encounters from their previous work.

2. Michel Foucault, *The Order of Things* (New York: Vintage Books, 1994), 137.

3. Maurice Merleau-Ponty, "The Eye and the Mind," in *The Essential Writings of Merleau-Ponty,* ed. Alden L. Fisher (New York: Harcourt, Brace & World, 1969), 252–86, quote on 259.

4. See chapters 1 and 2, which take up different methods of knowledge and/as consumption of animal flesh.

5. Martin Heidegger, *The Fundamental Concepts of Metaphysics: World, Finitude, Solitude* (New York: Doubleday, 1961), 185.

6. J. M. Coetzee, *The Lives of Animals* (Princeton, N.J.: Princeton University Press, 1999), 28–29.

7. Jacques Derrida, "The Animal That Therefore I Am (More to Follow)," *Critical Inquiry* 28, no. 2 (2001): 369–80, quote on 392.

8. Giorgio Agamben, *The Open: Man and Animal* (Stanford, Calif.: Stanford University Press, 2004), 75.

9. Heidegger, *Fundamental Concepts of Metaphysics,* 185.

10. Jacques Derrida, *Of Spirit* (Chicago: University of Chicago Press, 1991), 51.

11. Heidegger, *Fundamental Concepts of Metaphysics,* 198, emphasis added.

12. Tim Ingold, *Perception of the Environment* (New York: Routledge, 2000), 176.

13. Jakob von Uexküll, *A Foray into the Worlds of Animals and Humans,* trans. Joseph D. O'Neil (Minneapolis: University of Minnesota Press, 2010); Agamben, *The Open,* 52–55.

14. As an illustration of this problem in George Bataille and Heidegger, see Tom Tyler, "Like Water in Water," *Journal for Cultural Research* 9, no. 3 (July 2005): 265–79.

15. Gilles Deleuze, *The Logic of Sense* (New York: Columbia University Press, 1990), 128–29; Fredrik Young, "Animality: Notes towards a Manifesto," in *Glossalalia,* ed. Julian Wolfreys and Harun Karim Thomas (Manchester: Manchester University Press, 2003), 9–22, quote on 10.

16. Coetzee, *Lives of Animals,* 65.

17. Heidegger, *Fundamental Concepts of Metaphysics,* 198; Derrida, "The Animal That Therefore I Am," 53.

18. Deleuze, *Logic of Sense,* 133.

19. Young, "Animality," 16.

20. Coetzee, *Lives of Animals,* 65.

21. Peter Sloterdijk, *Critique of Cynical Reason* (Minneapolis: University of Minnesota Press, 1987), 104.

22. Heidegger, *Fundamental Concepts of Metaphysics,* 255, emphasis added.

23. Steven W. Laycock and Ralph R. Acampora provide a language and examples for an animal phenomenology in their respective articles, "The Animal as Animal: A Plea for Open Conceptuality" and "Bodily Being and Animal World: Toward a Somatology of Cross-Species Community," in *Animal Others: On Ethics, Ontology, and Animal Life,* ed. H. Peter Steeves (Albany: State University of New York Press, 1999), 271–84, 117–32.

24. Olly and Suzi, *Olly and Suzi: Arctic Desert Ocean Jungle* (New York: Harry N. Abrams, 2003), 8.

25. Ibid., 184.

26. Ibid., 162.

27. H. Peter Steeves, "They Say Animals Can Smell Fear," in Steeves, *Animal Others,* 133–78, quote on 136.

28. Olly and Suzi, *Olly and Suzi,* 145.

29. It should be noted that in their recent works, from 2007 onward, Olly and Suzi have deemphasized the animal interaction with the paper. They are currently highlighting the role of the environment, which has always had a place in their work. They considered the animals' endangered environments to be a primary rationale for their art.

30. Clive James, introduction to Olly and Suzi, *Olly and Suzi,* 2.

31. Conversation with Olly and Suzi, October 1, 2007, London.

32. Mary Louise Pratt, *Imperial Eyes* (New York: Routledge, 1992), 4.

33. Ibid., 6.

34. For an extensive discussion of working with companion species in a "contact zone," see chapter 8 of Donna Haraway's *When Species Meet* (Minneapolis: University of Minnesota Press, 2007), 205–46.

35. Steve Baker, *The Postmodern Animal* (London: Reaktion Books, 2000), 126.

36. Ibid., 24–25, 38.

37. Ibid., 117–18, emphasis added.

38. Jacques Derrida, "*Geschlect* II: Heidegger's Hand," in *Deconstruction and Philosophy,* ed. John Sallis (Chicago: University of Chicago Press, 1987), 161–96, quote on 175, emphasis in original.

39. Olly and Suzi, "New Elements," http://www.ollysuzi.com/galleries/v/newelements/ (accessed June 20, 2008).

40. Agamben, *The Open,* 16.

41. Coetzee, *Lives of Animals,* 65.

5. A Minor Art

1. See, for example, Giovanni Aloi, "Marcus Coates—Becoming-Animal," *Antennae* 4 (2007): 18–20, and, in the same issue, the interview by Aloi, "In Conversation with Marcus Coates," 31–34, http://www.antennae.org.uk/ (accessed July 24, 2008). Also see the interview with Marcus Coates on January 22, 2007, Bristol City Museum Art Gallery, in *In Profile Marcus Coates* (Bristol: Picture This, 2007). For further work on becoming-animal in contemporary art, see Steve Baker, "What Does Becoming-Animal Look Like?," in *Representing Animals,* ed. Nigel Rothfels (Bloomington: Indiana University Press, 2002), 67–98.

2. Jacques Derrida, "The Animal That Therefore I Am (More to Follow)," *Critical Inquiry* 28, no. 2 (2002): 369–80, quote on 372.

3. Ibid.

4. Ibid., 399. The original (on page 281 of *L'animal autobiographique*) reads: "et ce que les soi-disant hommes, ceux qui se nomment des hommes, appellent l'animal. Tout le monde est d'accord à ce sujet, la discussion est close d'avance, et il faudrait être *plus bête que les bêtes* pour en douter. Les bêtes mêmes savant cela" (emphasis added). My thanks to Steve Baker for suggesting I quote from the French text.

5. Gilles Deleuze, *Difference and Repetition* (New York: Columbia University Press, 1994), 131.

6. Fredrick Young, "Animality: Notes towards a Manifesto," in *Glossalalia,* ed. Julian Wolfreys and Harun Karim (Manchester: Edinburgh University Press, 2003), 16.

7. Jacques Derrida, "Psyche: Invention of the Other," in *Acts of Literature,* ed. D. Attridge (New York: Routledge,1992), 312, cited in Steve Baker, *The Postmodern Animal* (London: Reaktion Books, 2000), 41.

8. Baker, *Postmodern Animal,* 40, 41.

9. Mary Louise Pratt, *Imperial Eyes* (New York: Routledge, 1992), 4.

10. Ibid., 6.

11. Gilles Deleuze and Félix Guattari, *Kafka: Toward a Minor Literature* (Minneapolis: University of Minnesota Press, 1986), 16.

12. Ibid., 22.

13. Ibid.

14. Ibid., 23, emphasis in original.

15. Ibid., 22.

16. Ibid.

17. Deleuze, *Difference and Repetition,* 55–56.

18. Deleuze and Guattari, *Kafka,* 22.

19. Ibid.

20. Ibid.

21. Derrida, "The Animal That Therefore I Am," 399.

22. Deleuze and Guattari, *Kafka,* 18, emphasis in original.

23. Gilles Deleuze and Félix Guattari, *A Thousand Plateaus: Capitalism and Schizophrenia* (Minneapolis: University of Minnesota Press, 1987), 234.

24. Ibid., 261.

25. Mark Bonta and John Protevi, *Deleuze and Geophilosphy: A Guide and Glossary* (Edinburgh: Edinburgh University Press, 2004), 94.

26. Deleuze and Guattari, *A Thousand Plateaus,* 263.

27. Ibid., 234.

28. Alec Finlay, "Chthonic Perjink," in *Journey to the Lower World,* ed. Marcus Coates and Alec Finlay (Newcastle upon Tyne: Platform Projects, distributed by Trans-Atlantic Publications, 2007), n.p.

29. Marcus Coates, "Linosa Close (Sheil Park)," in Coates and Finlay, *Journey to the Lower World.*

30. Marcus Coates, "Transcript of the Ritual," in Coates and Finlay, *Journey to the Lower World.*

31. Coates, "Linosa Close (Sheil Park)."

32. Jacques Derrida talks about this future in his concept of "haunting," an event that was never manifest within culture, yet it lingers: "Untimely, it [haunting] does not come to, it does not happen to, it does not befall, one day, Europe, as if the latter, at a certain moment of its history, had begun to suffer from a certain evil, to let itself be *inhabited* in its inside, that is, haunted by a foreign guest. . . . But there was no inside, there was nothing inside before it"; *Specters of Marx* (New York: Routledge, 1994), 4. This event is neither within history as assimilated (think Hegel and digestion in chapter 1) nor as outside, as if culture had an inside apart from that which it rejects as "outside."

33. Deleuze and Guattari, *A Thousand Plateaus,* 258.

34. Ibid., 249.

35. Ibid., 238.

36. Jakob von Uexküll, *A Foray into the Worlds of Animals and Humans,* trans. Joseph D. O'Neil (Minneapolis: University of Minnesota Press, 2010), 43.

37. Viv Groskop, "Chirps with Everything," *Guardian* (London), January 25, 2007.

38. Ibid.

39. Steve Baker, "Sloughing the Human," in *Zoontologies: The Question of the Animal*, ed. Cary Wolfe (Minneapolis: University of Minnesota Press, 2003), 147–64, quote on 159.

Coda

1. Matthew Barney, *Matthew Barney: No Restraint*, DVD, dir. Alison Chernick, perf. Gabe Bartalos, Matthew Barney, and Barbara Gladstone (Voyeur Films, IFC First Take, USA 2008).

2. Luc Steels, "Matthew Barney's Narrative Machines," in *Matthew Barney: Drawing Restraint*, vol. 2, ed. Matthew Barney (Tokyo: Uplink, 2005), 21–26, quote on 23.

INDEX

RON BROGLIO is assistant professor of English at Arizona State University. He is author of *Technologies of the Picturesque*.